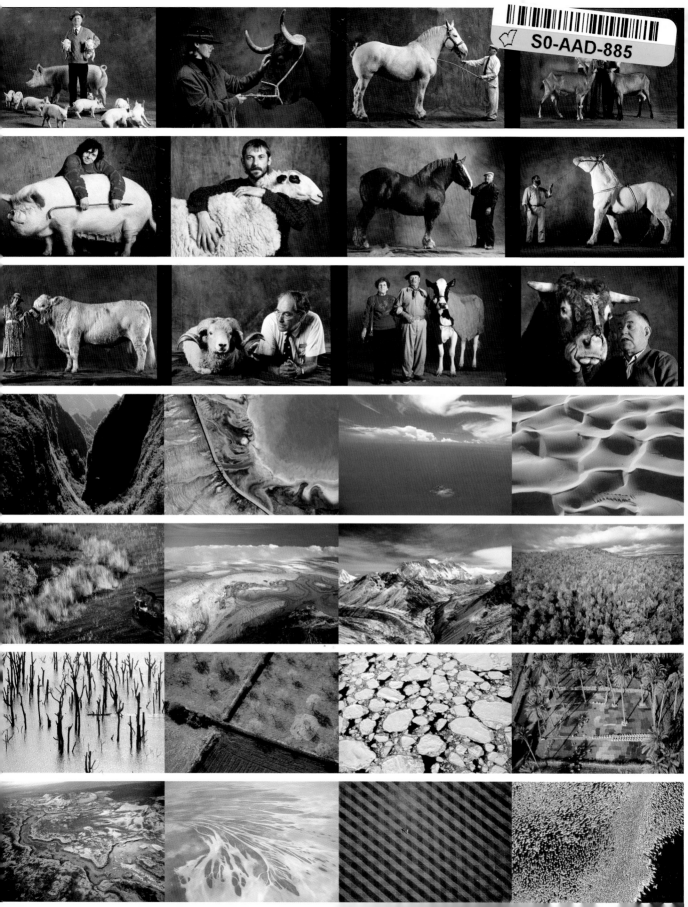

It was September 2003, and I had just returned from the Perpignan International Photojournalism Festival, comprised of 1,300 professional photographers and twenty-six fantastic exhibitions. The profession has changed since. In the 1980s, we were just a handful of independent photographers drawn together by similar desires for travel or escapism. Photography enabled us to travel the world while earning a living. It was a carefree period; we learned our profession as we encountered each assignment and our eye developed little by little. My personal calling was to come later in photographing the Earth. I have the impression that photographers today have a sharper consciousness of the world in which they live and the role that they play. They seem to me more mature, as much in their commitment as in their understanding of their art. Photography schools afford them a cultural and professional hindsight that my generation took much longer to acquire. They are certainly more diligent, more skilled, but they are considerably greater in number. Being a photographer has become more difficult. Having seen all of these exhibitions and met all of these young photographers, I love the profession all the more.

YANN ARTHUS-BERTRAND

Being a Photographer

TEXT BY SOPHIE TROUBAC

TRANSLATED FROM THE FRENCH
BY SIMON MOORE

HARRY N. ABRAMS, INC., PUBLISHERS

MADAGASCAR
Assistant Armand
Pilot Yersin

<u>Checklist for Flight Photos</u>
Confirm there is sufficient film
for trip before leaving hotel. ✔
Check maps are in bags ✔
Take Yann's PDV glasses
Take VHF equipment
Take GPS (with batteries charged) without
Clean lenses before leaving ✔
Bring security harness **NO**
~~Bring red jacket~~ **NO**

1 camera = 1 lens

Camera No.1	14mm and
	17–35mm
Camera No.2 (EOS3)	24mm
~~Camera No.3 (EOS3)~~	~~35mm~~ (OUT)
Camera No.4	50mm OK
Camera No.5	85mm
Camera No.6	135mm
Camera No.7	70/200mm
Camera No.8	200mm
	f 1.8

If using Pentax don't forget 220 film
+ 2 lenses ✔

1) Check batteries are charged ✔

2) Clean lenses and check them
during flight

3) Set shutter speed at 1/500th second,
aperture at f 4.5 <u>and check again regularly</u>
<u>during flight</u>

ASTIA "135" → 20
VELVIA "135" → 180
VELVIA "220" → 30

4) Check that button activating aperture
ring is working ✔

5) Set autofocus to A1 MANUAL ✔

6) Adjust cameras to Yann's eye ✔

7) Ensure cable release for vertical
grip is activated ✔

8) Check lenses are on autofocus ✔

9) Confirm that skylight filters correspond
to lenses ✔

10) Check that 5 collimator lenses
are in focus ✔

11) Spot Meter: Adjust to 1/500th
second and 50 ASA ✔

12) Check felt-tip pen

13) Charge batteries and fill bags with film
at Hotel ✔

<u>Record number of lens on each film</u>

+ cameras
Duct tape for writing on
YAB

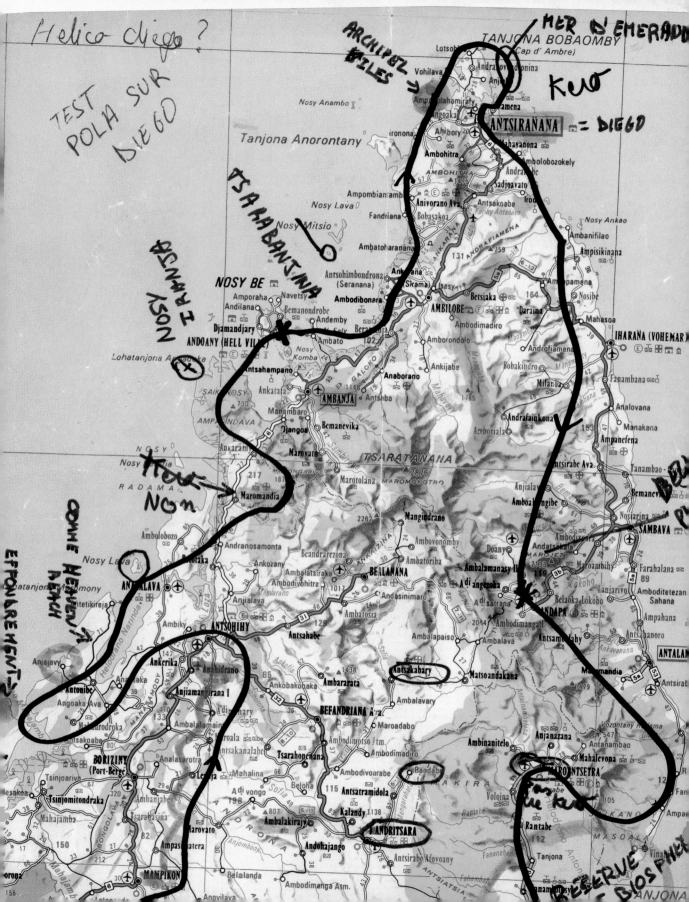

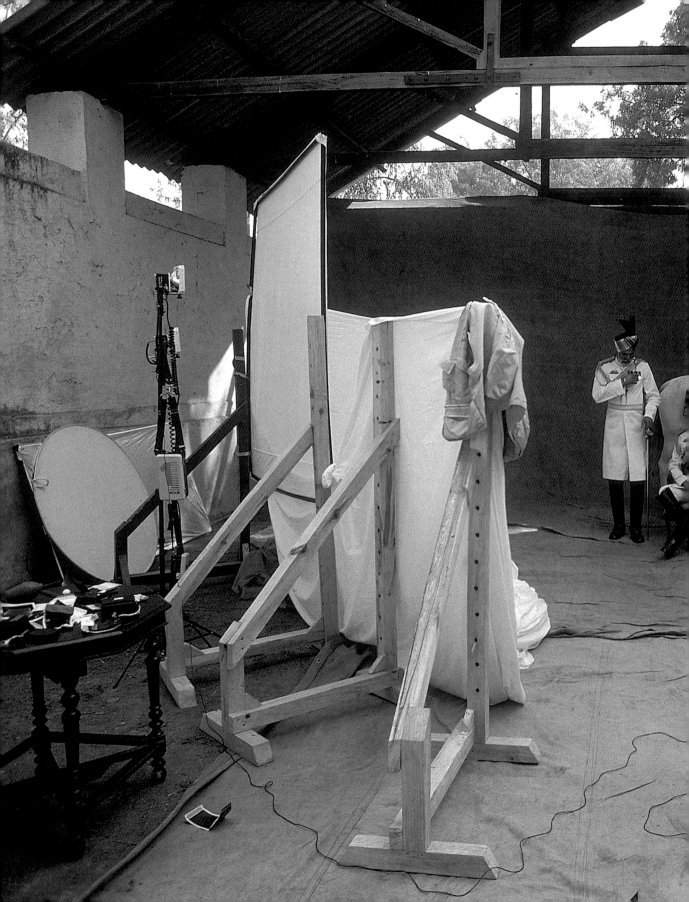

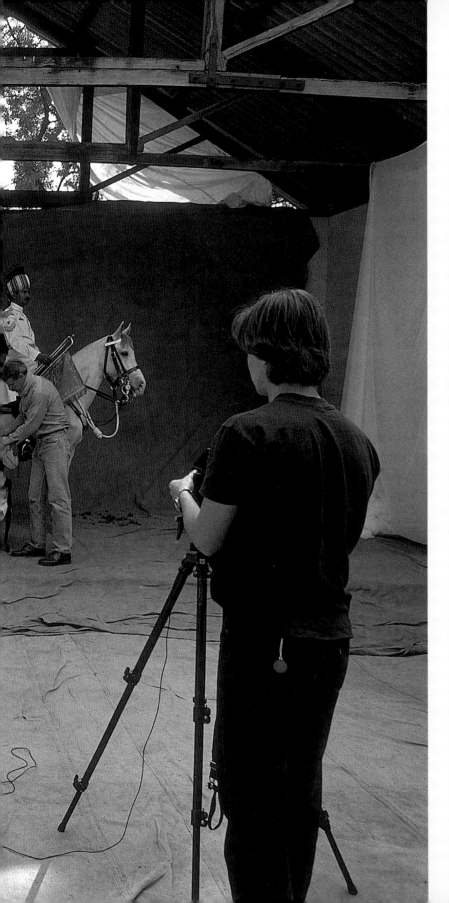

This book is dedicated to all the assistants who have helped me photograph over the last twenty-five years.

Yann Arthus-Bertrand

◄◄
A large part of my work is devoted to aerial photography. The procedure always begins with a map. We require it at every stage of the process, from the flight preparation to the shots themselves, and then in producing the captions once back in Paris. Even the texts accompanying the *Earth From Above* photographs are written alongside a map to retain the geographical context. We sketch a few things down before and during the flight, which accounts for the rough notes along the side. The maps often get torn by the wind inside the helicopter; sometimes they even fly out the doorway.

The checklist serves as a reminder for the assistants: "It represents a detailed list of all the materials to bring, from the camera to the felt-tip pen. It is imperative that you automatically check the camera and it is always a good idea to ensure that you have enough film, accurate maps of the region you will be flying over, and so on," explains Arnaud, one of Yann's assistants.

◄ Taken in 1986, this is one of the first photographs of what was later to become part of the horse series. We were undertaking a huge project on the uniforms worn by the Indian army and these represent my first ever shots from an outdoor studio, an aspect of photography that I love. Jean-Philippe Piter, my assistant at the time, knew a great deal about lighting. I learned a lot from him.

Between Friends

When discussing this book with Yann, I had always seen myself writing the text. Who knows him as well as I do, personally and professionally? Yet time was never on my side and modesty finally persuaded me against the idea. His own reservations did little to encourage me: "A book about me—seriously? It's the photographs people are interested in, not me." His reaction made me smile, as it was so typical of him. Yann is self-effacing, anxious to remain behind the scenes.

And so it seemed impossible to write a piece on him, even if not actually about him. Nonetheless, a book took shape, guided first by one author, and then another, and motivated a desire to feature a selection of photographers. Gradually, the idea developed alongside of the DVD. As far as I know, a photography book visually supplemented in this way has never been done before. It charts the history of Yann Arthus-Bertrand, enabling young and old alike to understand his work and be inspired, whether interested in his profession or merely by his life. Yann Arthus-Bertrand's passion for photography and photographers remains perceptive and unassuming. He says about Annie Leibovitz: "I love her work, she is a great photographer, but I could never achieve what she has." His eclectic taste ranges from Cartier-Bresson to Mondino, Föllmi to Salgado, Avedon to Michaud. Yann views everything with enthusiasm, consciously mixing generations and styles in his work. He is one of the very few photographers who will seldom criticise his contemporaries. He finds something of interest in all of us; he treats everybody with modesty and respect.

Today, photography is everywhere, confirmation of a staggering and rapid evolution. The last two decades brought the glorious eras of Cartier-Bresson, Doisneau, Lartigue, Brassaï, Boubat, and Izis to a close. These snapshot photographers possessed an ability to convey life, the Leica cameras they used were a mere extension of their arms. This work was consistently produced in black and white and remains authentic to this day. A transition then emerged toward the end of the 1970s, most notably with the Michauds, pioneering a new genre of images that blended travel with quality ethnographical photography. The *Caravans to Tartary* sparked a revolution that is hard to imagine ever occurring today. And despite criticism at the Arles International Photojournalism Festival, the photographs endured, internationally acclaimed from that moment forth. The style was to influence an entire generation including Silvester, Föllmi, Bourseiller, Valli, and many others. These photographers traveled the world, not in one week, one month, or even two. Olivier Föllmi lived for years in Tibet before publishing *Frozen River*; Hans Silvester never worked less than three years on a project before publishing it.

This generation not only changed photography completely but galvanized the journalistic and publishing communities as well. The emergence of the journal *Géo* during these years owes its success to them. What magazine today does not regularly publish the portfolios of these photographers? Illustrated publications have also evolved

dramatically, as much in terms of quality as the standard of print. Less than ten years ago, the idea that a book like

Earth From Above could sell in excess of two million copies would have reduced the publishing community to laughter.

Books by photographers like Plisson, Silvester, or Föllmi can sell beyond one hundred thousand copies; this is an

extraordinary achievement in itself if one considers that literary novels three times less expensive become best-sellers

when sales surpass twenty-five thousand.

It is curious that Yann reminds me vaguely of August Sander, a photographer he greatly admires. At a time when

the silver print was disappearing, Sander devoted his life to photographing people within their professional and social

categories. He never digressed from his creative obsession. The work he produced would weather the centuries, not

only in terms of its aesthetic value, but more significantly on a historical, anthropological, and social level. I find in Yann

a similar obsession for providing a testimony. His is an eye not content with a simple image reproduced on beautiful

paper. Yann is committed to permanence. He ceaselessly refines projects and allows his work to evolve in order to

serve future generations.

This is true of the Earth, his subject of choice, of which his best-seller, *Earth From Above*, and its accompany-

ing exhibitions are not actually an end in themselves. He pursues his photographic and ecological projects with a

Marking the creation of Éditions de La Martinière at Yann's in 1992.

religious fervor, aiming to reach as many people as possible. The same is true of the French people he photographed over the years, and the animals he recorded at agricultural shows, a long and fascinating project exploring their relationship with man.

And so Yann finally accepted this book. I am all the more grateful to him because he is revealing himself as never before, and not without anxiety on his part. This is not a self-serving book, but one that reveals the world of Yann Arthus-Bertrand and his creations. It is a testimony of an original approach to photography, providing inspiration perhaps, or, even better still, the beginnings of a passion.

Hervé de La Martinière

Henri Matisse once said, "A hand offered to others is purely the extension of sensitivity and intelligence." The gesture becomes alive when given freely, an accompanying smile making it all the more pleasant. And so Yann Arthus-Bertrand is, quite simply, a charming man. But it is his expression that is most distinctive. The eyes are clear, the look is determined and perceptive—demanding even. He has the air of a photographer; a man not content with just seeing, but one who applies his camera to record and convey all that he sees. Here we have the mystery and paradox of photography! The photographer is a witness, enabling us to share in his vision, yet it remains unclear how exactly he does this, and why.

"Taking photographs is about pressing a button." Yann's frank assessment of his profession is disconcerting. Undoubtedly mere finger pressure in itself lends the process a certain childish simplicity or banality. But the formula is too brief. The tool does not create the craftsman, and just as the fountain pen never shaped the writer, the use of a camera in itself is not enough to produce the photographer. The same is true of all craft techniques. Although they may be widely used in society, expertise is limited to only a few. Those with the talent to raise their work to the level of art are even scarcer in number. Yann leaves it to us to decide whether he belongs among these elite.

But let us leave the question of art here for a moment. The majority of photographers, away from all pretenses, are reluctant to be acclaimed as artists. Yann is no exception. His sense of modesty stems from the purely mechanical nature of the tool he serves. A camera is just another machine obeying perfectly determined rules of optics and chemistry, and whose function is the faithful reproduction of reality. It is operated, at the most basic of levels, by a simple trigger mechanism. Click.

This apparent lack of mystery can be better understood by looking back at beginnings. Photography was conceived in 1816, the product of a French inventor's industrial intelligence. It was the dawn of a century that saw the West embarking upon a love affair with pragmatism. In all domains, whether chemistry, engineering, biology, physics, or geography—man consistently displayed his genius. While art turned to realism and progress was elevated to a virtue, educated society found a real vocation in the methodical and passionate classification of men, figures, and microbes. In such an élan of progressive fervor—bolstered by constant successes—truth was believed to be one and

universal. And this was proven scientifically, as various instruments confirmed, for all of us to share.

By the end of the nineteenth century, the apparently endless advancement of technology ground to a halt. Photography, however, appeared to have had the most lasting significance. As a clear, exact representation of reality, the process resided within the realm of positivism. Through it science was finally able to banish the shadows of obscurity to describe the world as it actually was. Through the deification of glaring reality, photography won the praise of those enthralled by the hard facts of the industrial revolution. An overflow of self-assured materialism merely induced the bourgeoisie to hurry up the rue Saint-Nadar to have their portrait taken. Conversely, the process also engaged the loathing of the poets. The disgust of Baudelaire, who despised photography and photographers, cannot be overlooked.

The dazzling lure of photography lay in its perfection. The seduction was so strong that no one actually grasped its intrinsically paradoxical and subversive nature. Humanity unwittingly craved realism, and photography, in its claim to be a pure reflection of reality, offered it unlike anything else. This truly represents a remarkable technical deception. Concealed within the *camera obscura*, the silver-eyed chimera bided its time.

In 1914, Western society was confronted by the harsh realities of war. Realism consequently succeeded surrealism, truth replaced relativity, and doubt was restored. Photography, like humanity, found itself consigned to a reality in which glory no longer existed. People began to ask themselves what photographs were actually communicating—a conformist reproduction or an inaccurate reflection? Illusions about photography had been shattered and reality appeared indistinguishable from that which remained. Our paradox gains clarity within this confusion; it is evident that the invention is considerably more complex than the process itself. And so Yann Arthus-Bertrand's assertion is less straightforward than it may otherwise have seemed. Appearances can be deceptive after all.

Yann is a pragmatic character born into a century shaped by certainties. He is someone who has always defined himself by his actions. Photographs displaying a modest observation of the world, or the "logical" result of a thorough action, accurately equate to Yann's own vision of reality and his work. But the paradoxical aspect of photography—the additional value beyond what is actually displayed (when it is not obviously something else)—escapes neither his intelligence nor his discerning eye. There is every reason to think that Yann has been, beyond all appearances, as paradoxical as the process he serves. The photograph, taken in the light and developed in the dark, allows us to see what is actually not there. It renders movement by suspending it, offering us an image essentially torn from reality and, in doing so, it is responding by doing exactly what was demanded of it.

Similarly, photographers make us question the meaning of reality through their observations, working in the belief that they are revealing the world as it is. Yann's assertion that photography can be reduced to pressing a button is just his modest way of informing us of the pitfalls he suspects, without going so far as to denounce them. It represents a subtle invitation or challenge for us to look within ourselves for the intimate sense, profound and true, of the things we see around us. Interpreted in this way, our knowledge of Yann and his work take on an added significance too easily obscured by the beauty of appearances.

The eldest of six children, Yann was born in Paris in 1946, a time marked by the aftermath of a devastating war. At twenty-two years old, he was already moving away from the comfortable circles of the Parisian bourgeoisie he had grown up around. The revolt exploding on the Paris streets in May 1968 was nothing new, as he had himself already been a rebel for many years. After exhausting the goodwill of his hapless parents, as well as that of the fifteen or so headmasters who attempted to guide him along the right path, he had taken to hanging about the drugstore on the corner of the Champs-Élysées and Pigalle. From age fifteen to eighteen, he committed himself to an uncertain future that could have just as easily led him to the Prison de la Santé as to the Paris Conservatoire. Where it did eventually lead him was into the arms of the French actress Michèle Morgan while on a film shoot—he was then an actor—and then on to Saint-Tropez, where, in only a month and a half, he bore all the hallmarks of a young man without a future.

His life still possesses that 1960s charm and vigor today. He has yet to rid himself of his youthful exuberance, and his roguish nature still endures. Sleepless nights, often the result of poor accommodations or from sharing his bed with others, forged an already determined character. His misbehavior was as much his own doing as it was encouraged by those around him. Yann remains discreet about his errant youth. It marked the hazardous development of a rebellious young man, who, rather like Jean-Pierre Léaud, felt confined by the pretenses of a rigid society. He was simply trying to find his own way.

Yann's destiny was determined by an inner rebellion that expressed itself in his defiance. "I hated the life they wanted me to lead. I wanted school to burn down." It is precisely because he refused to follow the path set aside for him by others that he has become the man that he is today. Only the rare few know what or who they want to be. Yann, however, knew exactly what he did not want to do. One cannot presume to understand him without first recognizing this fierce determination, a resolve not immune to a certain aggression, a violence, to which we will return. He refused to conform to the established order. Of the world and its images around him, he wanted to experience everything his way.

At twenty years old, Yann had quickly but thoroughly exhausted all that Saint-Tropez had to offer— "I was earning my living as an actor, but the cinema just wasn't my thing." He met a woman who introduced him to new horizons and helped him establish his first real

foothold in life. This woman wanted to create a wildlife reserve on the hunting ground of Saint-Augustin in Allier, which she owned. Yann was immediately intrigued by the idea, as it appealed to his need for action. He took on the project and, in no time at all, he had taken charge of the organization and development of the business. At only twenty-five years of age, he oversaw fifteen other staff members, revealing the entrepreneur in him as much as the natural leader. The project flourished and a zoo soon opened its gates. This turn of events was crucial to his development.

His independence, his desire to create something, and even more than that, his confusion over how to be successful, were all of the sort to prevent him from drifting too long in acting. Nevertheless, without the adult guidance he had always utterly rejected the danger remained that he could go off the rails. The support of a woman that he loved, his newfound contact with nature and the animals in his care, finally enabled this unstable young man

to reach a sort of equilibrium. The animal world provided him with a passion capable of leading his life in a positive direction. Yet, once he discovered the satisfaction of finding himself through his work, he then also realized that success, once established, lacks fulfillment. He had further deeds to perform and fresh challenges to take up while his thirst for action, enterprise, and discovery remained undiminished. Managing success was not enough for this young man; he needed something more, something to surpass all else.

▲ When this Himba came aboard the helicopter in Namibia, she was not at all impressed. She described to me in the simplest terms all of the places that she knew in the world. I couldn't get over it.

◄ I really like this photo. We were flying over Kyrgyzstan, a country with 3,000 glaciers, in an MI-8 Russian army helicopter. My friend, René Cagnat who speaks Russian, was with us during this trip. The radio had broken down and he was trying to explain to our guide what we wanted.

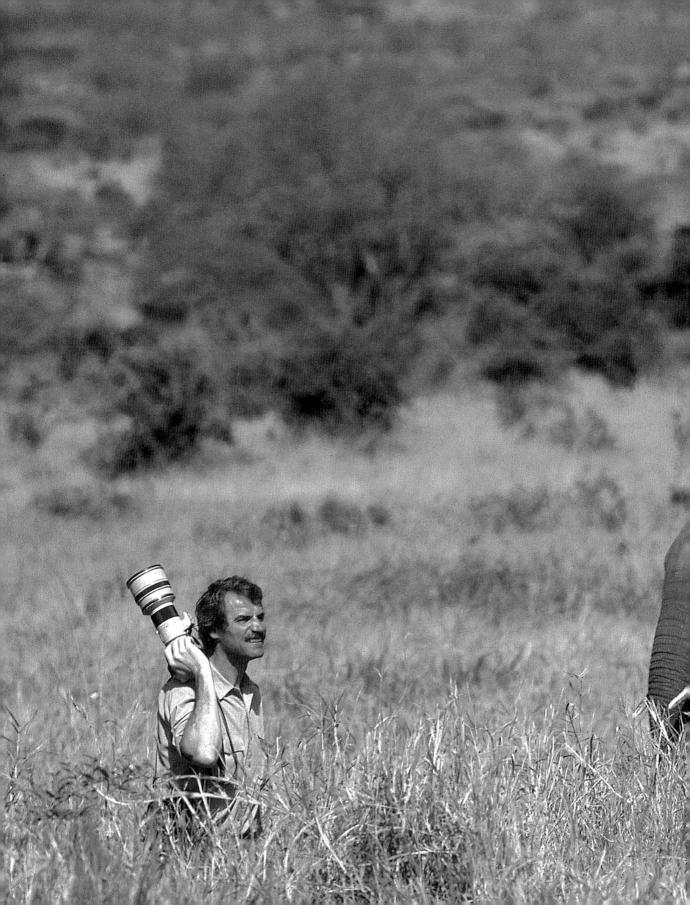

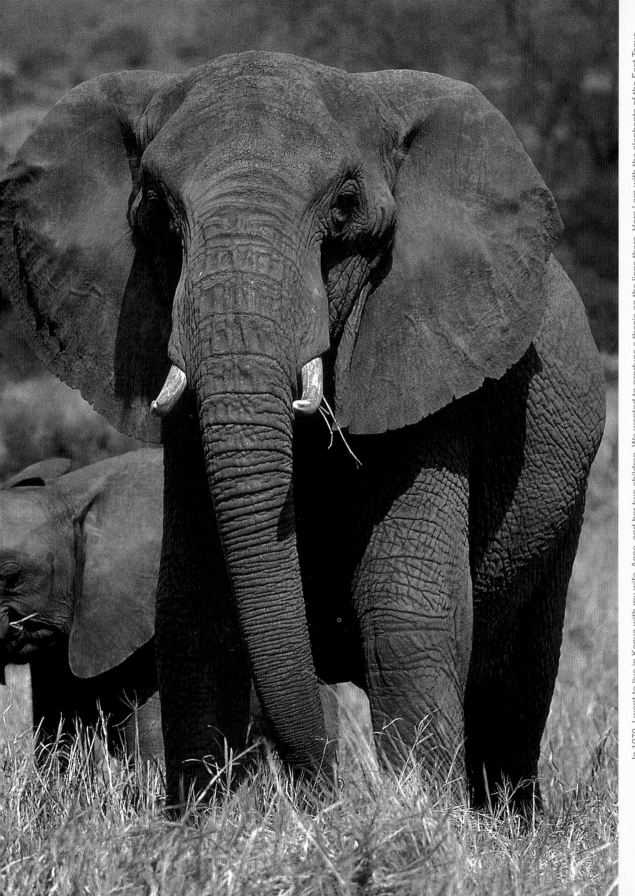

Africa

In 1979, I went to live in Kenya with my wife, Anne, and her two children. We wanted to produce a thesis on the lions there. Here I am with the elephants of the East Tsavo nature reserve. These animals are tame, which explains why I can get so close to them. It might seem impressive, but anyone could have done the same thing. They have been released from the Nairobi Orphanage, a shelter for animals whose mothers have died or been poached. I have come to photograph their skin. It is extremely detailed. Photographs such as these often reveal the same structures found in an aerial image.

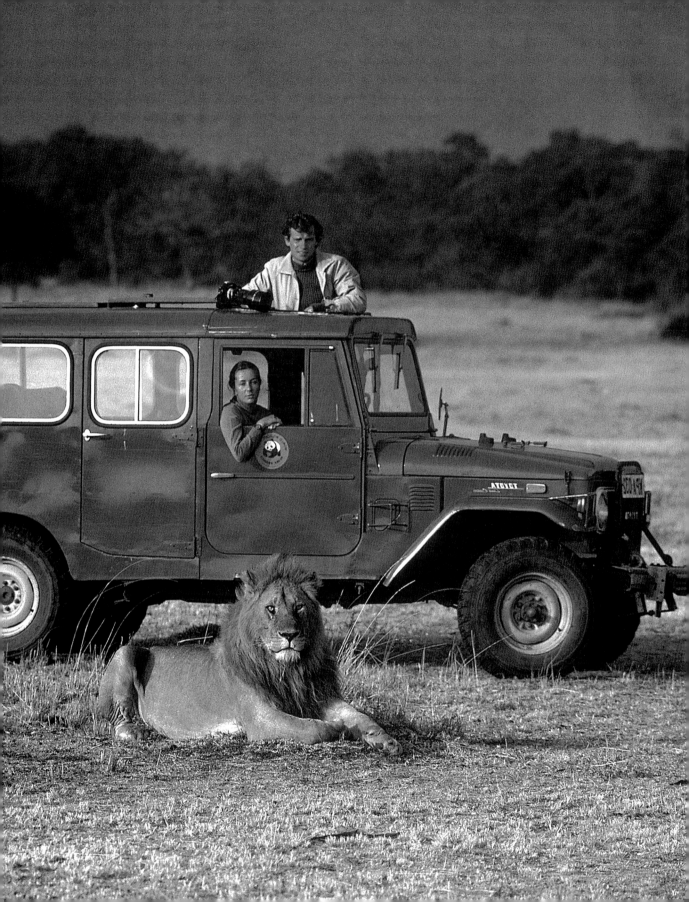

1979

Arthus-Bertrand's desire to make a mark on the world urged him toward change. The ten years spent in the Saint-Augustin nature reserve had merely strengthened this resolve, something that even the nature there could do little about. The wild animals remained confined to the center of France and their captivity troubled him. He wanted to see them living free in their natural habitat. Dreaming of adventure and the great outdoors, he soon set off for Africa and the fairy-tale lands of Kenya. He was thirty-three years old, initially winging it as a guide on photographic safaris. He was then hired by Africatour to chauffeur tourists around, searching for wildlife and adventure. This provided him with much needed experience. It also enabled him to finance his new project, a study of the animals that he had become familiar with while working at the reserve. He was following in the footsteps of Dian Fossey, George Adamson, and Jane Goodall, all of whose dedication and achievements he admired. Yann was not afraid of a challenge. Although he had never acquired his baccalaureate, he viewed himself as a naturalist nurturing an ambition to produce an academic study on the behavior of lions in their natural habitat.

He applied the same drive and determination to pursuing his studies as he did to carrying out the project itself. Yann's desire to be a naturalist will last throughout his lifetime. He is blessed with a strong character, one that adds weight to his aspirations. He is not someone who offers wild ideas and ambiguous explanations, but instead is precisely as he appears: determined, curious, extraordinarily willful, and carried by action. Nothing irritates Yann more than lost time, procrastination, indecision, or idleness, but his anger is simply a measure of the depth of his passions.

His personality traits are consistent with his alert and pleasant appearance. His look professes a love of adventure and freedom, sparking memories of the great explorers from years gone by. Yann emerges as a successor to these men, and in some cases women, who made the nineteenth century a period of progress, learning, and technological advances. He has the same appetite for

◄ This was our last day at the nature reserve after spending three years with the same group of lions. We took this image rather like a family portrait, as we were leaving our friends behind. We put it on the back cover of the book *Lions*.

discovery and enterprise as his predecessors, and he is fueled by a similar desire to impart his findings to others. This adventurer and keen naturalist was devoted to empirical study because he lacked the formal academic training of one schooled at university. Moreover, he is the great-grandson of an 1860s Parisian cartographer who published the work of explorers from the French Navy and Society of Geography. When Yann discovered these travel and investigative books much later on, he was struck by the correlation between his own work and that of his great-grandfather before him. This ancestor, bringing first and last names together as one, began the line of Arthus-Bertrand.

"I saw myself as an adventurer—I liked that—but I also wanted to achieve something serious." This admission, uttered randomly during a conversation, reveals a great deal. The knowledge of his dual passions for adventure and learning further strengthens our understanding of him.

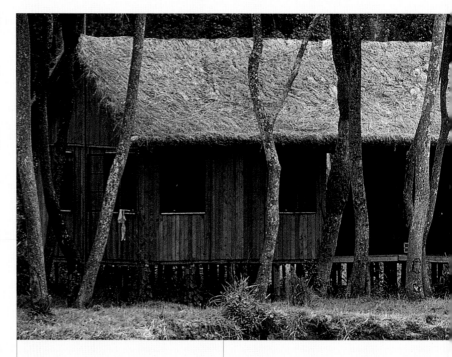

Yann got his timing right. He made his future wife Anne's acquaintance one evening during one of his brief visits to France. "I introduced myself. I talked about Africa, my work as a guide, and my ambition to produce a study of lions. I had begun to take my photographs."

He laughs at the memory of himself as a young man, embellishing things a little to impress the woman he loved even then. It was the beginning of a love story. Anne, a mother of two very young children, left Paris, her work, family, and friends to follow him to the Governor's Camp on the great plains of the Masai Mara. The life Yann had always imagined began to unfold before his very eyes. It was a magical period. "I was very much in love. All of a sudden, I had a family, children. There was Kenya before me, the lions...."

He threw himself happily into the new life that embodied his ideals so completely. Together, the two of them built a house and settled down. The house was constructed from large wooden panels, with handmade bamboo partitions that initially served as the children's room. Yann felt, perhaps for the very

▲ We built this house ourselves from wood and bamboo, and on piles because the Mara River was often flooding. It is without doubt the most beautiful place I have ever lived. For a wildlife photographer, living by the river with the animals before me was a dream come true. To live there with my wife and the children was paradise. I couldn't believe it.

◄ Anne gave up her life in Paris to accompany Yann to Kenya with her two children. She wrote the text for their joint study on lions, combining scientific rigor with anecdotes that revealed the love they both shared for these big cats.

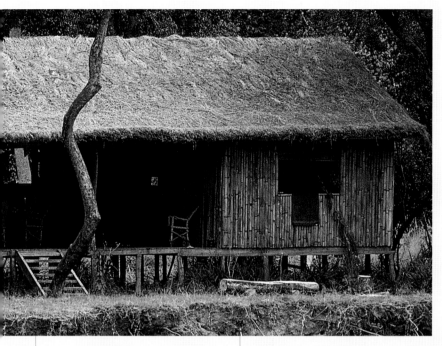

opment of nature's wildest animal in order to learn more about it. He had raised a lot of lions at Saint-Augustin. "I would feed them from a bottle for weeks, let them sleep at the foot of my bed, stimulate them with a damp sponge so they would go to the toilet; my relationship with them was almost intimate. I regularly performed my little show of rolling on the ground between their paws for the visitors. It was effortless, and yet their violence was intriguing. They fascinated me."

Yann, with Anne, studied lions meticulously for three years. It is undoubtedly the creature that resembles him the closest. Shy, perceptive, imperious, powerful, with a grace and outward nonchalance, it is the most natural of all animals. Lions survive by fighting with each other and continue to strive against an environment in which they nevertheless coexist peacefully. The profound and intimate relationship that Yann shared with these animals is so significant because it was conducted unconsciously.

first time, an enormous sense of well-being. "We were very, very close to nature. Every day, we would experience the reality and hardship suffered by the wild animals. Nature is demanding." The fight for survival is of fundamental importance. It is in such a concrete understanding of the world that Yann finds the meaning and validity of his own existence.

What can we make of the black box hanging around his neck? The photograph seems the best way of capturing the fleeting and fragile nature of existence. It is not surprising that the animals constituted his

first point of observation and experience. "You cannot cheat with animals." He was indeed searching for the truth of living naturally.

He carefully observed the devel-

▶ A snapshot of "three years of total bliss" living with Baptiste and Guillaume in the perfect house. This image of a utopia-become-reality was shared with family friends in the form of a greeting card marking the New Year, 1981. "My right hand activated the camera by remote control."

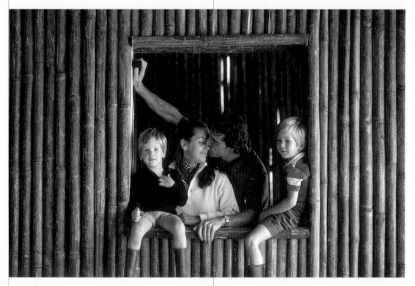

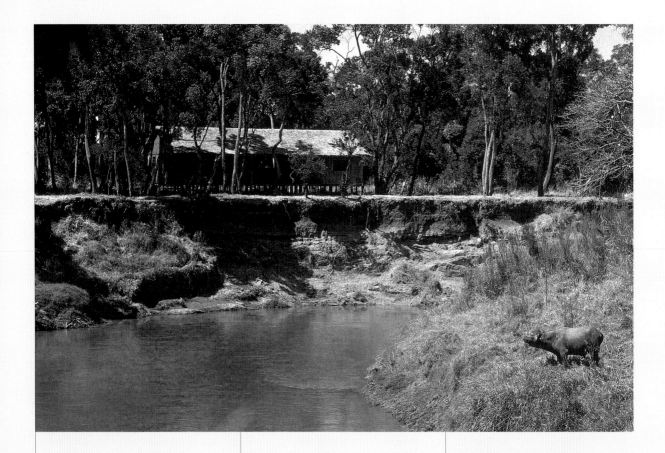

During his three years in Kenya, Yann found fulfillment. He gained a sense of responsibility in his commitment to family life and to a serious project. He was finally living where he felt happy and could do what interested him.

"I was aware that this was what I wanted to do." He soon discovered qualities he never knew he had. "For someone who could never normally remain in one place, I was suddenly spending hundreds of hours in the car, watching and waiting for lions." He experienced a peace as yet unknown. "I was walking in the savannah, which was strictly forbidden. One day, a rhinoceros charged at me, but I wasn't afraid. It was really stupid, but I felt safe."

Each day, the couple set off to search for big cats. "We did not possess collar transmitters. Finding the lions sometimes proved impossible." The wardens in the reserve offered them invaluable assistance, but this was not always enough. The answer arrived in the form of two Frenchmen that he met at the camp. They wanted to organize hot-air balloon trips above the savannah for the tourists. Weary of working as a guide, Yann seized the opportunity to try his hand at something new. As someone who "loved flying," he offered his services as a balloon pilot. His persuasive talents quickly swept

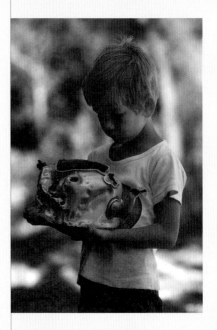

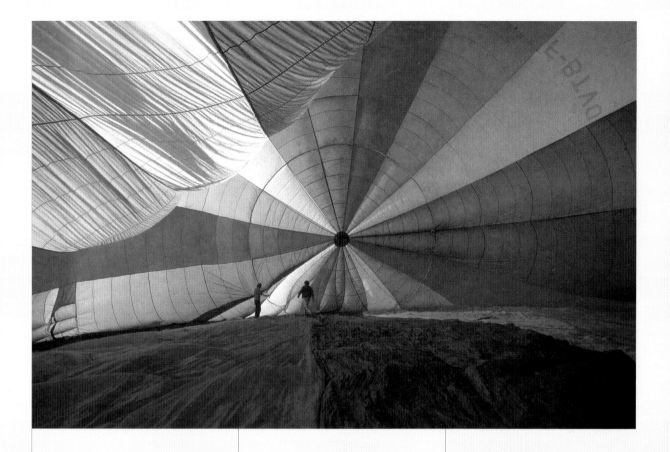

◄▲ The house was situated in the center of the Masai Mara nature reserve. It attracted a large number of animals; many wildlife photographers worked there. Baboons were regular visitors and we had to leave the radio on to keep them away; they once stole a day's work by unwinding my exposed film. But it was brilliant: elephants and rhinoceros would take their baths in front of the house. The very first day, a couple of lions were mating as we arrived and we had to wait twenty-four hours before we could move in.

◄ Baptiste, Anne's eldest son, finds a forgotten kettle outside that had been gnawed at by hyenas during the night. Their jaws are extremely powerful and able to crack bone to get at the marrow within.

▲► In order to earn a living while studying the lions, I traveled to England to acquire a professional pilot's license for hot-air ballooning. The ballooning enabled me to take out tourists and locate lions. Sometimes we had difficulty following them because they did not have collar transmitters. We would fly at six o'clock in the morning owing to the temperature and cloud height at that time of day. In accordance with the weather conditions, we traveled in different directions because the wind was not always the same. It was in this manner that I discovered aerial photography; I was photographing the Earth from above for the very first time.

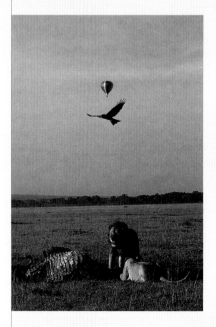

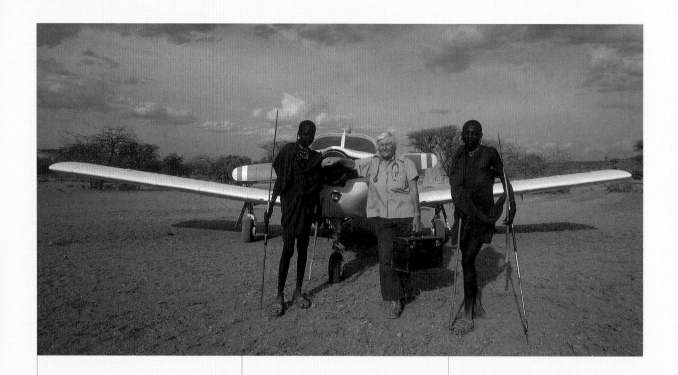

aside the doubts of the Frenchmen. In an arrangement that suited all parties, the young man was made a partner in the business, in exchange for a one-year commitment. With this agreement secured, Yann acquired his pilot's license in England and upon his return he began to organize trips. "I would carry out balloon flights very early in the morning. That enabled me to earn a living and occasionally locate the lions scattered during the night." He produced his first aerial photographs.

This was the start of a long period of surveillance, the only work of real interest to Yann at that time. Despite the sheer enormity of the project, the study of the lions was detailed and extensive. Undeterred, Yann and Anne surrounded themselves with everything essential to facilitate

their research. They sent for all of the books that had ever been written on the subject; the doctoral thesis by George Schaller served as a point of reference. The subject of their study was the influence of the environment on the lions. In Paris, they consulted Pierre Pfeffer, then President of the World Wildlife Fund, and the Director of Research at the Natural History Museum, who encouraged them in their work. Anne took the first important step of creating detailed note cards on each

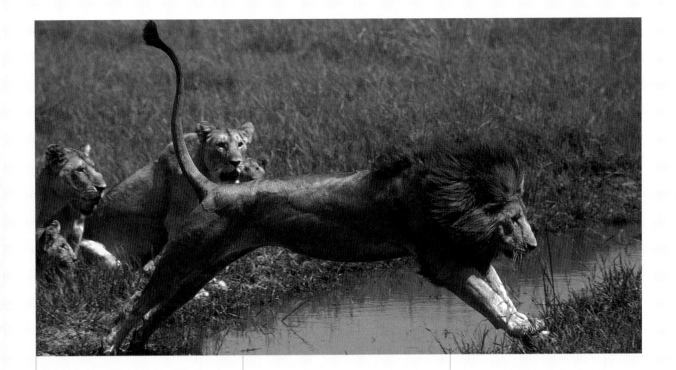

of the animals. She identified and named the individual lions from each group, recording their movements, diet, and battles day after day. She completed about one hundred note cards, which were complemented by photographs. But the equipment needed to complete the project was expensive. Yann consequently returned to Paris and once there, armed with his usual determination, he approached various manufacturers. Arriving on Canon's doorstep, he once again claimed to possess skills he did not have. Introducing himself as a wildlife photographer, he presented a book containing photographs cut from different magazines and demanded that he be lent the equipment of a professional. "It pays to be bold." This statement proved to be true by those who kindly met his requirements!

The project subsequently took on a new dimension. "I noticed that the photographs gave a different meaning to our work than the text." There is no doubt that something can appear in photos that is not conveyed by words. This was the case with the first book, edited on their return to France and the result of three long years of hard work. The

strength and beauty of the lions are revealed in these images depicting hunts and tender exchanges. The grimness of their struggle is astonishing; one can only imagine the extent of nature's severity and the implacable laws that govern her. "Inevitably, two lion cubs out of three die before the age of one, either killed by other lions or simply

◄▲ Anne Spoerry was a voluntary doctor of AMREF's "flying doctor service" (African Medical and Research Foundation). She continued, at the age of seventy, to take care of nomadic tribes from all four corners of the Kenyan territory.

◄ Anne Spoerry was one of those tenacious personalities and extraordinary human beings attracted and held by the magic of Kenya and its incredible nature reserves. Through their energy and adventurous temperaments, Anne and Yann made Kenya their home. They relished meetings such as this one.

▲ From the outset, any photography taken in our study of lions was merely intended to complement the text. The real objective was to produce a scientific thesis. Maybe this was addressing a regret I had in not having ever pursued my academic studies. It was at this point that I understood how a photograph could provide information unique from Anne's texts. From this moment forth, I realized I'd become a full-fledged photographer.

▶ Here is one of my very first aerial photographs. You can see the Mara River and the paths forged from where it once flowed, sealed by the earth and now inaccessible. The animals came here to hide.

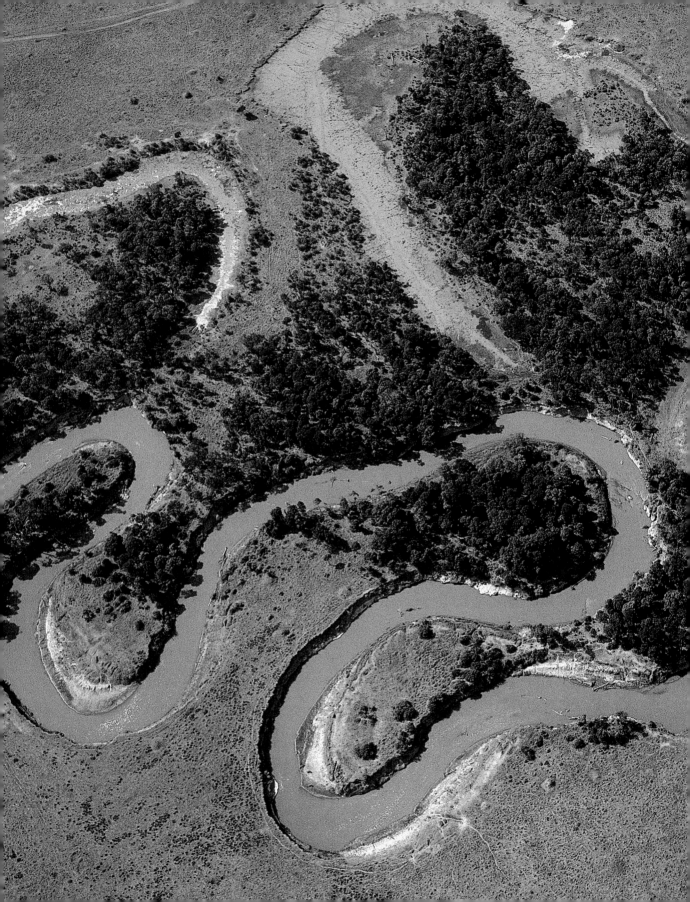

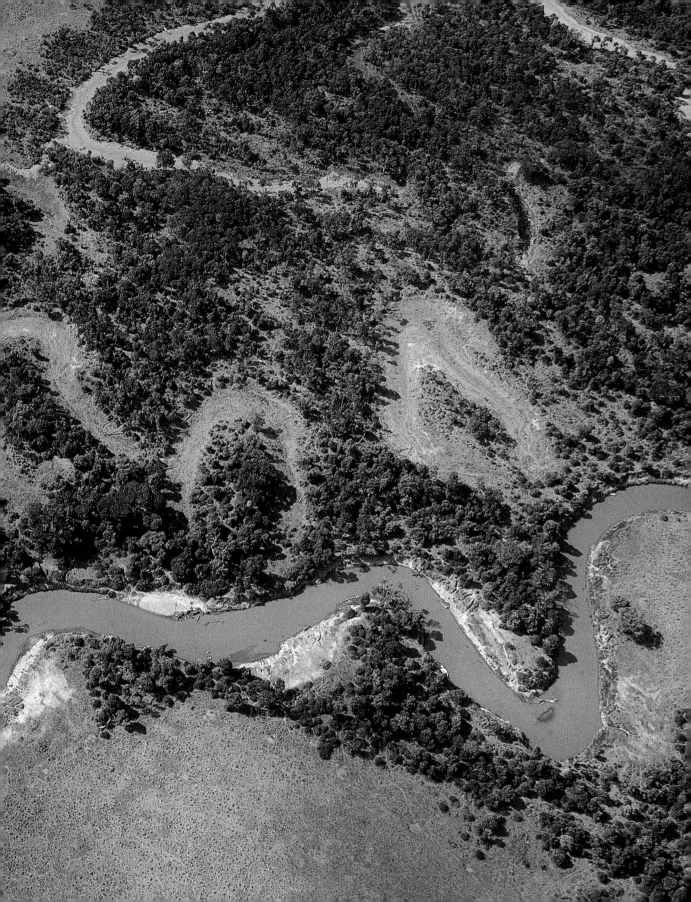

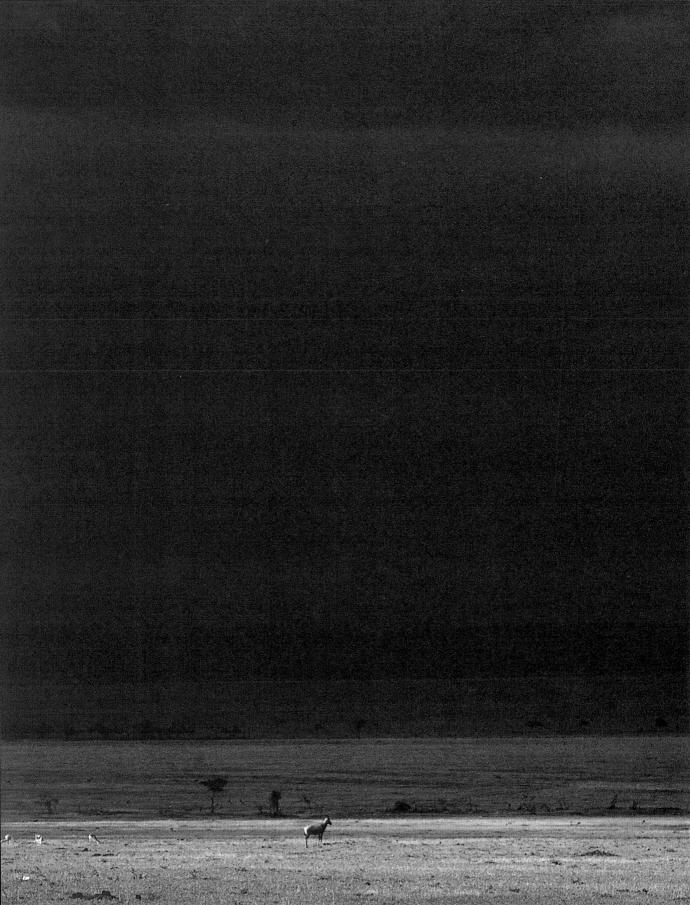

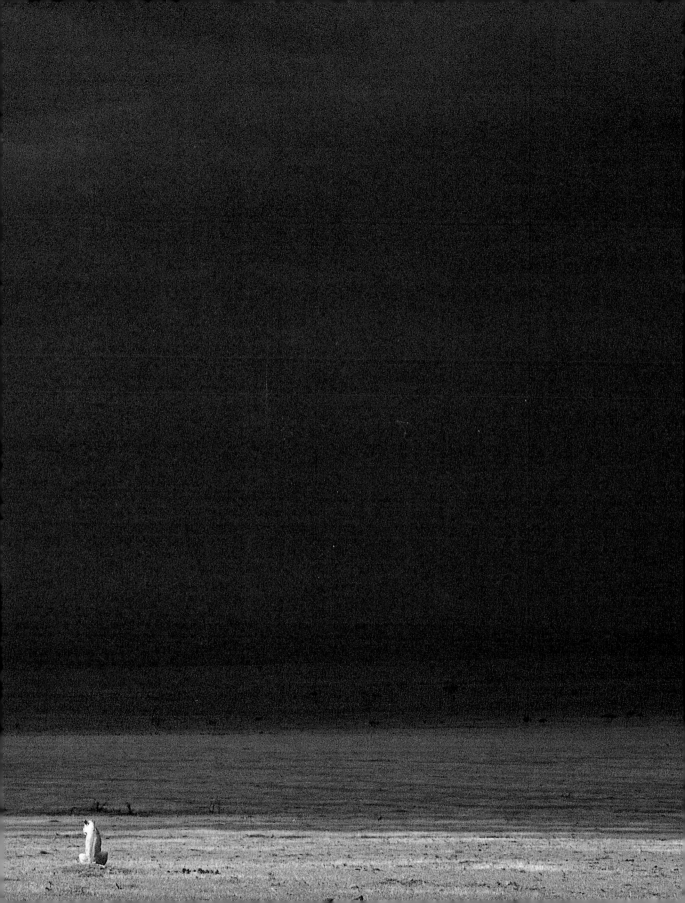

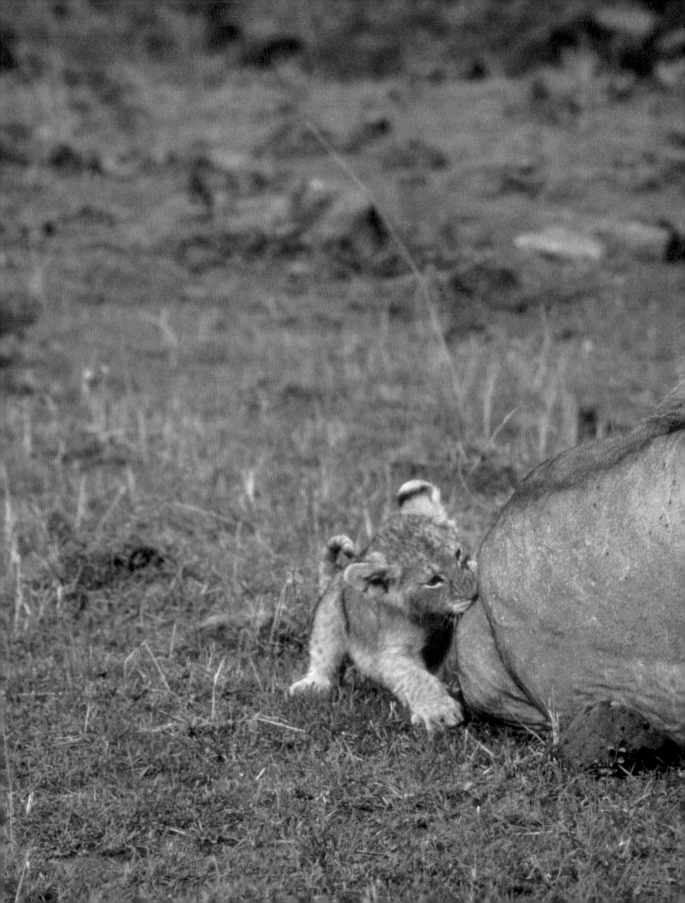

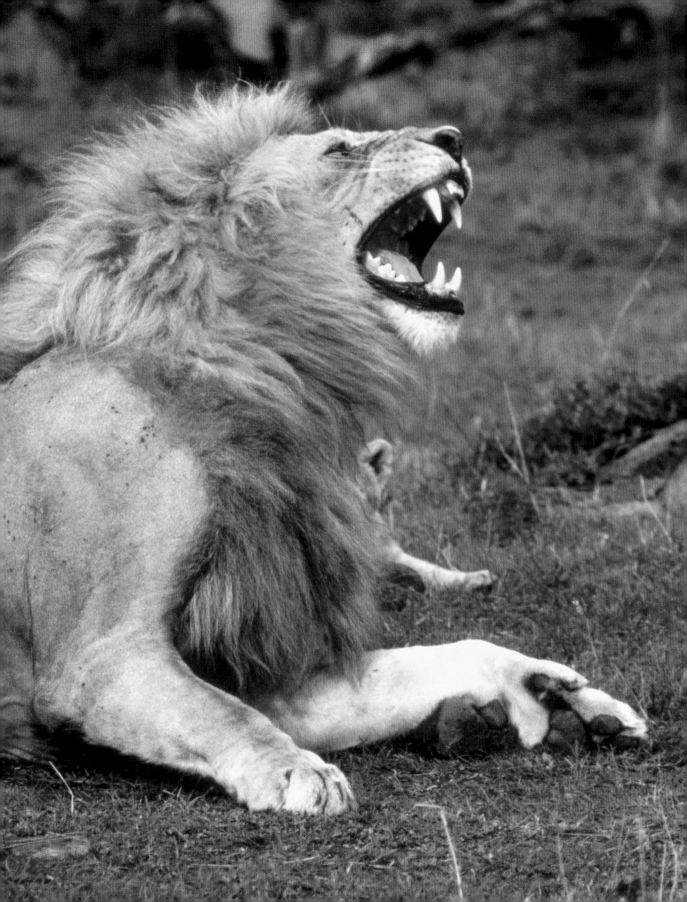

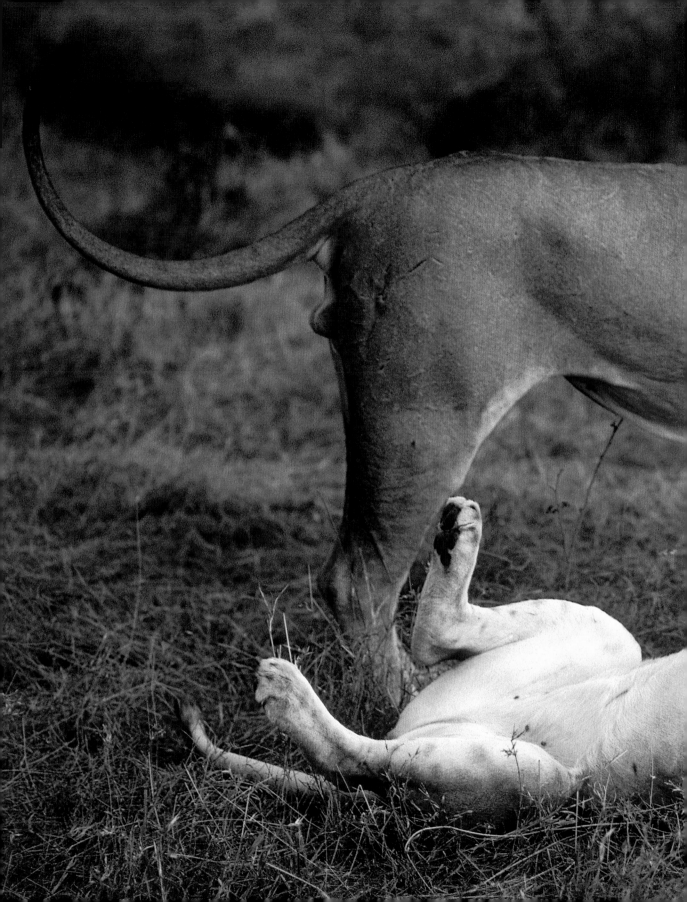

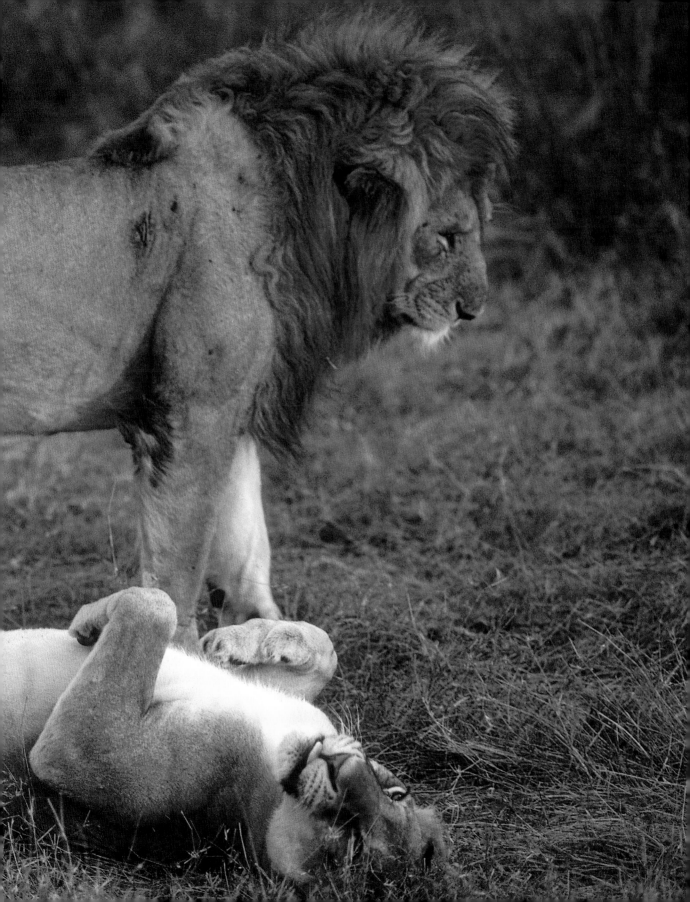

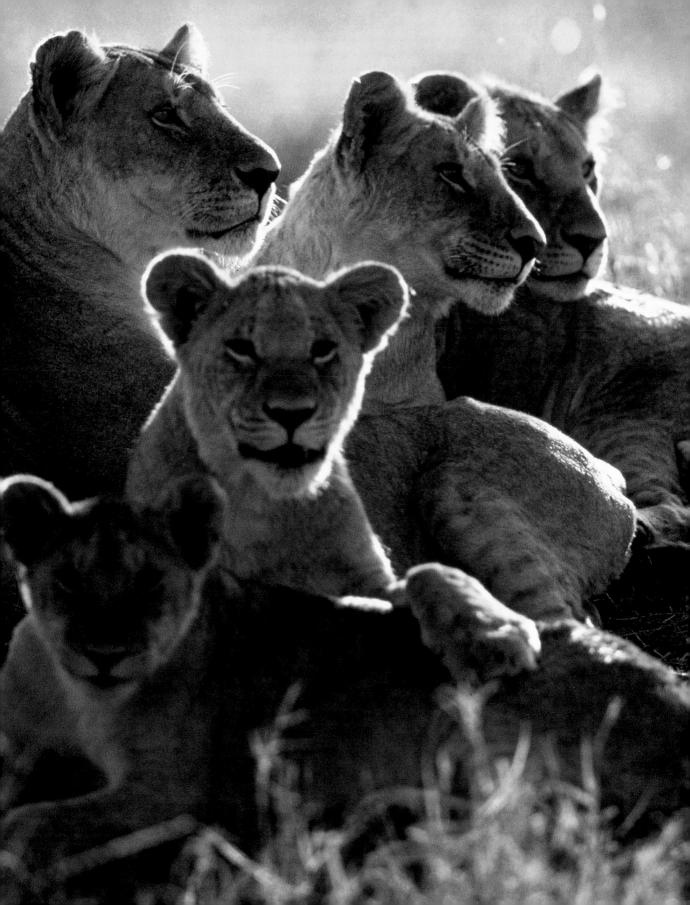

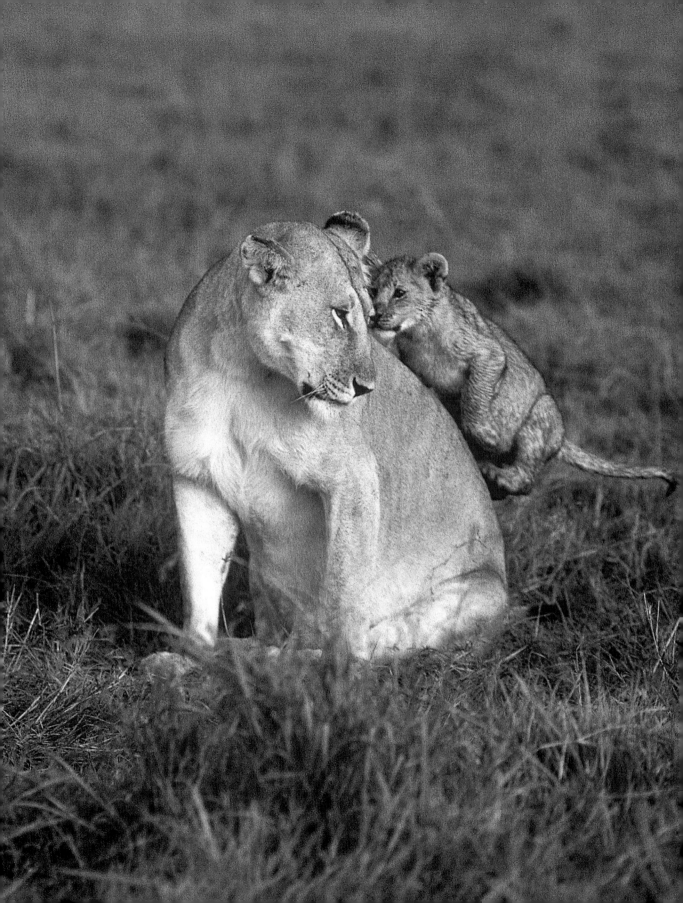

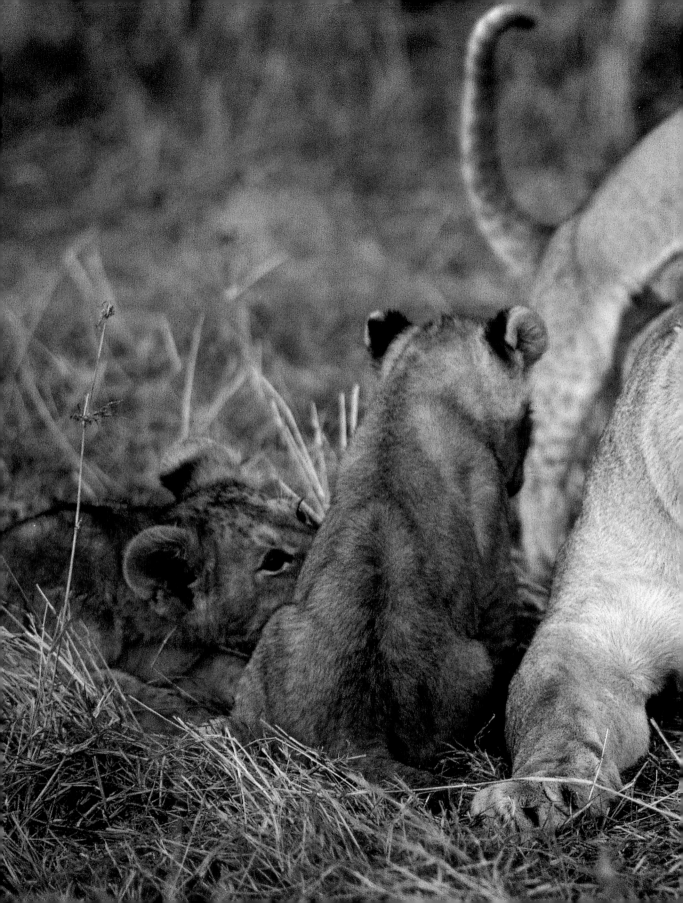

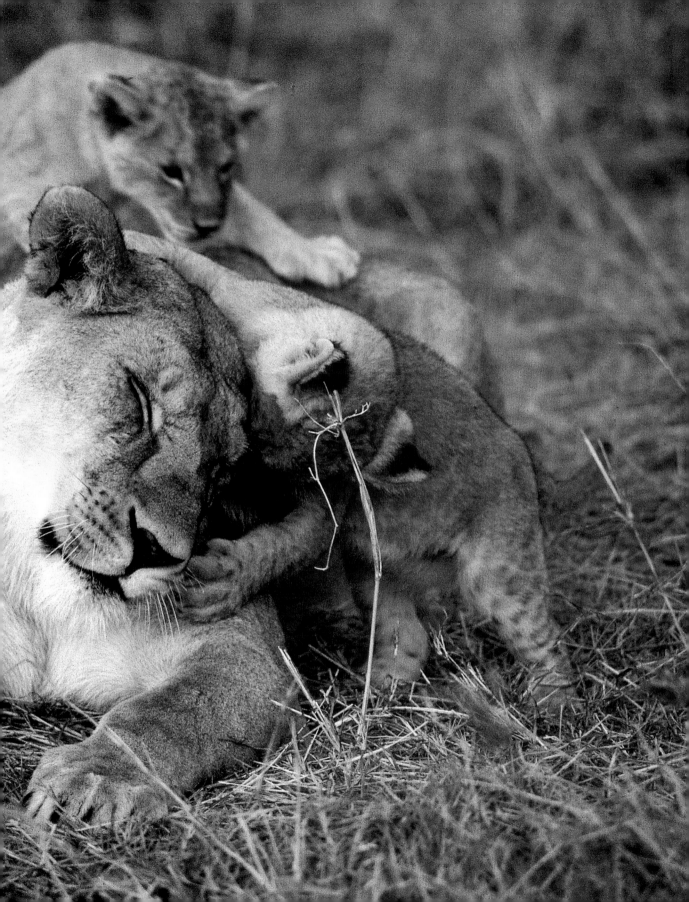

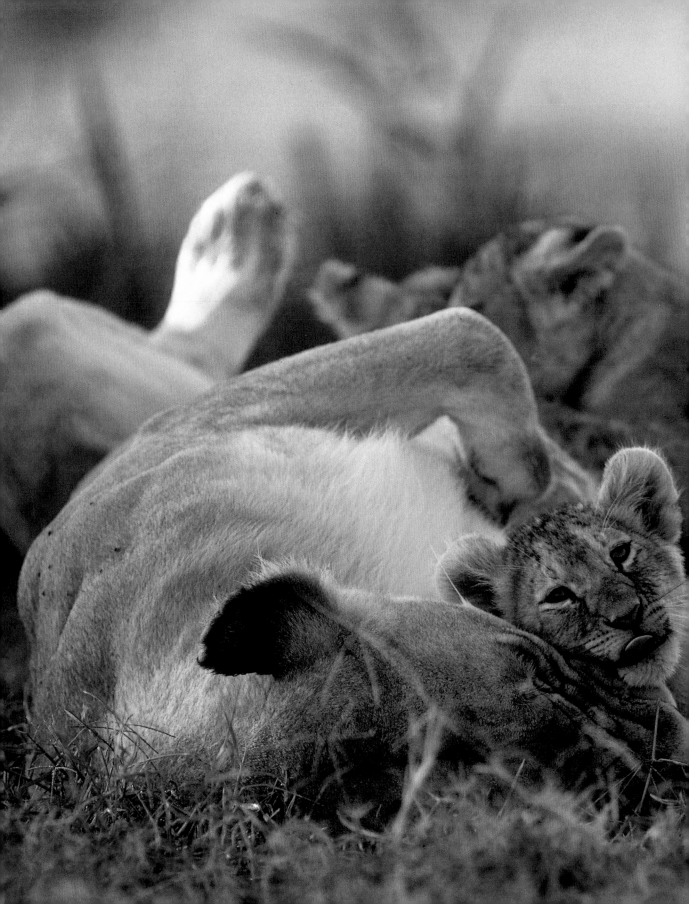

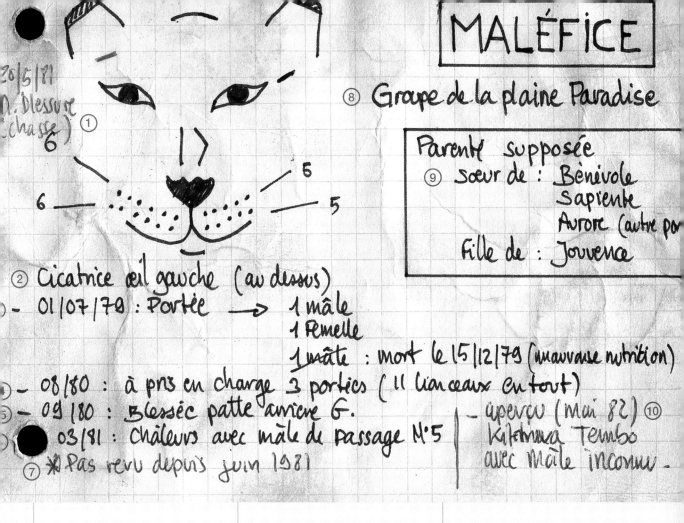

MALÉFICE

⑧ Groupe de la plaine Paradise

20/5/81
N. blessure
(chasse) ①
6

Parenté supposée
⑨ sœur de : Bénévole
Sapiente
Aurore (autre po...
Fille de : Jouvence

② Cicatrice œil gauche (au dessus)
- 01/07/79 : Portée → 1 mâle
1 femelle
1 mâle : mort le 15/12/79 (mauvaise nutrition)

- 08/80 : à pris en charge 3 portées (11 lionceaux en tout)
- 09/80 : Blessée patte arrière G.
03/81 : Chaleurs avec mâle de passage N°5 - aperçu (mai 82) ⑩
⑦ * Pas revu depuis juin 1981 Kitchmara Tembo
avec mâle inconnu.

from starvation. Adults sometimes deprive them of reaching the kill." It would have been impossible for a university thesis this complete to convey the same sensitivity, respect, and love that Yann and Anne developed through their long hours and daily observations. "We knew them all, their behavior, habits. We observed almost every day the violence in nature and the uncertainty of survival. The children, often with us in the 4 x 4, seemed to cope better with the bloody hunts and savage slaughter." Their work stood as testimony to the many different threats weighing heavily on the existence of lions in Africa. Expansions in agriculture and cattle rearing, poaching, and relentless conflicts continue to erode their once immense territory. "The essential role of a photographer is to give evidence. Nothing is made up."

▲ Anne recorded the features, movements, and injuries of every animal on these cards. To identify them beyond any doubt, we would count their moustache hairs through binoculars. In a vehicle, we could get extremely close to the lions. One day, I was sleeping in the car. I opened the door, forgetting that the lions were there, and stepped on one as it lay there in the shade! It uttered a terrible roar. I was terrified, though the lion was probably more so!

The individual lions were each given a name, as the one noted here is called Maléfice. The card tracks her movements starting July 1979. It records the number of babies she had, and that she hadn't been seen since June 1981.

Translation of the above card:
1. 5/20/81: injury (hunting)
2. Scar left eye (above)
3. 7/1/79: litter > 1 male, 1 female, 1 male: dead 12/15/79 (malnutrition)
4. 8/80: took care of 3 litters (11 cubs)
5. 9/80: hurt in the left hind leg
6. 3/81: mated with a passing through male
7. Haven't seen her since June 1981
8. Pride of the Paradise Plain
9. Presumed lineage: sister of: Bénévole, Sapiente, Aurore (other litter), daughter of: Jouvence
10. Seen (May 1982) Kitchmara Tembo with unidentified male

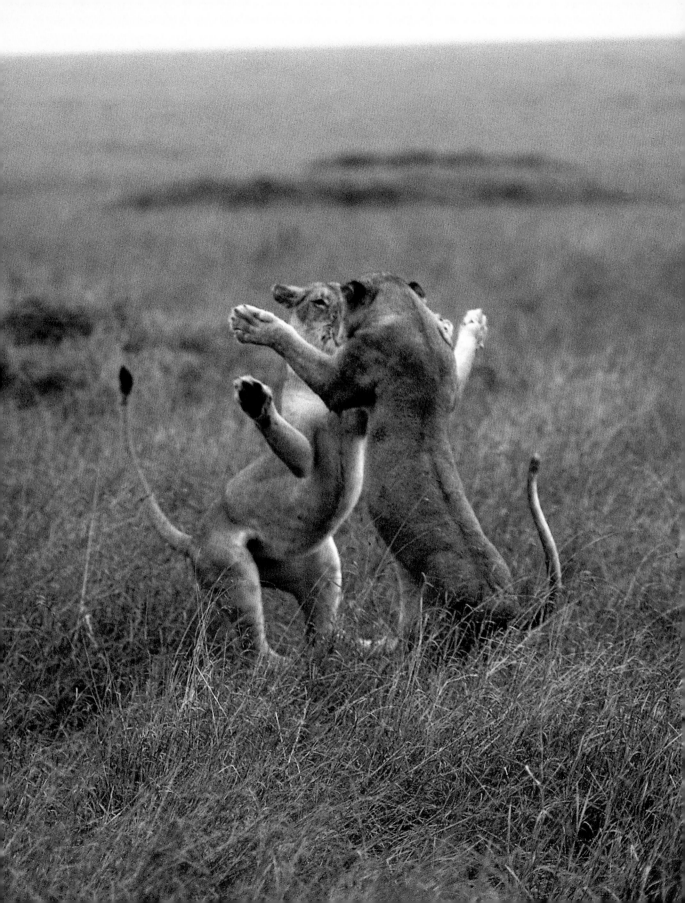

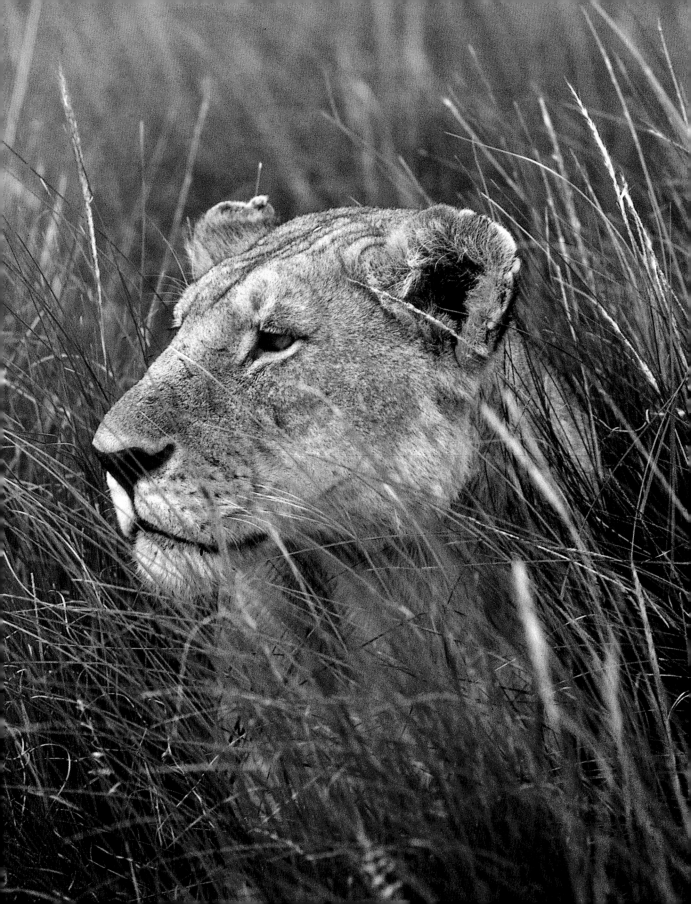

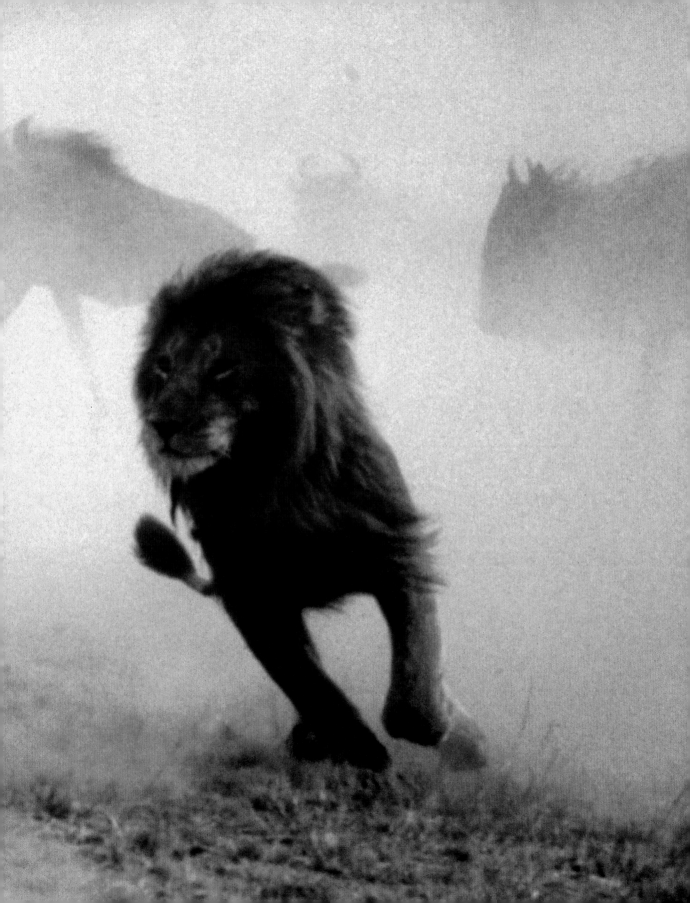

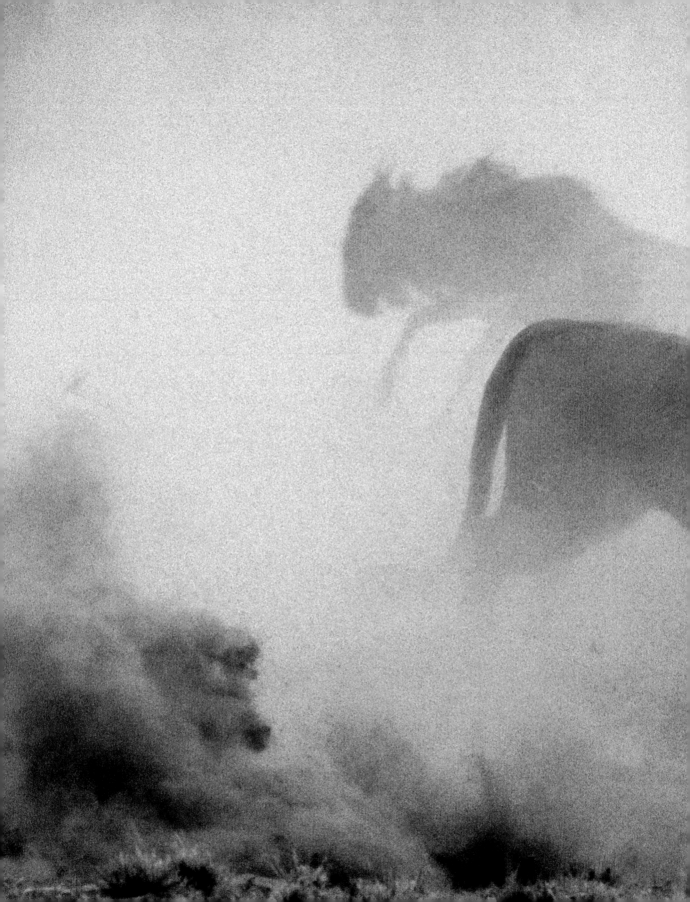

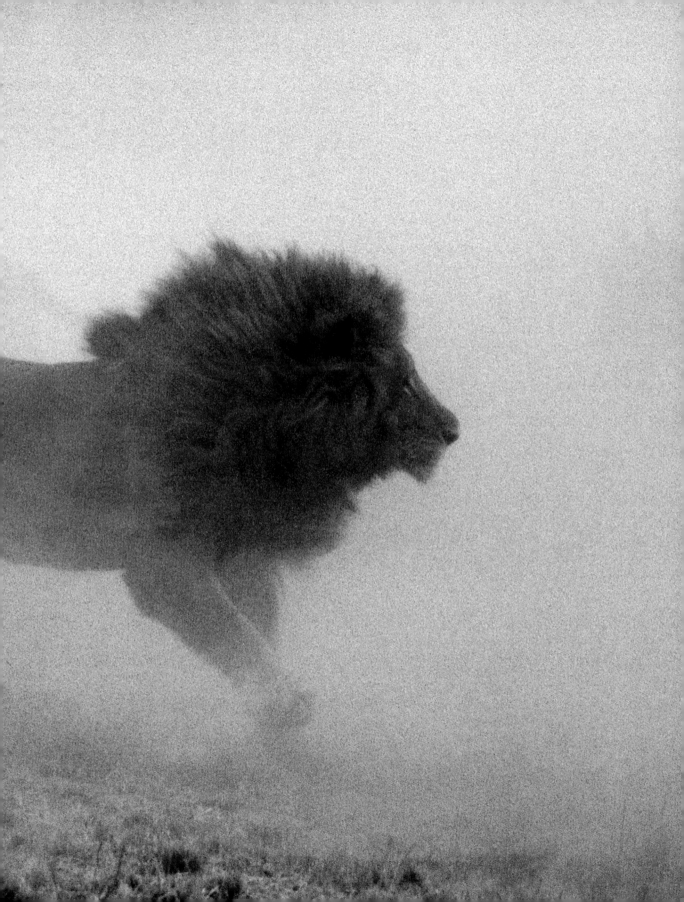

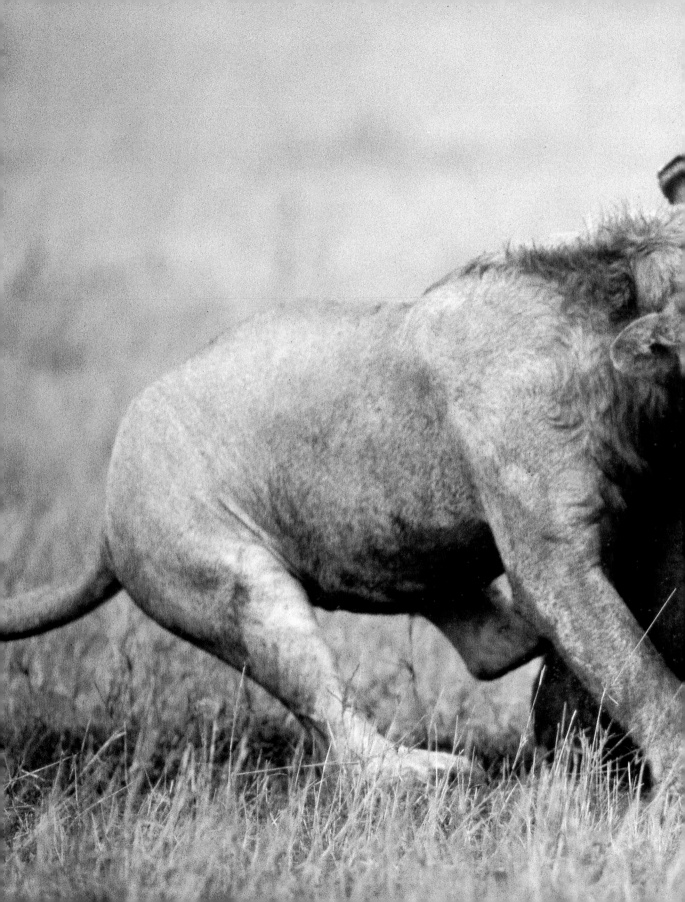

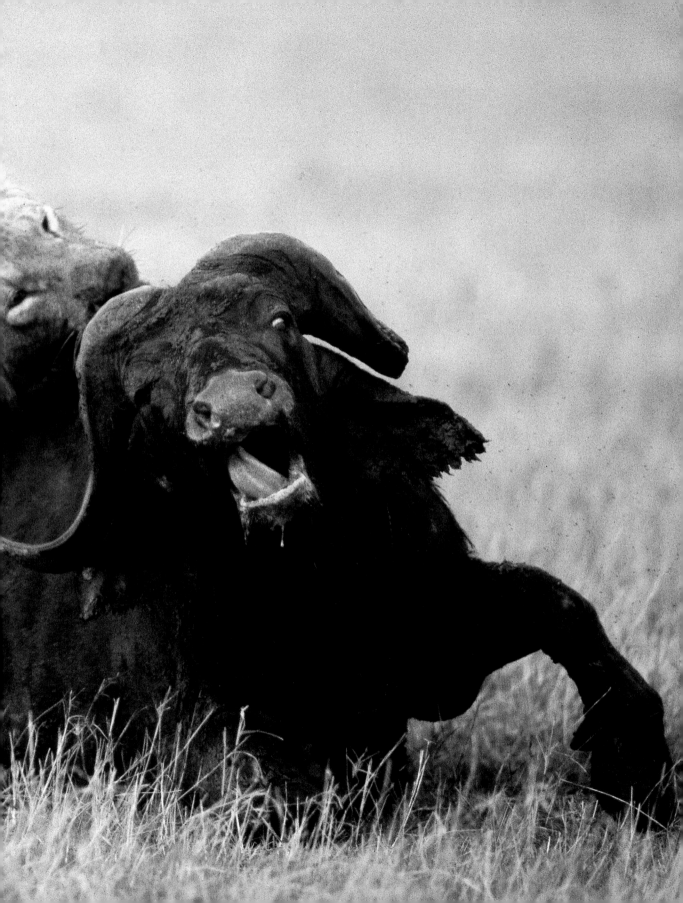

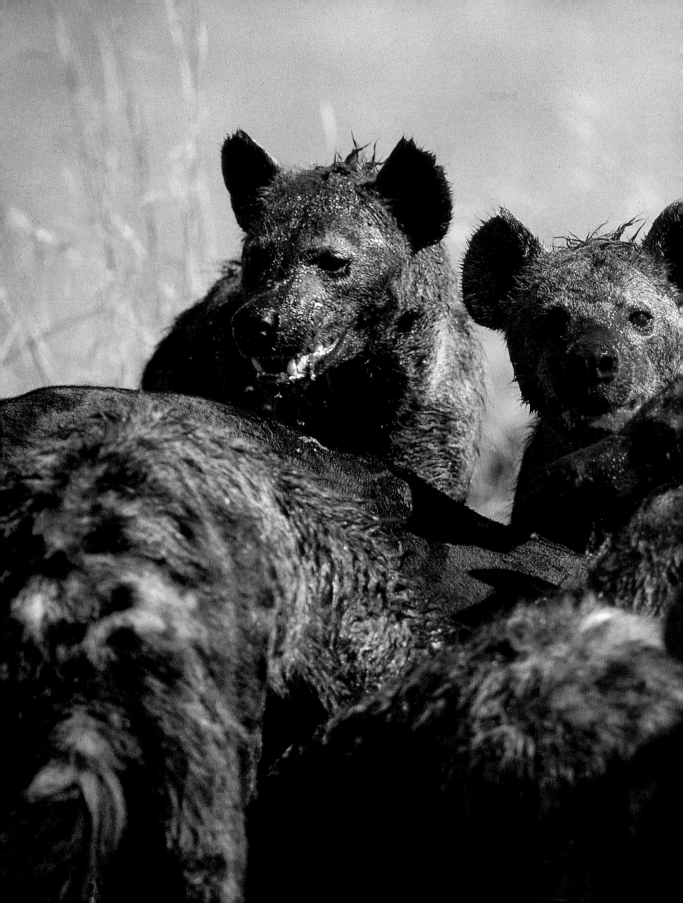

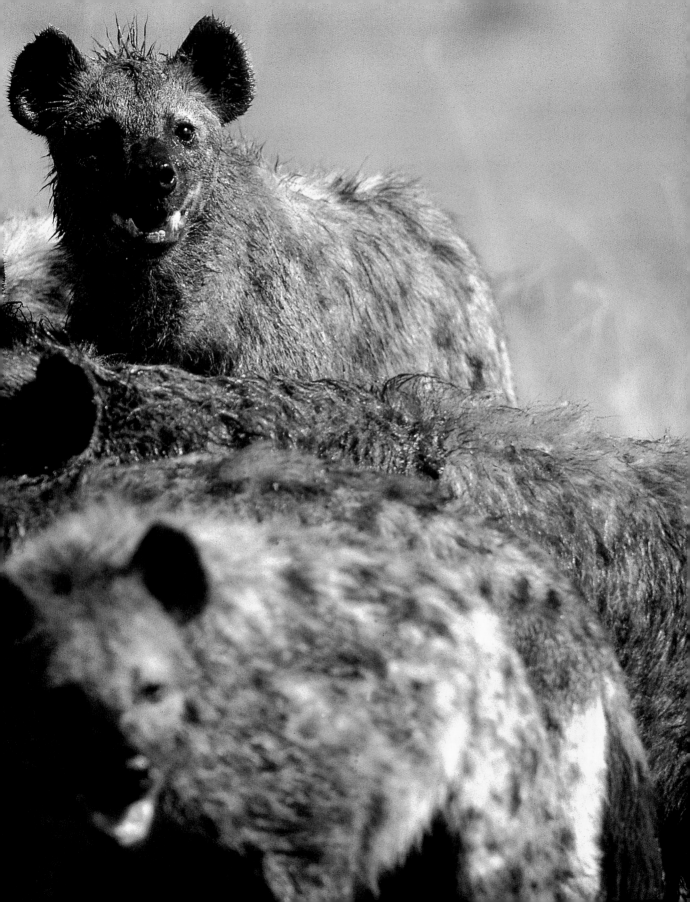

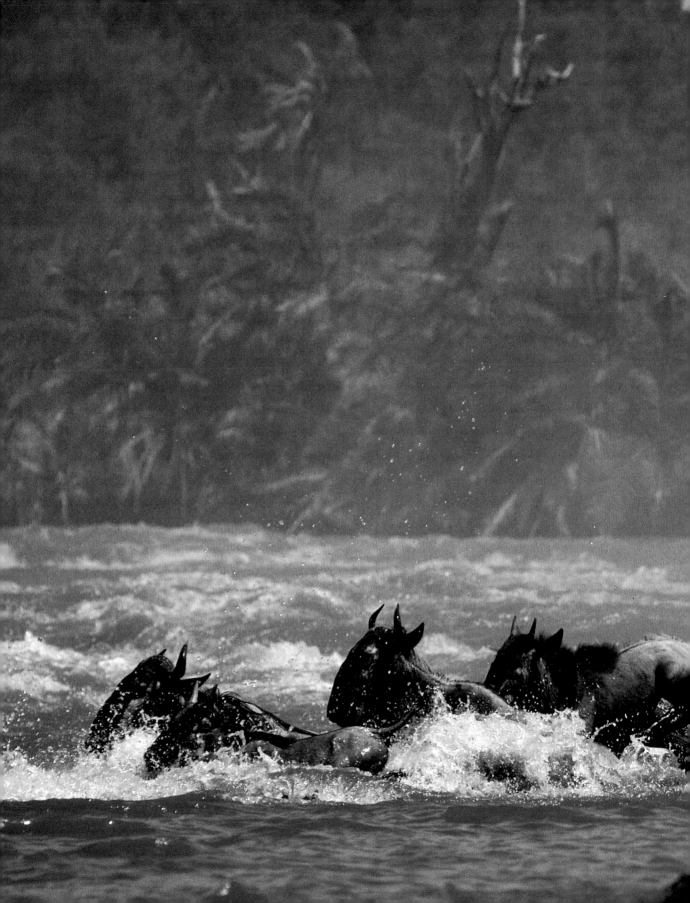

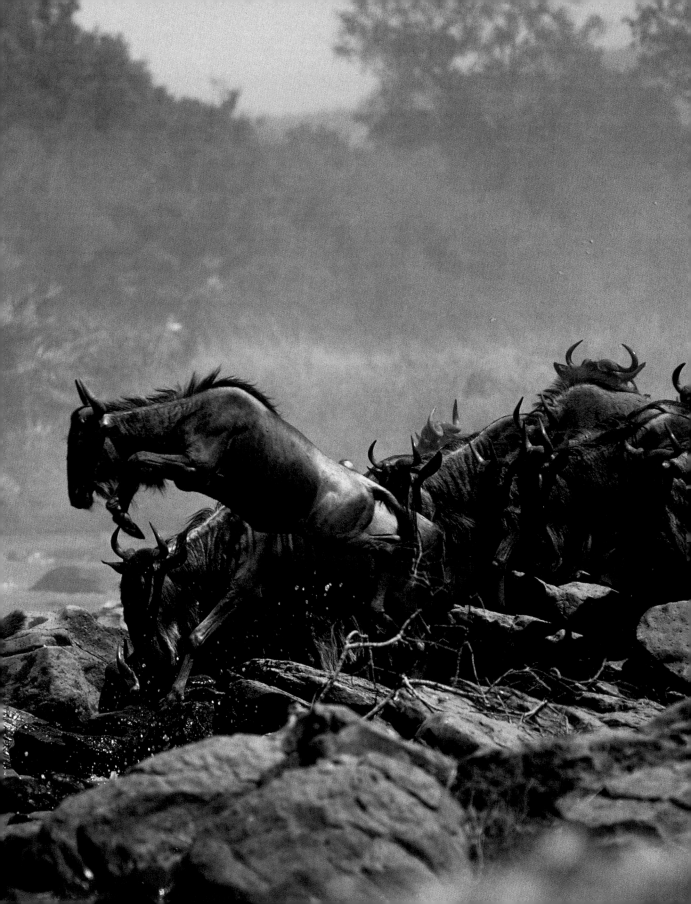

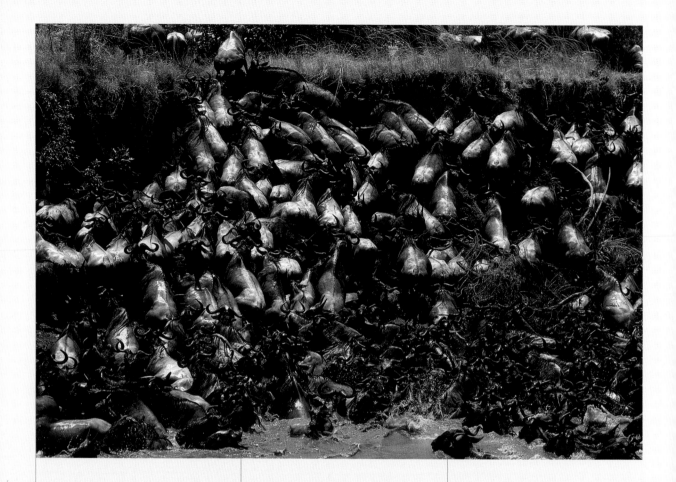

This quest for truth, still elusive to Yann, is revealed in the photographs he produced on migrating wildebeest. The topic was impressive. First, visualize this multitude in search of pastures new, furiously launching an assault on the plains. Two million animals pound the soil, all belonging to the same herd. An incredible rumbling can be heard in the distance. Arriving, they surge forward like an enormous wave. Nothing can contain them, not even the Mara River's treacherous shores and powerful waters, swelled by the rain at this time of year. And Yann remains in the midst of it all. "I was on the lookout for the herd, as were the crocodiles, lions, hyenas, cheetahs, and vultures. They arrived behind me, the animals so close they nearly touched me. I was standing in their path, protected by a small tree.... I was completely hemmed in. It was one of the few times I have felt afraid." An epic scene unfolds around him. The wildebeest must clear the river to migrate. He is standing by banks formed on one side by a sort of gently sloping beach, and on the other, by a small defensive wall of earth. The first to arrive hesitate before the current. Sensing the

▲▶ These wildebeest are drowning. They are all not able to cross. They struggle, the little ones drown and the mothers call for them. Thousands of wildebeest are thus left behind in the river. When I lived in Kenya, I was astounded by the daily presence of death. You sense a ceaseless fear among the animals; when they eat and when they rest, they are always on their guard. For example, only about ten percent of male lions reach the age of ten. Nature is violent and death plays a role within its certain logic. But no one could ever get used to seeing such a sight as this one.

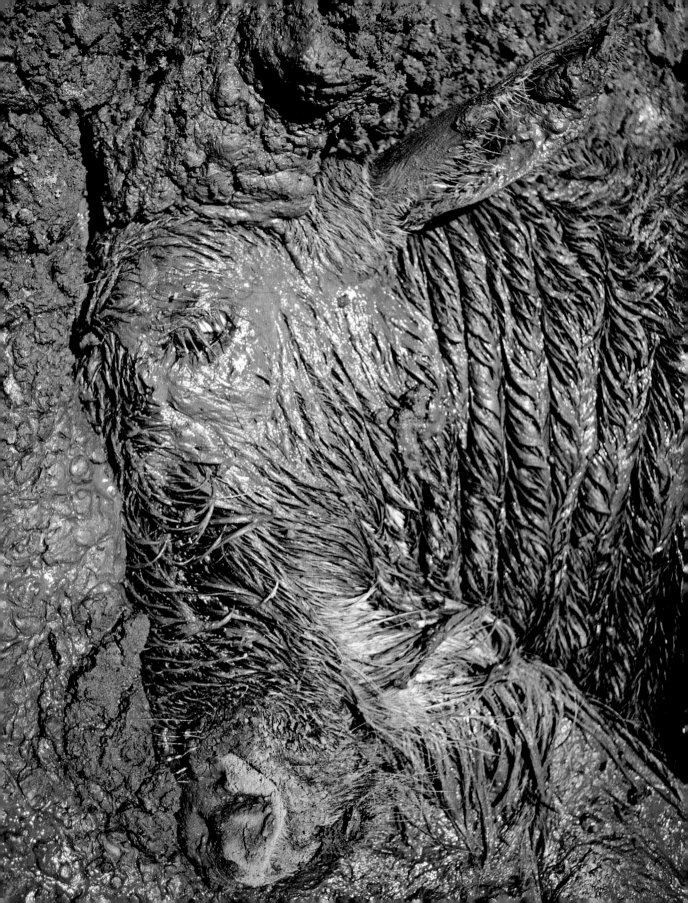

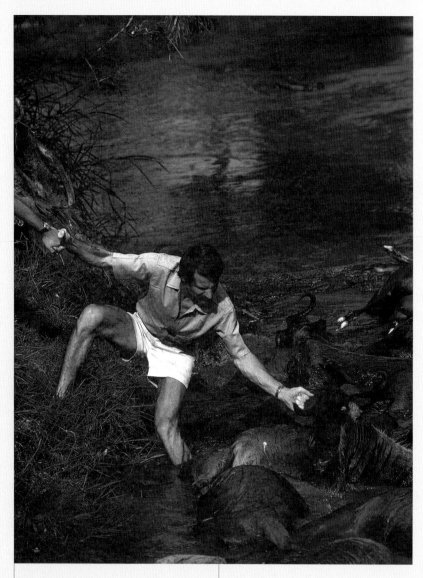

▲▶ We always tried to rescue the wildebeest. As with all the people who lived out there, we were crazy about the animals. But they were terrified, distraught, and charged at us as soon as they were back on their feet.

danger, they wait, sometimes for several days, before resolving to throw themselves in. "And all of a sudden, they plunge into the water, squeezed by the rest of the herd accumulating behind on the plain. On the other side, the steep slope is severe. Attempting to hoist themselves up it, they sink back down and try again. Already, those following behind are upon them, and then the others after them. The horde crushes the weakest. On the raised bank, mothers call for their little ones trapped below. Some tourists, stumbling across the scene by accident, were shocked at such gratuitous violence. They wanted to alert the authorities and level the banks at the place of passage. But this event, without equal in the animal world, constitutes a natural selection that would be wrong to end.

"In the 1950s, the wildebeest population had been decimated by a bovine epidemic. It only took them a few years to replenish their numbers. But to witness these trapped animals struggling, walking over one other, crushing themselves to death in the mud, many of them buried alive, was too much to bear." With Anne's assistance, he attempted to hoist some of them onto the bank using the 4 x 4. When they were set down, the survivors immediately attacked them. Yann, armed with his camera, did what he could to capture these pivotal moments when nature is unleashed, furiously expressing herself. His magnificent portrait of a wildebeest embedded within a clay shroud poses an important question. In the face of this frozen mask of death, the outcome of an instinctual violence, does anything remain of their fierce, cruel struggle for survival?

Yann was still oblivious to having any particularly definite role as a photographer. He initially wanted to impart his passion for nature and wildlife. However, the number and quality of the photographs he had taken of the lions put an end to any further thoughts of completing an academic thesis. A book aimed at the general public now seemed more appropriate. As the children were getting older, and the project was completed, they returned to France where Yann channeled his considerable energy into finding a publisher. Hervé de La Martinière, working at *Hachette-Réalités*, recognized the depth of Yann's photographs and immediately agreed to a publication. A book was produced, coauthored by Anne, whose text revealed remarkably perceptive powers of observation. Anecdotes and scientific insight are deftly interwoven, displaying the extent of the love and respect they both shared for these wild animals. *Lions* would constitute the first publication in a subsequent collection that today numbers around sixty books, all produced on greatly different topics.

"A newspaper is thrown away, but a book survives. Seeing three years of my life consigned to a book was important." Something fundamental in Yann's character is again revealed here, under the guise of simplicity. Books, for Yann, provide the tangible proof of what photographs attempt to show. This desire to reveal and substantiate truths inspired Yann to meet with Hervé de La Martinière, and a friendship immediately bonded the two men. As a publisher, Hervé was

clearly able to offer something that legitimized the artistic process. Yann is also gifted with an artistic approach to life, as confirmed by his constant examination of reality, thirst for the absolute, refusal to compromise, and need to create.

His work is defined by his refusal to claim responsibility for its creation. Yann cannot grasp the relevance of modern photography without the content provided by his books. He ratifies an approach that he is the first to mistrust. "I always felt obliged to make my work useful." Without this value, he detects a vanity within the photographic procedure.

But the question does not arise when he is back in Africa; there, Yann must work. He became a photographer as events dictated, and he continued in this vein. "I loved the animals. I'd taken some photos and all of a sudden, I discovered an intrepid side to it all. A photographer's life doesn't differ that much from an adventurer's. It represents much of the myth and pleasure allied to the profession."

While he was carrying out his tour of publishers, Yann began an offensive on the editorial offices. Robert Fiess, the director of *Géo Magazine* eloquently remembers. "He arrived and you became immediately aware of his presence. He was the only one to turn up with his dog, Rigolo, who proceeded to make himself comfortable on our office carpets. Professionally, he didn't delay in displaying the kind of impatience indicative of one with no time to spare. Although he was not familiar with the battalion of photographers working at the magazine, throwing open the editor-in-chief's door to take issue with the

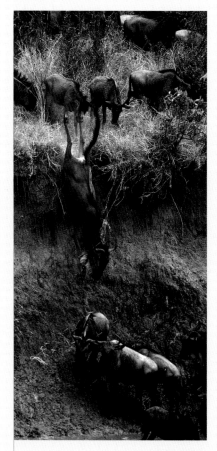

sluggishness of certain editorial decisions was not out of character. His impatience was forgivable." Yann was anxious to see his work published by the press, so certain was he of its impact. *Paris-Match* released his account of the migrating wildebeest, a phenomenon alien to the general public at that time. *Géo Magazine* published the coverage of the lions, supplemented by an extensive report. The report on the Masai offered a vivid account of the Eunoto ceremony, which was held every ten years to mark the symbolic passage of warriors to mature men.

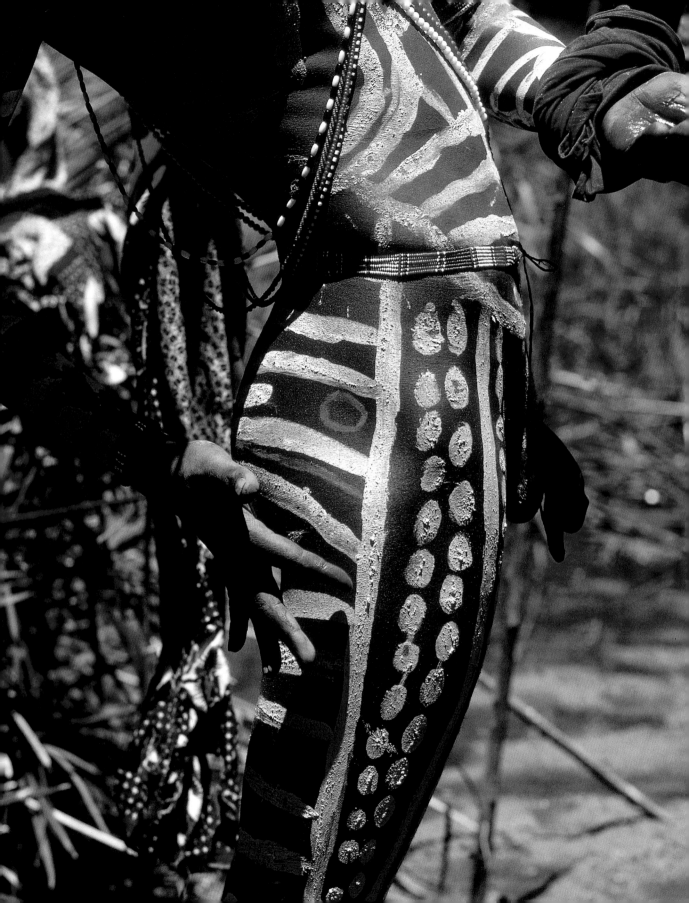

A Dutch missionary, passing through the camp, was the first to inform Yann of this vast ritual ceremonial gathering, involving hundreds of people. Yann had forged friendly relations with the Masai, who worked among the teams of guards and camp drivers. Every day, they helped him inflate the hot-air balloon, moor it, and fold it away after landing. They spoke to him of their life in the villages, their complex social organization, their architecture, and their ceremonial rituals. Because of his friendship with the Masai, Yann was permitted to photograph the event. This was how he found himself—accompanied by two other fledgling photographers, Carol Beckwith and Angela Fisher[1]—amid the euphoria emanating from the ceremony. For Westerners, the lions and the Masai exist as part of the African myth. They both share a fascinating pride, independence, courage, and beauty. But the parallel does not end there. Yann explains that "the Masai are the lions' counterparts."

And it is a strong bond that unites one with the other. Masai tradition effectively dictates that warriors undergo single combat with a big cat.[2] Killing a lion represents the bravest feat they can boast of accomplishing. Afterwards, they cover themselves with the animal's mane as a trophy confirming their nobility. The coverage was essential to Yann's progress because it signaled his decisive passage from a photographer of wildlife to one of humans. The fact

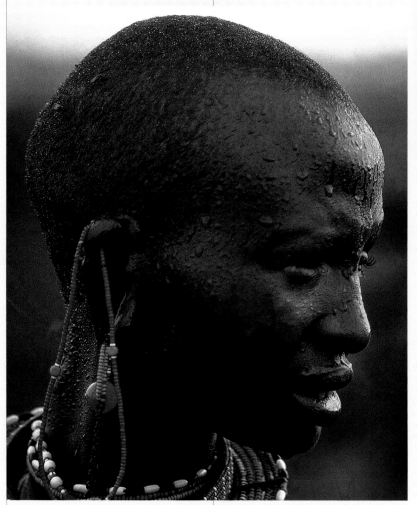

▲ In 1978, we were camping out by the Mara River and the Masai women would come every morning. The Masai loved to flip through our animal guides. They had a name for all the animals, even the smallest.

◄ Many magazines, one of which was *Géo*, published the reportage on the lions, Masai, and wildebeest. "During the 1980s, the arrival of *Géo* paved the way for an entire generation of wildlife photographers or ethnographers. A market created itself and we were able to publish our work. Other magazines subsequently followed, though they were non-specialized. It was an easy period for a photographer; you would travel, you would come back, you would publish and then you'd leave again. This no longer happens today."

1. Themselves the authors of a magnificent work entitled *African Ceremonies*.

2. This occurred until governmental legislation banned it in the 1970s.

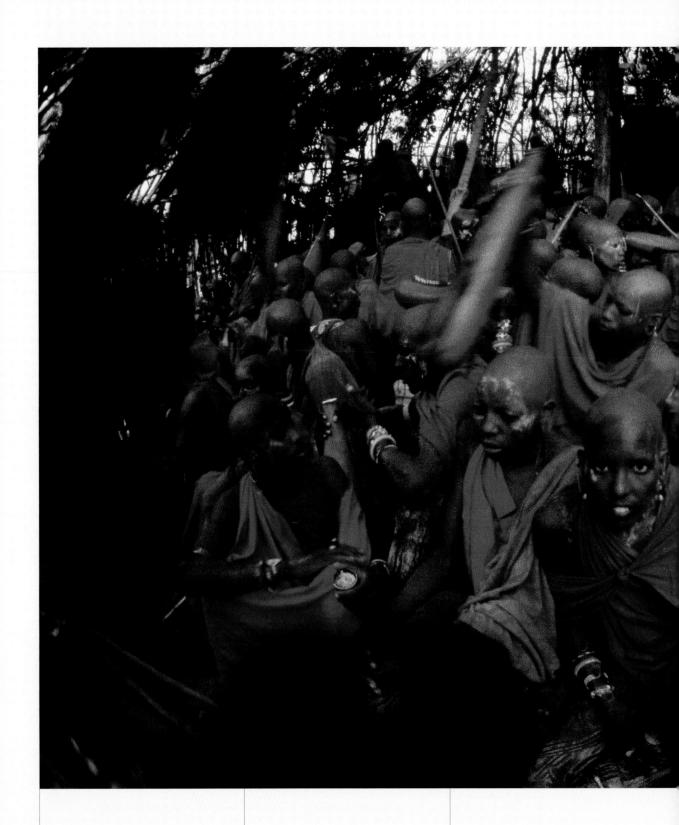

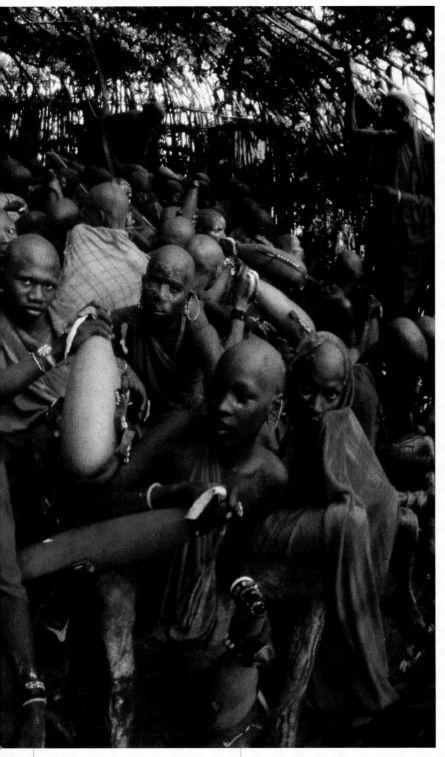

that he inaugurated the transition by photographing a ritual Masai ceremony reveals the coherence and consistency of his development.

Yann has remained a photographer because the profession brought him something more than distinction and an easy life to take pleasure in. He experienced genuine happiness from the start, playing a role he self-effacingly compares to that of the hero of the television series, *Daktari*, an adventurer who leads his life as he determines. Yann eloquently describes his first publication as: "Three years of complete happiness consigned to a book." But this is not simply a foolishly idyllic vision of life in the African savannah, confined to familiar sentiment. It is rather a question of experiencing a

◄▲ The Masai invited me to attend the ritual ceremony of Eunoto, which marks the passage of a warrior to that of a mature man. I had been fascinated in the past by *The Nuba* of Leni Riefenstahl. When taking these images, I thought of her work because the photos are extremely powerful. Even if one is a beginner, as I was then, it was easy to take beautiful photographs with a subject like the Masai. The noise, the movement, the body paintings... all that was required was the press of a button. These are my first portraits.

happiness that is renewed daily through thoughtful harmony with the world. At fifteen years old, Yann was an unruly teenager flirting with the law. At seventeen, he left an environment that was preventing him from expressing his aggressive nature. At twenty, he discovered wild animals, most notably the lions that symbolically embody his true character. He soon became fascinated by their power and underlying aggression. After caring for the big cats in Saint-Augustin, the African lions taught him important lessons about their violent nature, as it was evident when he observed them in their natural habitat. It is not representative of a blind and destructive instinct to fight, but rather a response to deep and absolute necessities, the foremost of which was the need for nourishment.

Posing questions about the nature of violence, seeing it firsthand and observing how it governs and is governed by the different members of the group, serves as a way of redeeming it. When photographing violence in animals, whether passive or actively aggressive, one is tempted to capture moments that speak most directly to our personal

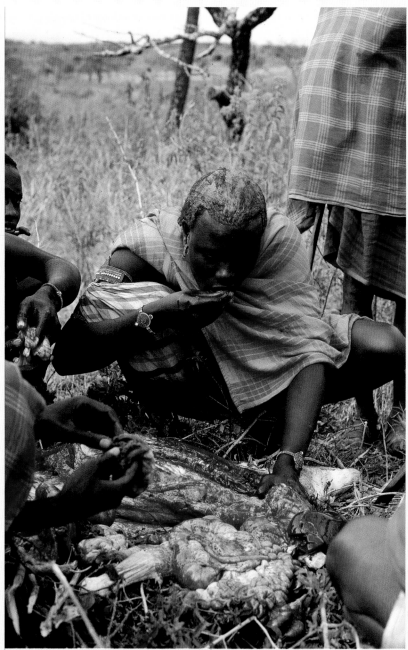

◄▲ When I took these photographs, I had a tin of sardines and I offered them some. Disgusted, they asked me: "But when did this fish die?" The fish had in fact died about two years ago! They preferred to drink fresh blood.

▲ Certain parts of the slaughtered animals are eaten raw, such as the kidneys, cuts from the stomach, and the fat. The rest is either boiled or roasted. The skin of the animal can then used as bedding or for shelter.

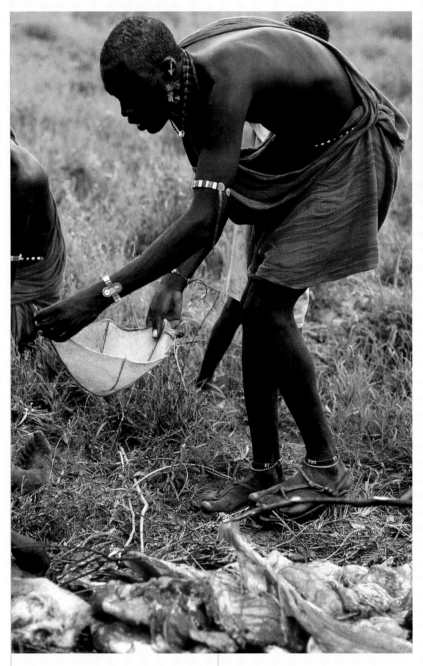

understanding. It is not absurd to suggest that Yann became a photographer because the profession offered him the visual means for a profound reconciliation with his own intrinsic character.

This understanding was as yet unconfirmed with humans. His coverage of the Masai led to a second book being published in 1984 by Berger-Levrault. The sincere and absolute harmony Yann initially experienced at the sight of animals living in the wild finds a correlation with the Masai. The fundamental importance of these photographs is illustrated by his realization in Africa that: "Man is a part of nature." The assertion would seem naive without first considering its polemic implications. It is because Yann's own presence in the world is unclear that he closely questions the relationship of men with their environment. This enables him to understand the meaning of his own integration with nature, and consequently his own private motivations for being a photographer emerge.

▲ Warriors who take pride in their appearance transform the stomach of a goat into a nightcap that protects their hair when smeared with red ochre.

▲▶ This teenager is wearing the hat that symbolizes circumcision. The young Masai must travel far from the village to look after their herds. During this time, they kill birds and save the feathers to make this headdress.

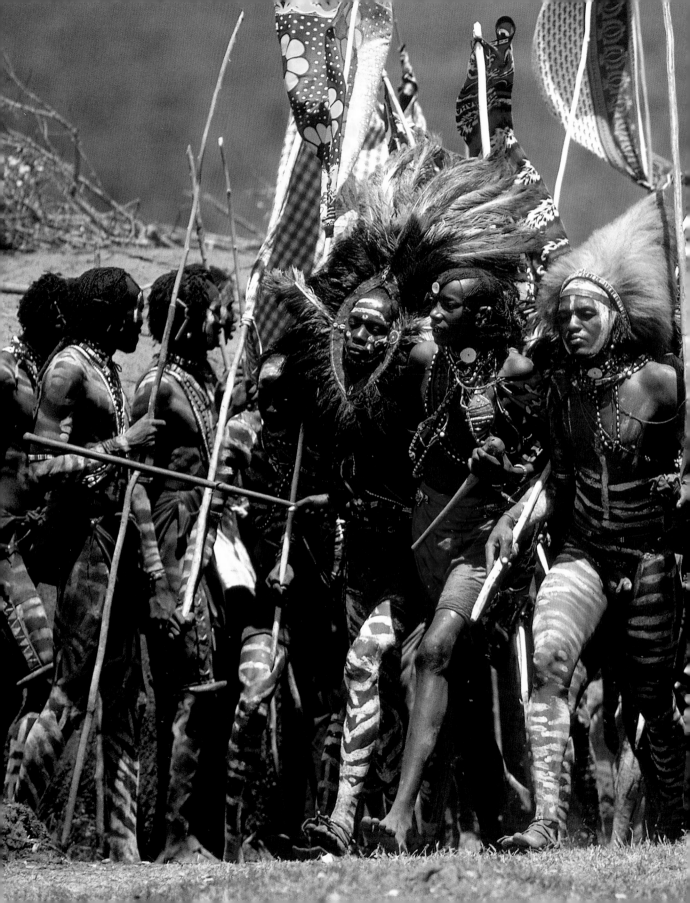

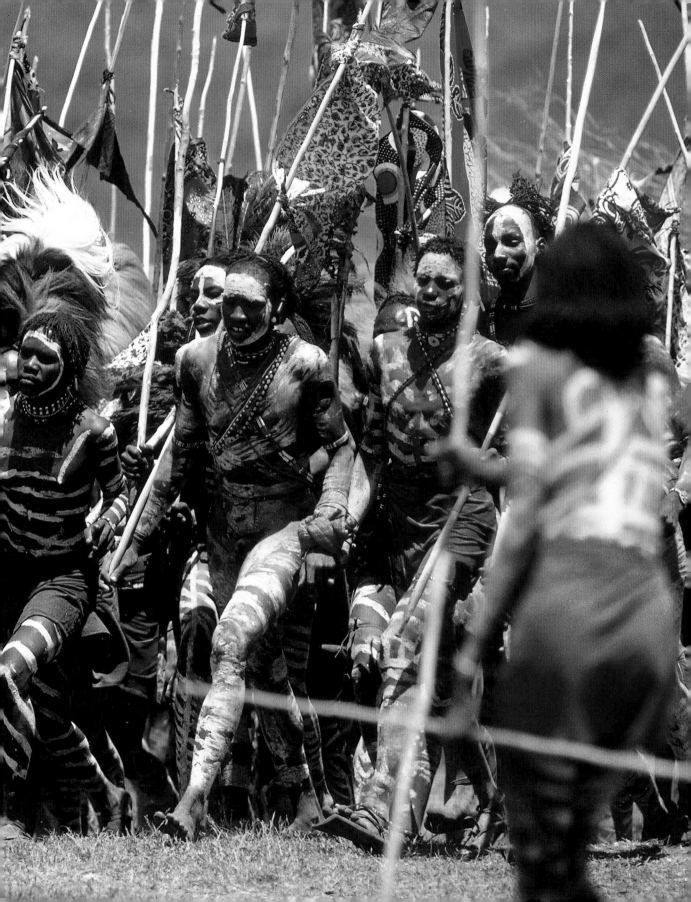

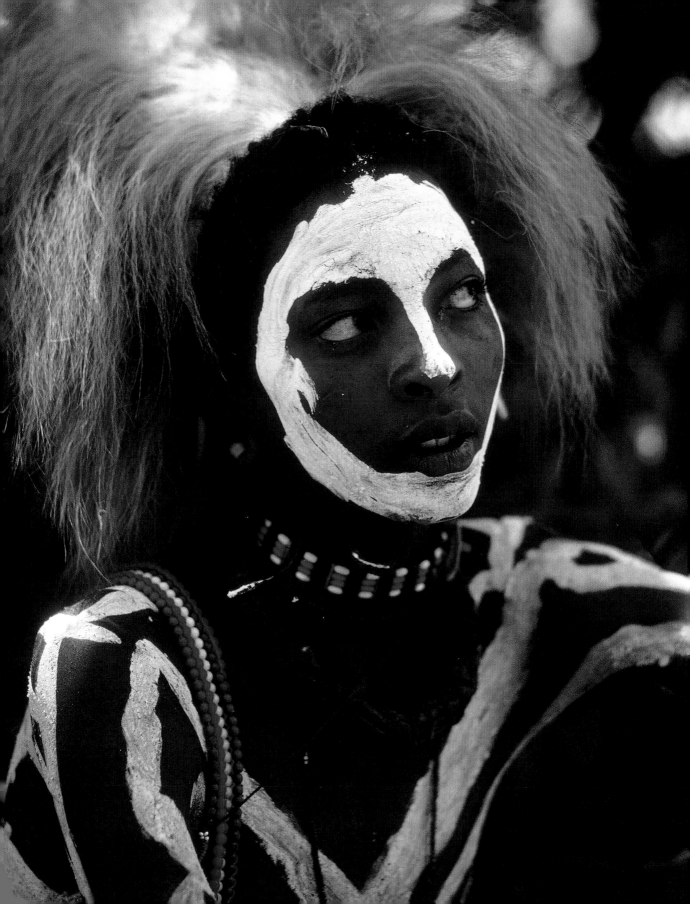

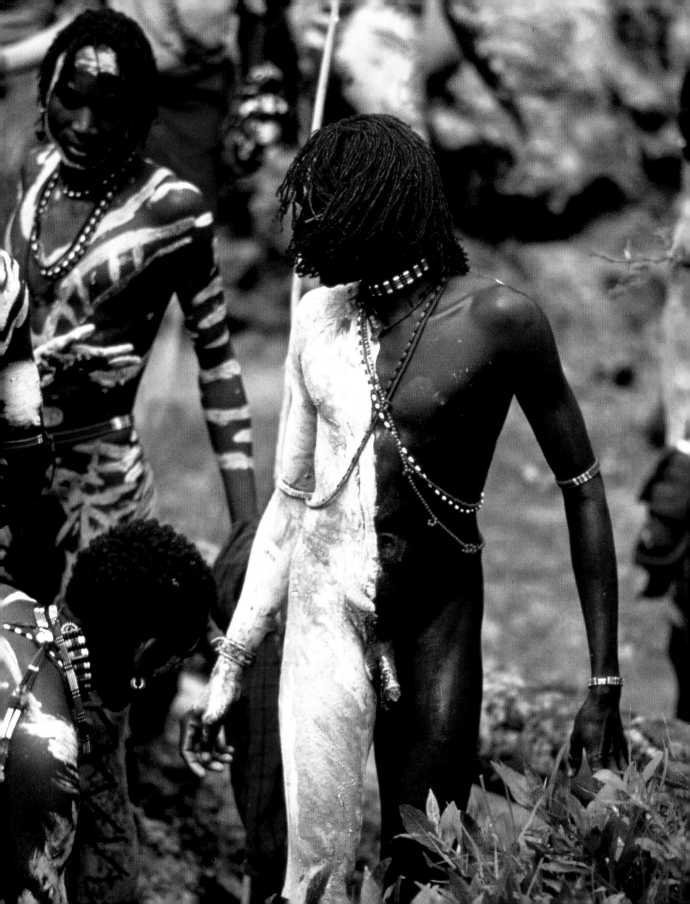

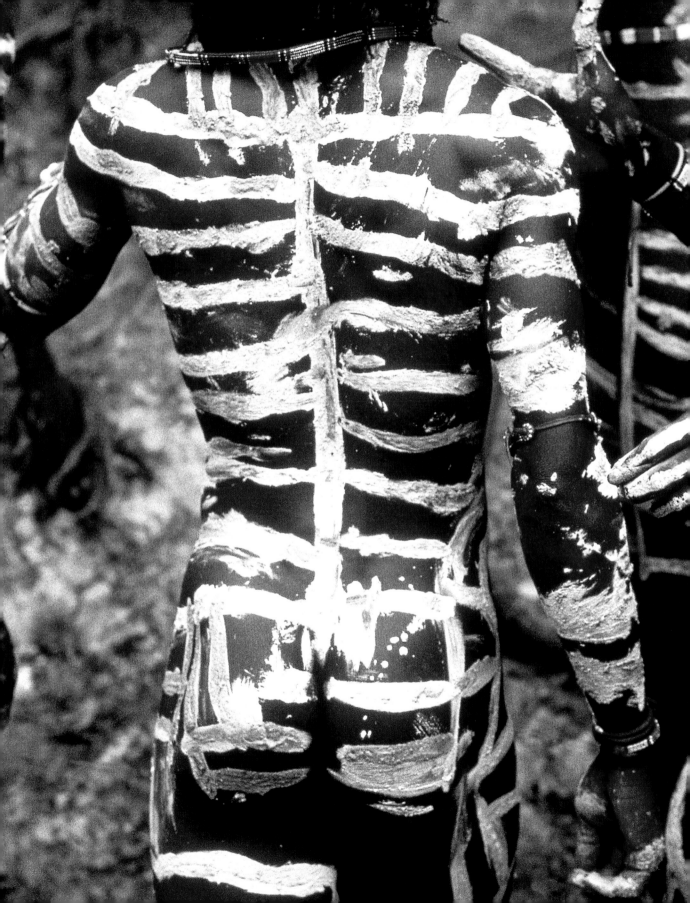

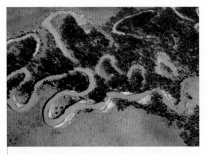

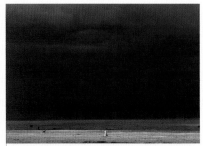

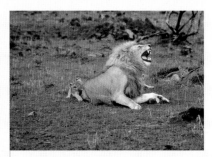

pp. 26–27. Every morning, Yann would fly over and photograph lion territories hidden away in the remote and invisible corners of the Earth. His early aerial photos initially targeted such locations. They revealed a whole new landscape; here the dried beds of the Mara River.

pp. 28–29. The Masai Mara engendered in me a passion for light and an understanding of its fundamental importance within photography. The first and last hours of the day, the so-called magic hours, enhance everything. A little luck is again necessary because planning remains impossible in wildlife photography.

pp. 30–31. This rare image brought Yann's work recognition. Yet, at the time of the shot, the transience of the moment escaped him. He didn't discover the photograph until developing it six months later. Hook, a particularly benevolent lion, lets himself be manhandled by a little lion cub. Often adult males arriving in a group to assume power will kill the infant lions so that the females become sexually active again.

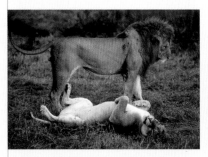

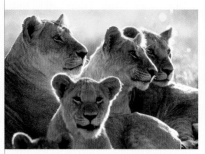

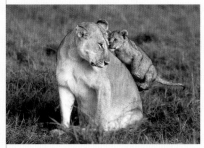

pp. 32–33. Mating periods are short (four to eight days every three months) but intense (lasting twenty minutes). The day of their arrival, Yann and Anne discovered two lions mating in front of their house and had no option but to postpone moving in until the following day.

p. 34. High and to the left sits Maléfice, a lioness particularly dear to Yann and Anne. This was because she had willingly taken it upon herself to care for all the youngsters in the group, hunting for them and letting them eat before her, which is rare. To her, they dedicated their book, *Lions*.

p. 35. Playtime for Maléfice and the little lion cubs. Nature determines that two cubs out of three never reach one year of age, either prevented from suckling by the eldest or simply killed by adult males. Such vulnerability increased the affection that Yann and Anne felt for them, and equally, their sadness on finding them dead.

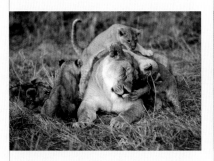

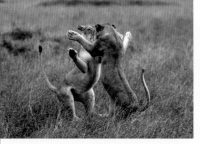

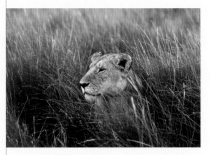

pp. 36–37 and 38. The group of lions that Yann and Anne studied became like a second family and observing their little ones reinforced this attachment. Yann noticed that the gentle innocence of the young lions, as of all young mammals, engendered human kindness. "Seeing the lions' protective instinct for their offspring reminds us of our own natural instincts."

p. 40. After several weeks of drought and heat, the sudden arrival of the rain seemed to release the lionesses, which led to euphoric dancing. Excited, they played and provided us with this astonishing image.

p. 41. Maléfice captivated Anne and Yann. Nature's simple beauty is easier to convey in photography than through a text. Their book also has the value of a testimony; in 1980, the lions were not yet all confined to the nature reserves. Demographic pressures and agricultural development have since changed all that.

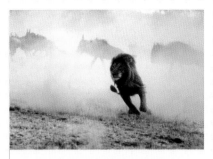

pp. 42–43. This hunt left Anne and Yann stunned. The lions took advantage of the excited confusion amongst the thousands of wildebeest preparing to cross the river. Whereas usually they only hunt when hungry, that day they made a kill of eighteen, a vast number amassed in "a moment of synergetic madness."

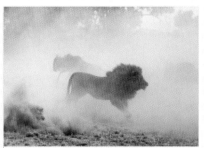

pp. 44–45. Upon development, the photographs of this extraordinary hunt scene disappointed Yann, who decided not to keep them. He believed a good image should be in sharp focus, and these are blurred. It was Anne who retrieved them from the wastepaper bin and added them to the collection.

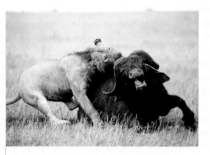

pp. 46–47. This young male lion has not yet learned the "kiss of death"; imprisoned in his jaws the buffalo is slowly choking to death. His prey is too big for him and will consequently suffer for three long agonizing hours. "Exposure to such routine violence taught me how fragile life is, as much for the prey as for the predators."

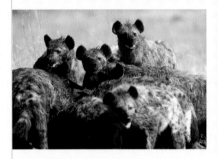

pp. 48–49. Yann does not share the common antipathy for hyenas. He is appreciative of their intelligence and even raised one at the animal reserve in Allier, France. "Hyenas are the predators of the old lions. When they arrive, the old lions leave. If they catch one however, they become ferocious and kill it, though always leave it uneaten."

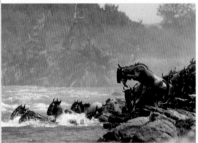

pp. 50–51. From August to November, two million wildebeest migrate from the parched plains of the Serengeti in Tanzania toward those of the Mara, which benefit from the climatic change instilled by Lake Victoria. After several days of waiting, they throw themselves into the river from a soft slope and surge into a narrow, steep bottleneck on the other side.

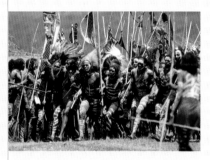

pp. 62–63. In a trance-like state induced by a decoction of bark, the warriors walk and dance for hours, during which nothing nor anyone can stop them. Yann was aware that it constituted "a good photo" just by surveying the violent and impressive scene through his viewfinder. He also had the feeling "that this moment is unique, something I won't ever see again."

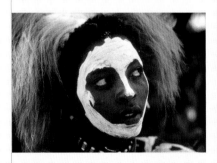

p. 65. For Yann, the Masai closely parallel the lions. They deem single combat with a big cat to be the height of heroism. During the Eunoto ceremony, their plumes are abandoned; nostalgia and apprehension then give way to violent behavior. "These were moments of great jubilation but at the same time, extreme tension."

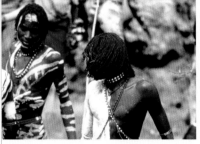

p. 66. In the lime quarry, body drawings are improvised according to taste, but only the most valiant warriors are allowed to whiten one half of their body entirely. A deep bond unites them with their immediate circle and fellow men.

p. 67. "Photographing my Masai friends represented my own personal testimony. At that time, I never imagined it would ever become genuine reportage." Beauty and harmony in the environment remain the positive ideals by which Yann attempts to anchor his own photographic work.

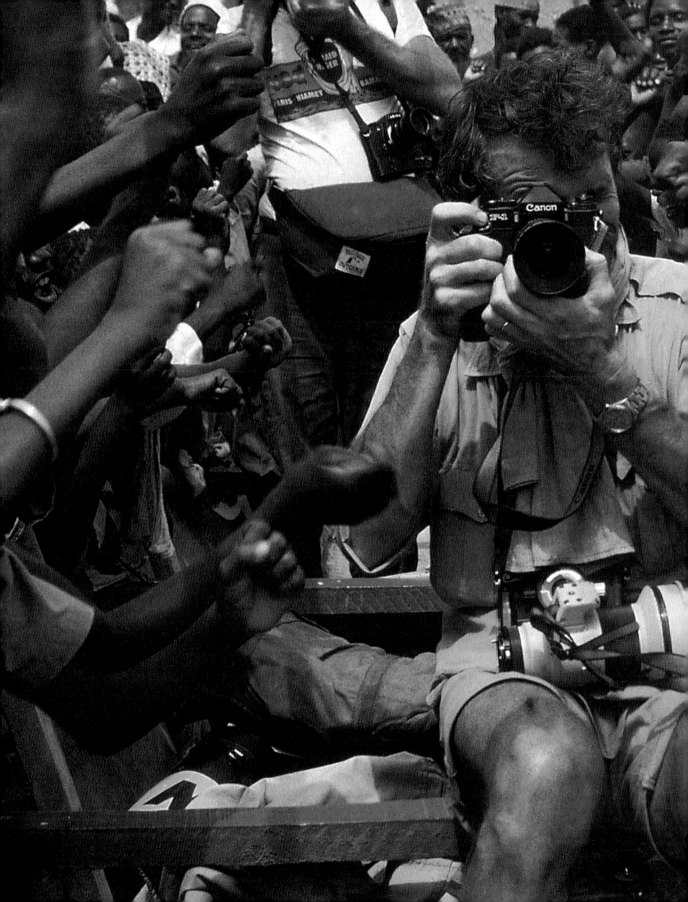

Reportage Photography

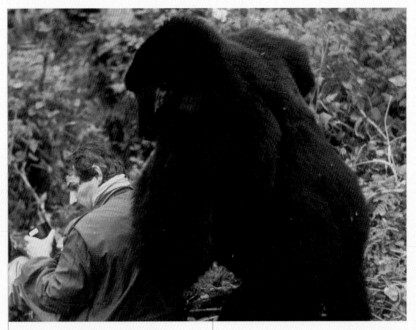

◄ When Yann arrived at Dian Fossey's home in the Rwandan rain forest, he experienced terrific back pain and learned that Dian would not be able to accompany him due to illness. With a guide, he disappeared into the forest to meet the gorillas. "This young male—the fur on his back is still very black—began to strut about behind me while I was photographing two other gorillas mating. He made a terrifying noise and broke some branches... I was rather worried. He then struck me in the back, throwing me some three yards away. When I stood up, my vertebrae were all in place!"

▶ As the hour for their siesta approached, Yann waited in the rain for the gorillas to arrive. There was no point lying in ambush to observe this sleepy male. "Another time, he came and rested his head on my foot; it was a very powerful moment and I had tears in my eyes. It was the first time a wild animal had ever trusted me on such a level."

There was nothing remarkable about his return to France. Yann had reached fulfillment in his profession and was showing a sort of maturity. But reconciling the demands of family life with those of his restless temperament was not always easy. "I like working, creating, taking action. I am incapable of thinking in any other way. In Kenya, I became obsessed. I could not spend even half a day without seeing the lions." His demands sometimes impose a pace that is difficult to follow or sustain. "I am completely free. I choose. It is perhaps a little selfish of me, but I feel free. And I noticed that very few people had such a freedom."

Yann is aware that exercising this freedom always comes at the cost of something or someone else. "I realize now that my profession and success rest upon the benevolence of my wife. I would always leave and

return to find the domestic sanctuary that marked my way. I am extremely privileged to have married a woman who accepted and offered me that. With the lions, Anne was worried for the children; a danger I didn't see. And yet she always encouraged me to see things through to the end." Conscious of his responsibilities, Yann gave up wildlife photography on the ground. "I considered carrying out a project on tigers in India. But, because of the children, I couldn't leave for four or five months at a stretch."

If he did forsake a certain kind of adventure to "settle down," he did it without ridding himself of his ambition. The 1980s offered him opportunities that would take full advantage of his abilities. At this time, photography was experiencing a revolution. The leading agencies were going through a crisis from

which they did not immediately recover.

All their major creative talents had left, some departing through weariness, others by a desire for independence or higher pay. Cartier-Bresson stepped back from Magnum, Depardon broke with Gamma; Riboud and Salgado both took off. Brassaï, Doisneau, and Boubat did not delay in quitting the photography world. This is without mention of prominent photojournalists like Gilles Caron, killed in Vietnam.

A generation was dying out, these pioneers of photography with a style, eye, and visual sociology that extended far beyond the simple snapshot. The black-and-white image no longer prevailed and color had begun to establish itself. It was in this period that a host of up-and-coming adventure and travel magazines were created, such as

Géo Magazine, *Grands Reportages*, *Double Page*, and even *Le Figaro Magazine*. The photography of escapism, introduced by publishing houses building their own photo collections, conquered one category after another. "All the projects sold themselves. All one needed was ideas. It was easy." Photographers, aided and abetted by authors, specialists, and researchers, penetrated the borders of even the most reclusive countries. They reported major developments, recorded the practices and species disappearing into oblivion, and paved the way for future tourist destinations to come. "*Géo Magazine*, dedicated to world exploration, created an opening in which we immersed ourselves," explains Yann. "It provided us with an existence. All the photographers of my generation owe these publications a great deal. They gave our work a platform and strengthened our images."

The fact that Yann had spent time in Africa, and Kenya in particular— "the land of great individuals"— meant he had something to offer the chief editors. Brigitte Huard, working for *Ça m'intéresse* magazine, contacted him about producing a project on Dian Fossey. "It was a dream come true." However, Anne was several months pregnant and had just suffered an accident. Yann was hesitant about leaving her. Aware of the importance the meeting held for her husband, Anne encouraged him to go. But as he was saying goodbye to her on the footbridge of the barge they lived in, Anne stumbled on her crutches and Yann sprained his back trying to stop her from falling. The pain was excruciating, but the taxicab, Dian,

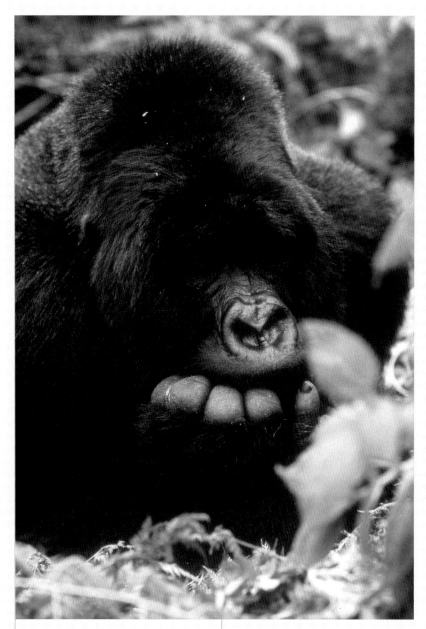

and the gorillas were waiting for him. In the plane, the stewardesses plied him with aspirin. In Kigali, the person who greeted him drove him to the hospital, where he was given an injection of cortisone. On this occasion, he came across patients suffering from AIDS; it was the beginning of the epidemic. He took some photographs and then rejoined the camp for a three-day walk in the mountains.

While aware that his hostess had a short temper, he had not expected the welcome that was waiting for him. Dian Fossey was furious. She had been expecting him all evening and it was now too late to eat the cake she had prepared! Yann, absolutely shattered, did not take offence. Dian was a role model for him. Since 1967 she had lived in this remote corner of the Rwandan tropical forest—"the country of seven volcanoes"—spending the last twenty years of her life amid the humid climate and lichen covered soil, dedicated to the study and defense of gorillas.

She had taken over from George Schaller, a distinguished researcher, tremendous photographer, and another of Yann's idols. Her work on gorillas is exceptional for its scientific precision, courage, determination, and passion. Yann, touched and excited, discovered a petite, gray-haired woman, robust despite her illness. Dian had paid the price for the exhausting local climate. Asthma, and the removal of a lung, prevented her from regularly visiting "her" animals. In a soft tone that forbade discussion, she informed him that he must disappear into the jungle alone to find the gorillas. She taught him the basics that he should remember of gorilla behavior, and Yann promptly left the next day in the company of a guide. "I found myself back in the mist and rain—it rains all the time there—sweating like an invalid under the oilskin protecting us and the camera equipment, suffering like a condemned man." The medicine taken in Kigali had for some time ceased to be effective. The guide left him by himself, not far from the spot that Dian had suggested. "I knew that the gorillas would come for a siesta at around ten or eleven o'clock. I installed myself about fifteen yards away. I was very, very impressed."

Squatting in the undergrowth, his heart was in his mouth as he saw the big apes arrive and settle themselves down around him. But when the large dominant male drew near and lay down with its head on Yann's foot, he "cried with joy." "It was the first time a wild animal had ever invited me to share in its life like that. It was fabulous. Wildlife photographers spend all their time tracking animals that fear man, in order to get as close to them as possible. And there I was, watching over a full-grown gorilla sleeping peacefully against my leg." Photographing gorillas with black fur against the backdrop of a dark green jungle often presented a frustrating technical challenge: "We never succeeded in recording all the shades of their black fur. The result was always disappointing." But Yann remembers the intensity he experienced in meeting the wild animals so intimately. "The event had a profound effect on me. There was never any affection or complicity with the wild animals.

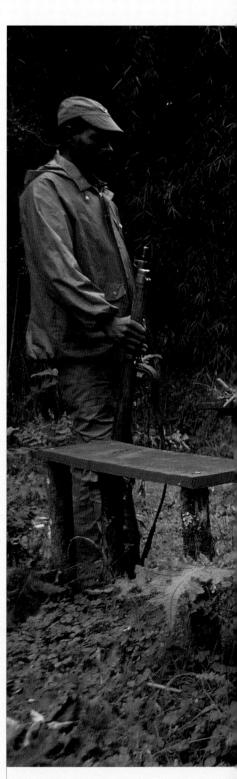

▶ Dian Fossey and her team reveal traps made of rope and even cable. These are laid down by farmers to capture animals, most notably the antelopes. But gorillas are also caught in the often fatal snares. Strong demographic pressures extend the clearings and erode gorilla territory little by little. Dian Fossey opposed all this at the cost of her own life, four days after this photograph was taken. She is recognized as a national heroine in Rwanda today and appears on the country's banknotes.

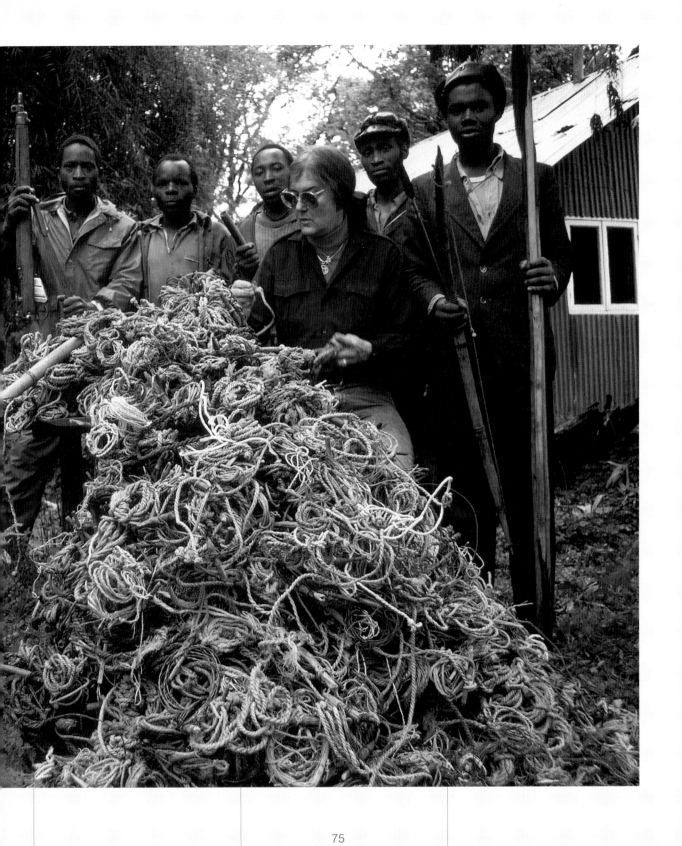

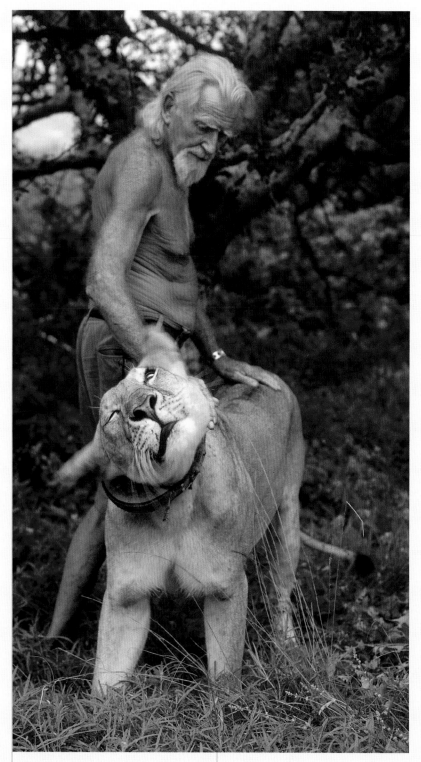

Man stands definitively apart, but it is extraordinary to see an animal four times as great as you, staring and acting for all the world as though you don't exist! The fulfillment one feels in such moments is indescribable."

The gorillas appeared quite peaceful: "You can follow them for days taking notes and photographs during which they will pay you absolutely no attention, so long as there is no aggression or rivalry on your part." One day however, a young male launched into a display of intimidation. Yann knows what position to adopt. He sits down, lowering his eyes, remembering above all not to look at the gorilla, but to demonstrate submission before its anger. When he utters a few friendly vocal expressions, the gorilla moves away.

The same ritual occurred the next day and during the following days to come. Despite the photographer's best efforts, the animal seemed determined to do battle. This was until the day when "he withdrew from his swaying walk, danced a little and abruptly returned at full speed, bearing right down on me. Fortunately, he avoided me but I was still struck in the back as he passed. It was with such force that I flew three yards away." Yann, petrified, kept quite still. When the gorilla had

◄ George Adamson, another mythical figure, seen here at the age of eighty-three. Surrounded by about ten lions previously raised in captivity—this one recognizable by its collar transmitter—he attempted to reacquaint them with their natural habitat, as his wife, Joy, had done elsewhere with panthers. She was murdered by poachers some years before he was.

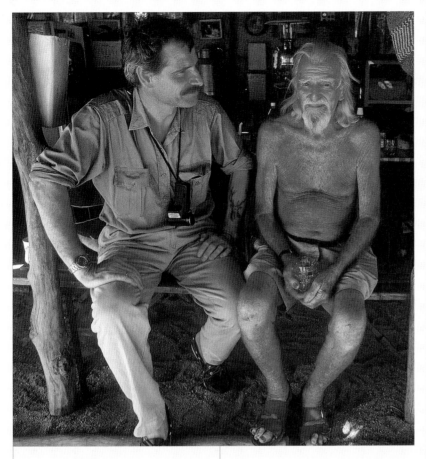

◄ Yann paid many visits to North Kenya in order to see George Adamson at his camp in Kora's nature reserve. He maintained a correspondence with him. "An exceptionally nice man, hospitable, generous, and warm. He kept an open house all year long and always lived half naked in just his shorts."

▼ The fame resulting from the movie, *Living Free*, attracted a great many young people, researchers, and admirers to Adamson's home. They came in search of a legend, for he had become a mythical figure. Laid upside down, these elephant jaws functioned as the camp toilets.

departed, he got to his feet and amazingly discovered that his back pain had disappeared! The shock had somehow put his vertebrae back into position.

Each evening, Yann would return to camp and report back to Dian, who was waiting for him. He gave her the kind of photographs she had asked for as additions to her archives, as well as droppings collected from specific animals she had indicated to him. Analysis of their shape, size, and consistency makes it possible to track the movements of each individual. Over the course of their conversations, Dian confided some of her concerns and the difficulties she encountered. Poverty and growing demographic pressures force the farmers to trap gorillas for their meat. The number of animals killed or crippled, then overcome by infection, was constantly on the rise. Dian, marked by the tenacity of the life she led, lacked the means and recognition her efforts deserved. She was probably aware of the threats on her life. Five days after Yann's departure, this exceptional woman was murdered.

Today, the Rwandan banknotes carry her image. And the gorillas still remain under threat. Yann's coverage followed in the footsteps

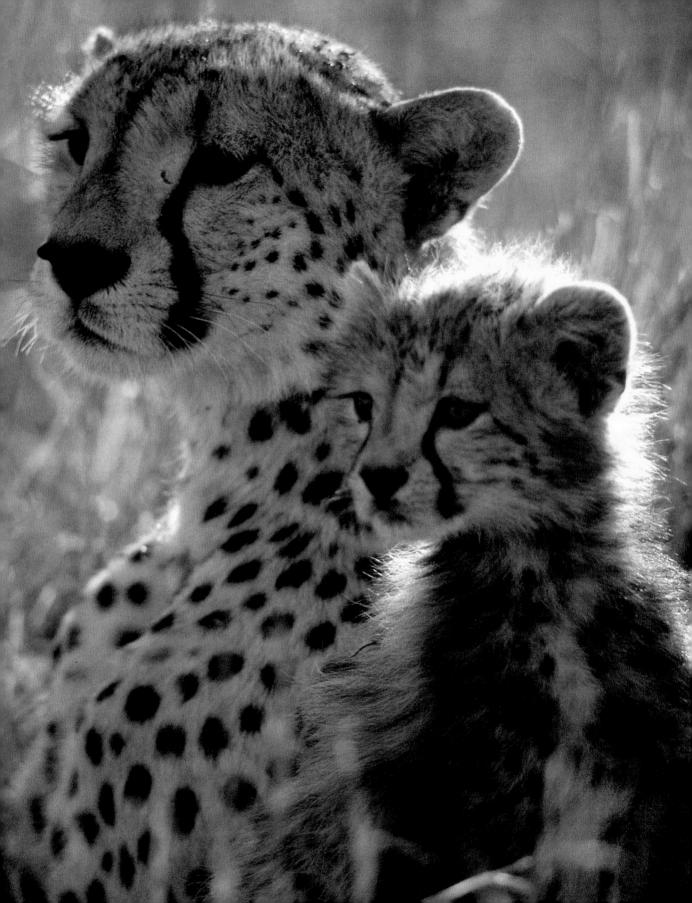

of his work on the lions, wildebeest, and Masai tribe. He considers it to be one of his strongest pieces as a wildlife photographer.

George Adamson represents another "pioneer of the movement to safeguard endangered species," and Yann met him on many occasions. "He was also someone, who in this lost corner of the Kora reserve to the north of Kenya, surrounded by his tame lions, couldn't have been bothering anyone. He was a sort of old beatnik guru, granted celebrity status by his book and film, *Living Free*, which also secured him important grants for the maintenance of his animals. Young researchers, particularly Americans and those of the opposite sex, permanently surrounded him. He would let ten or so lions wander freely around the three worn tents in which he made his home. He spoke to them all evening long and if he wasn't committed to a particular project, compassionately received old lions "brought in sympathy, at the end of their career."

Adamson was murdered at the age of 83, suffering the same fate that befell Dian Fossey. Yann experienced the same disillusions during his time in Kenya. The discovery, for example, that his friend, the Masai director of the reserve where he lived, was implicated in the poaching of the only rhinoceros there, "changed something," he says.

With the benefit of hindsight, Yann is able to show "more understanding for this unpunished act, because you mustn't forget cultural differences and the difficulties facing those living in Africa."

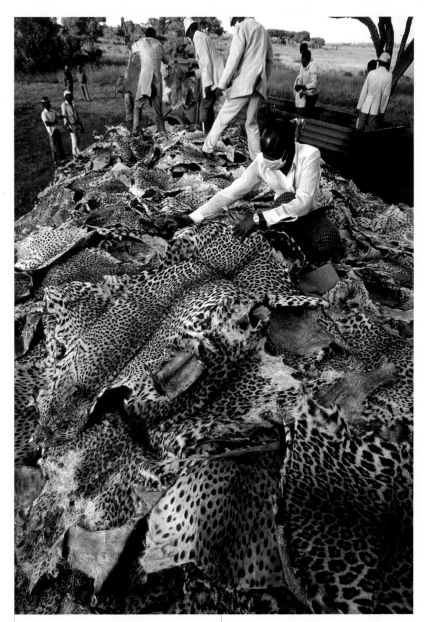

◄ Cheetahs are spectacular, elegant, and fragile creatures that can actually be trained, such as for hunting. They are able to reach speeds of 100 mph, but often find their prey seized by lions as they struggle to regain their breath. Cheetahs have very little defense and are always on the alert. Today, the cheetah has disappeared from many regions and hopes hinge upon those raised in captivity. In the year 2000, the world's cheetahs totaled a mere 12,000.

▲ In 1989, the Kenyan government delivered an unequivocal message to traffickers. Targeting elephant ivory, it ordered confiscated cheetah skins to be burned, an image of great sadness for Yann, who pictured thousands of these animals once alive and felt "a terrible sense of waste."

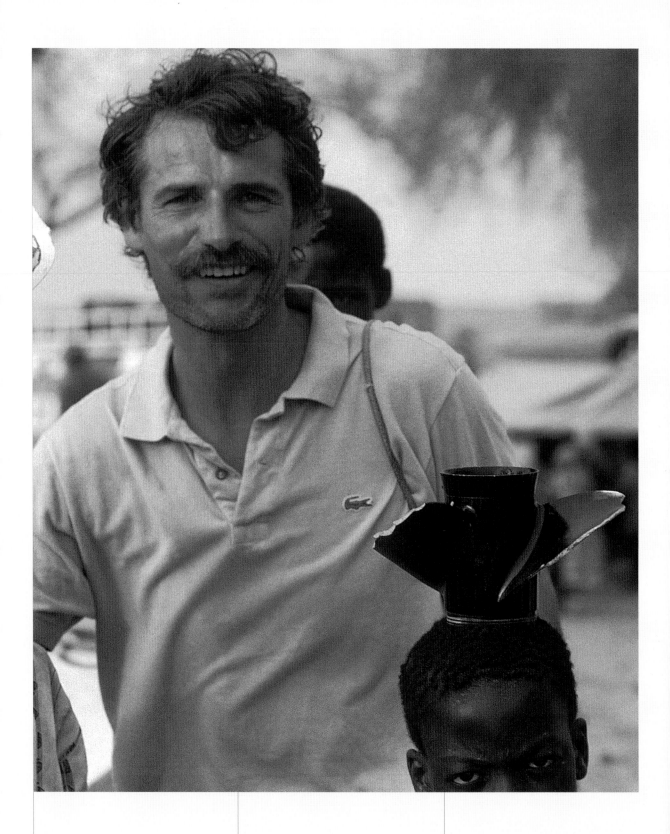

The ten years following Yann's return to France are marked by intense activity. Amid the fervor of the 1980s, Yann, a fervent figure himself, continued with his projects. He made a name for himself with his coverage in Africa, at a volatile time. He had no difficulty making a success of the lions. "Paris was then at the center of the photography world, or so I believed at the time." He didn't delay in joining a coterie of about fifty photographers that kept in regular contact. Yet Yann describes this period today as "a blurry ten-year period of disillusionment." He even goes as far as to label a major part of his work as "mediocre." "Beautiful, successful, genuine photos were so indulgent. They left me with a feeling of emptiness.... Newspapers were on the lookout and photographs went quickly. Everything was selling itself."

Such an affluent period proved an easy time for someone with Yann's character. He remained as demanding, obsessive, energetic, and keen to meet a challenge as before, even if just for the pleasure of accomplishment. Perhaps it was too easy. The effortlessness he experienced led him to assert that: "We need to stop thinking that photography is difficult. Anyone can take a beautiful photograph." The conclusion that photography is within the reach of us all is mistaken, however. Yann is a wholehearted character who, as we have seen, does not trouble himself with subtleties. The straightforward element in this case is the ease with which he integrates himself into unfamiliar territory. "I was well acquainted with travel and wildlife photography, but less versed in the works of Cartier-Bresson, Doisneau, and the others." Yann considers his own success to be unworthy of our interest, because it is simply the result of a natural talent for communication. He is persuasive and determined, he knows when to seize the moment and create opportunities. Despite possessing an outwardly casual appearance, Yann is anything but a dilettante. He loves his work; at worst, it has become a genuine obsession. He continually strives for perfection and his necessity is associated with a constant need to be somewhere else. His demanding nature is not spared on those who work with him, either. His sense of emptiness in those ten years was likely prompted more by his personal dissatisfaction than by displeasure with the

▲ Racing has never really interested me, but the Paris-Dakar rally was a human adventure. It heightened Western awareness of an Africa too often forgotten and neglected. One could rightly argue that the money invested in the rally could have been spent differently, but all things considered, I sincerely believe that Paris-Dakar served Africa.

distribution of his work and its perceived simplicity.

In 1982, Yann covered the Paris-Dakar rally for the first time. Drivers from another African event had spoken to him about the race and invited him to attend. It was only the second time it had been staged. Created by Thierry Sabine, the adventure was a human test of endurance and as much a technical feat as a sporting one. It continued in the tradition of the Citroën Croisières, launched by the famous car manufacturer with La Croisière Noire in 1924–1925 and La Croisière Jaune in 1931–1932. On such a difficult course, logistical aid was reduced to a bare minimum. Competitors needed to bring a healthy dose of courage or oblivion with them to the race. Many had not had access to an official racetrack and made their preparations over months or even years. Some would not hesitate from incurring substantial debts to pursue a dream that

more often than not became a nightmare. The course was physically tough and dangerous, especially for the bikers.

During the final stage, Yann, his face still covered with sand and sweat, witnessed the impressive spectacle of the survivors at camp. "These extremely courageous men persisted in cleaning or repairing their bikes, ready for departure the following day. They could have been benefiting from a little rest. This was the kind of commitment that Sabine sought, the extra effort he always valued. Pushing endurance to the limit created the legend of Dakar."

The race was mythical. It was detached from all controversy, commercial concerns, or intervening dramas, and lacked logistical support. The event left an impression on Yann. It also offered him the challenge of completing the book on Dakar, a rally rarely finished. He would repeat the experience over a period of ten years.

▶ Mano Dayak, hero of the Tuareg rebellion, was forcefully schooled in France and then the United States. A fantastic storyteller, he inspired Yann with a passion for the desert. Thierry Sabine, Mano Dayak, Yann, and two friends planned to clean up the desert after ten years of racing. "It was the year of Thierry's death. We nevertheless played the role of desert scavengers and brought back four trucks of debris."

▶▶ Despite attempts at on the spot repair, this plane is about to join the sand-covered wreckage that Dakar leaves in its wake. When a village is close by, nuts, bolts, and pieces of motor are recovered and recycled. Yann hurries to the scene in the fear that someone will come and leave a footprint in the sand before he can take the photograph.

◀▼ There were only about ten photographers at Paris-Dakar and we would make the same journey as the competitors themselves. In the morning, we left before everybody else and only returned once the last car had passed us. We encountered the same problems that they did—our gearboxes broke, we got lost—and we'd return exhausted. We formed a natural team on the ground and although our agencies were effectively competing, everybody helped one another. I made many lasting friendships in this period. Each day we returned with the injured; some competitors were lost. Our film would depart on stretchers with those being repatriated.

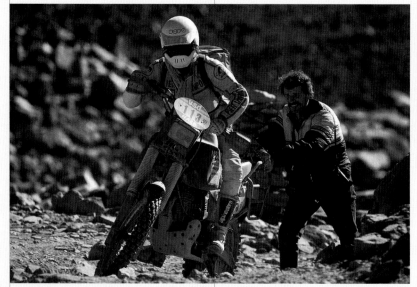

▲ Thierry Sabine instinctively knew how to make a race exciting. That extra something that he strived for, his boundless commitment, made the legend of Dakar. I was in a helicopter every day taking photographs for a book that was released soon after the rally. In 1986, the helicopter crashed. That day, I had given up my seat to Daniel Balavoine. For an entire day, my wife believed me dead.

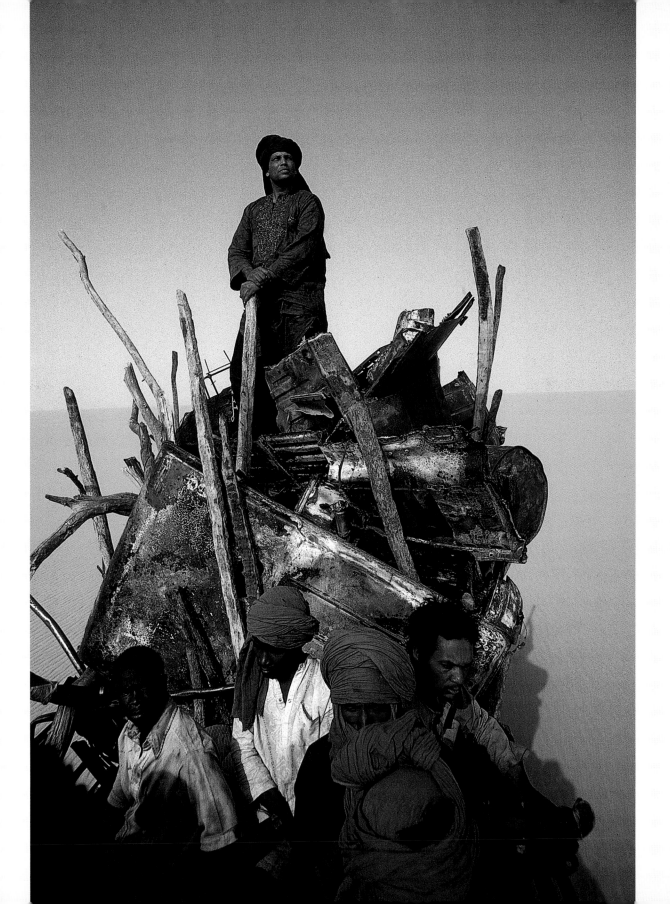

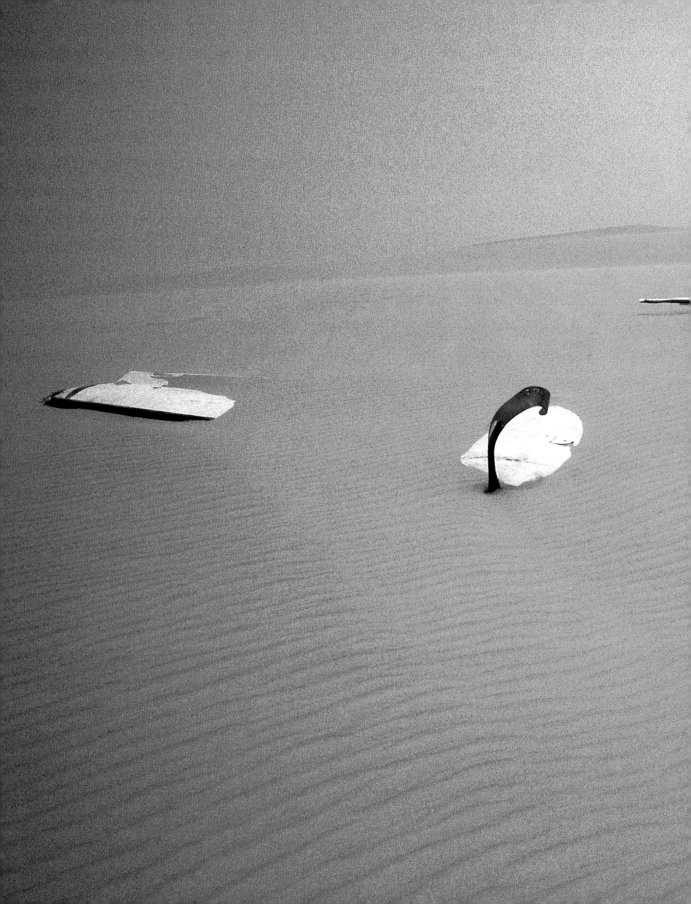

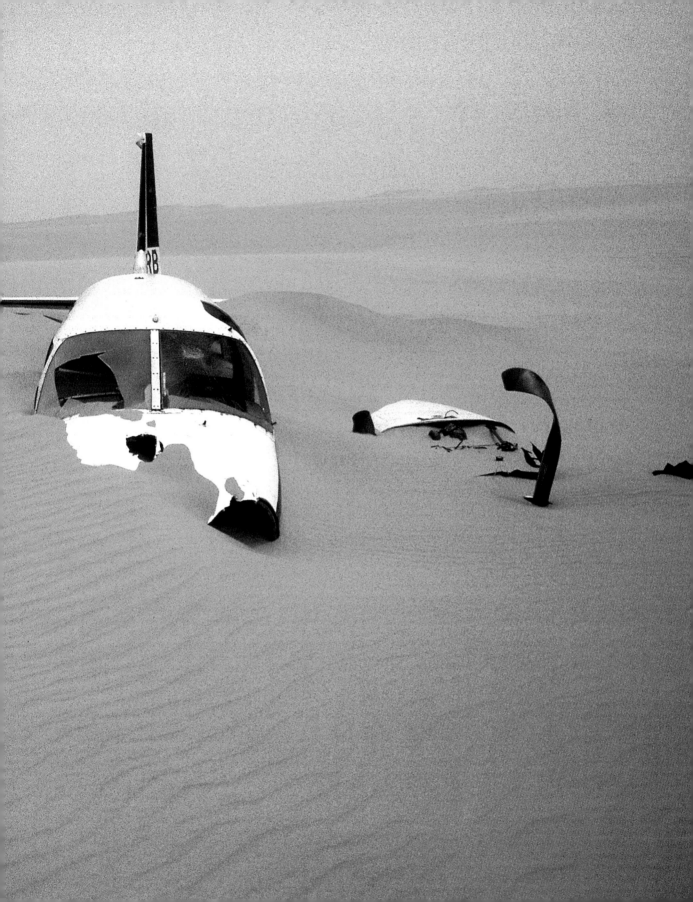

Yann states today: "Photography books like these, produced in fifteen days, barely generate any interest. Urgency did not allow time for reflection. If you missed a good photograph, it was too late. But they accurately record the race and behind the scenes."

Behind the scenes amounts to crossing ten countries in three consecutive weeks. It requires leaving early in the morning before the competitors arrive, so as to reach the site before dawn. The route or routes were mapped out, often through stony gorges, trails of sand dunes, and openings of jagged rocks. And each time, the course might provide a "moment." The last vehicle would pass on its return to camp, preparing to deliver that day's footage, as well its casualties, back to Paris.

"We would leave absolutely shattered." Yann learned a lot from the experience. For the very first time, he faced competition from other colleagues. He was working in extremely difficult conditions, attempting to distinguish his work as much as possible amid the thousands of images produced each day, while concentrating on recording key events in the stages. "There is not a great deal of difference between photographing a motorbike crossing a ford and wild animals hunting in the bush. It is about capturing the moment." Yann applied the same photographic techniques he had employed when documenting the lions. Yet he remains one of the very first photographers to use a powerful telephoto lens and produce inventive new images. He felt at ease in no time at all. Benoît Nacci, responsible for the selection and

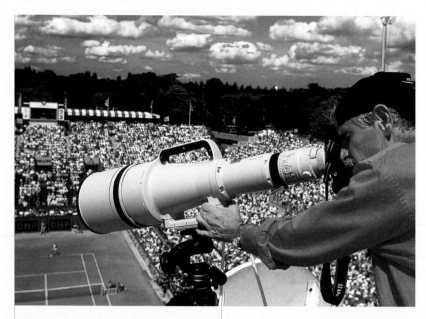

layout of the book, greatly contributed to this feeling. Nacci "always tried to understand my objective with each image. His talent and generosity played an important part in the success of the project."

Yann is someone who has "always loved photographing the landscape." The sight of the cars, motorbikes, and trucks in the midst of the majestic African countryside fascinated him more than the race itself. And he was bringing an original approach to his coverage of Dakar. He was capturing an environment that, in the very way it unfolded, inspired him beyond the spectacle he was supposed to photograph.

At the same time, Yann took to the courts of another well-known sporting contest: the tennis tournament at Roland-Garros. He soon found himself face to face with the real specialists of sports photography. Yet the grueling competition

and ordeal of jostling for space with fifty other photographers in the same row did not discourage him. The formula remained the same as with the rally in Africa, and he worked on the annual production of a book on the French Open.

Yann again offered the competition a novel perspective, armed with his telephoto lens. He knew exactly what he was trying to achieve, and, ultimately, a photograph of Yannick Noah approaching the net commands the same degree of execution as the pursuit of a lion on the hunt. The only difference was that his technique became genuinely innovative within the strict confines of the tennis court.

The photograph of a sporting act in itself suddenly "came alive" through a telephoto lens positioned above the court. "On the red clay, the court appeared as an arena. The tennis players reminded me of gladiators, focused and consumed

by a rage to defeat and 'kill' their opponent. Tennis is a sport of violence and intense solitude." He captured the raging look, the rough gesture of the stroke, and the sigh at the unforced error; all the moments that transmit a more detailed and accurate match perspective. The public, the crowd of spectators, were never actually featured. Other photographers did not hesitate in using the same equipment. Yann was nevertheless tired of the repetition of producing the same book every year. He decided to work alone, while at the same time gathering together twenty of tennis's major photographers.

He devoted himself over the next six years to selecting his photographs and their layout. But he didn't cease there. As we have seen, he is less interested in the image than by the message it conveys and, in this respect, the lines of the courts were soon proving limited. Roland-Garros, for Yann Arthus-Bertrand, is something other than clay, tennis players, or the competition.

And so Yann, with his characteristic independence, concerned himself with exploring the medium of environment. Roland-Garros revealed more than the social gossip columns would have him assume; he would observe the surrounding Boulogne wood and its dubious comings and goings, the merry-go-round of the dump trucks, the empty steps at night time.... Yann's photographs unveil another truth, not without perception. All of a sudden, the detachment of his work demonstrates a subtle subversion through its disruption of conventional code.

◄▼ During his seventeen years at Roland-Garros, Yann signed books as a photographer and then as a publisher. His training distinguishes him from others: he was one of the first to use a telephoto lens, he highlighted the animal side within the tennis players, and introduced close-ups without spectators. "If I had worked for a sports magazine, I could not have covered Roland-Garros from such a perspective. The book allowed me to bring out my own photographs, to attempt to create a style. I often went up on the television crane overhanging the central court and took photographs from above. I had to plan everything beforehand and would remain there uncomfortably for hours."

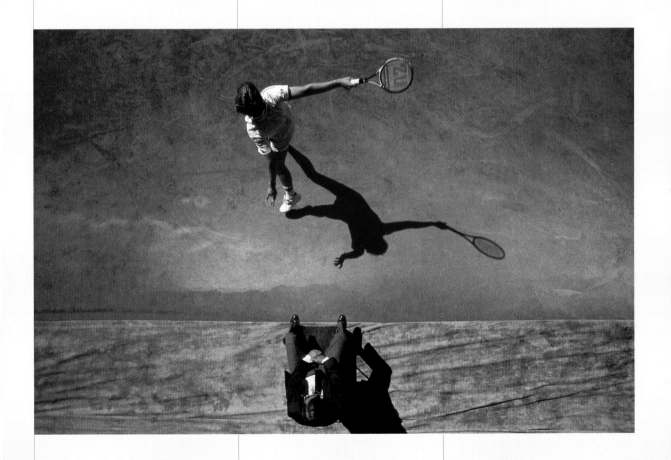

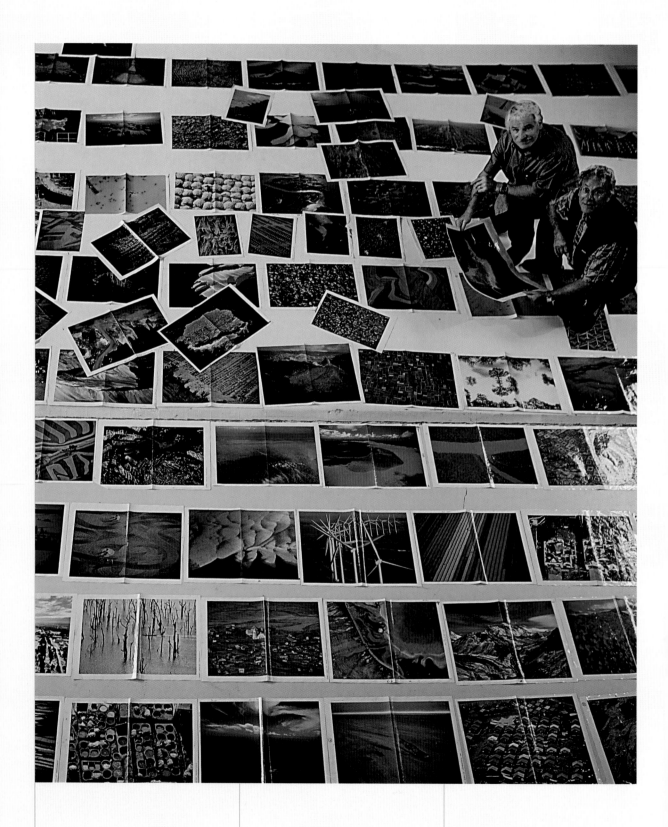

This powerful instinct stems from the unconscious and is one of the factors behind his success. If it sometimes occurs to him to impose it on others, and not without a certain tyranny at times, he is often understood and supported in his demands. The alternative vision Yann brought to Roland-Garros—which he wanted to photograph "like Paris-Dakar"—did not escape Benoît Nacci's attention. A melding of ideas had taken place at the rally, carried on by Yann and an artistic director "who knew what he was seeing." The complicity they shared enabled him to enhance and expose the originality of Yann's work. Time was another factor; not least so a book could take shape. Yann needed time to find his way. He had spent eleven years at Paris-Dakar, seventeen years at Roland-Garros, and three years in Venice. His work defined itself in its longevity and inevitably with a certain element of repetition. Books existed as his means to attaining permanence. They were the lasting extension of a momentary snapshot. But Yann required time to establish effective ties with those around him if he was to progress further.

Yann is acutely aware of the role and importance of others in his work. He requires his team around him and cannot imagine his profession or success without them. "I am not a solitary person. I need other energies besides mine to carry out my projects. It is extremely rewarding." It is with heartfelt gratitude—"I owe them such a great deal"—that he speaks of the "two Françoises," the pillars of his agency with whom he "made everything."

He professes the same gratitude to all those who have lent him their support, whether near or afar. However, when teamwork is no longer there, relations break down. This was the way the adventure at Roland-Garros ended.

◄ Benoît Nacci has been the artistic director for many of my books. He is aware of how best to assist and understand photographers. A lot of us wanted to work with him. He would immediately understand the sense of a photograph and what you were trying to accomplish, while developing an easy feeling of complicity and friendship. This is so important. Here, we are producing a layout for the *Earth From Above*. After many attempts at classifying the images, we decided to intuitively arrange the pictures according to contrasts in color and geometry.

▼ After some years making the Roland-Garros book, I was going round in circles. I had seen impressive photographs by other people and decided to publish my own along with those of the tournament's twenty best sports photographers. We were afforded a lot of freedom making the book. The ability to select and properly present a good photo constitutes an important part of the profession, whether my photos or someone else's.

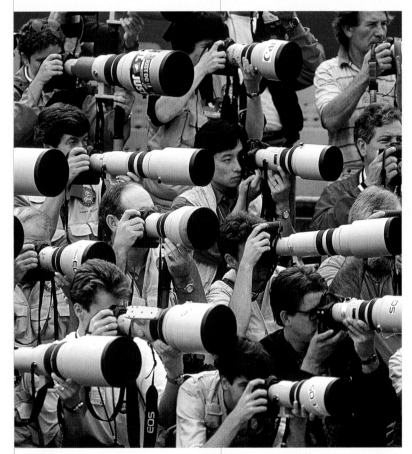

"The only thing the organizers paid attention to was the people page, where we had to show the President with his guests. The work of the photographers was neither recognized nor particularly considered."

One could rightly question whether his report on the Papuans of New Guinea in 1987, commissioned by *Lui* magazine, is not displaying signs of the same attitude, in its insignificance or even pointlessness. The magazine's chief editor wished for him to produce a piece on fashion "in the sort of spirit he enjoyed." He suggested that Yann locate and photograph the Masai tribe wearing swimwear.

Yann found this a stupid idea. "It was idiotic but he stuck to his decision." When he had run out of arguments for the idea, Éric Colmet Daage, the chief editor of *Photo*, was passing and called out, "Well, you only have to go to New Guinea and find the Papuans!" Yann found the idea just as baffling, but accepted anyway. "I had never actually set foot in New Guinea but told myself that as models are paid a lot of money producing fashion photos, we could at least reward the Papuans adequately for the same work. We left in a party of four: a cameraman, a stylist, my assistant, and myself. The missionaries there had already

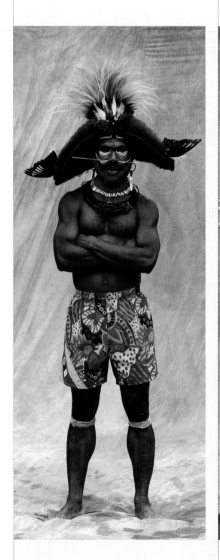

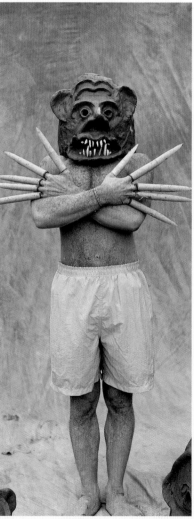

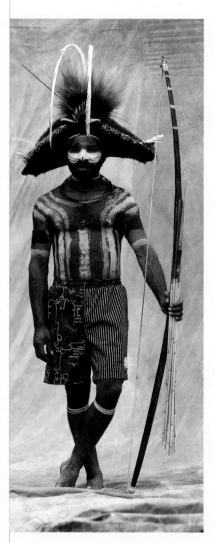

warned us on the telephone that photographing the Papuans was out of the question! Leave them alone, you will steal their soul."

"All the same, we were informed that a village existed where tourists were welcomed once a month. We went there just in case. Having made initial contact and explained ourselves, we were given a warm reception and the Papuans happily agreed to take part in a photography session. Using a canvas to create a sort of studio, we began taking photographs of the group 'au naturel,' wearing loincloths made of leaves, penis cases, and feathered headdresses. But as the moment arrived to photograph them in swim shorts, I honestly asked myself what I was doing there...." However, Yann is not the kind of person to dwell on his doubts, and as it happened, the spontaneous enthusiasm of the Papuans swept aside any further hesitations he may have had. "They threw on the shorts over their native dress without a thought for their waist size. Each chose his preferred design. Our attempts to distribute them according to build were futile; they wouldn't listen. We had to trim the leaves that were showing out-side the shorts. Finally, rather than appearing ridiculous, they carried them off very well."

After returning to France, the feature, supplemented by a short film, received a prize for fashion photography. "All the same, we received a good telling off from the sponsor for not returning the shorts!" adds Yann. Anecdote aside, the story is intriguing because it reveals the type of features magazines were publishing at that time. They had to

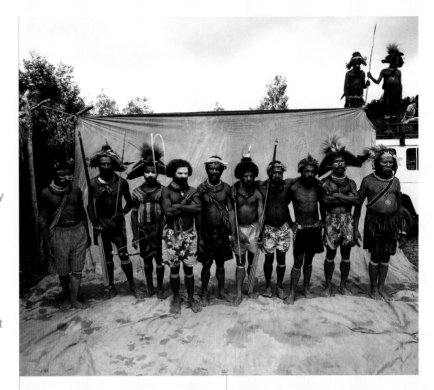

be light, trivial, amusing, and commercial, not without technical complexity but globally acceptable and certainly with strong potential for financial reward. While Yann produced this sort of commission without too much complaint, his motivations for doing so remain neither trivial nor financial. There is no doubt that it earned him a generous amount of money, and a lot of fun was had in the process. But again, the feature offered him a challenge; it was something com-pletely unconventional. New Guinea is poles apart from France, as much geographically as it is ethnically. Photographing the Papuans in swimwear is an absurd idea, comical and ludicrous, and something diametrically opposed to everything Yann had produced up till now. But

what it does show is a conviction strong enough to overlook the inconsistencies. It would be ill conceived to derive an air of frivolity behind his action. Yann Arthus-Bertrand is never quite where one might think to place him. Ultimately, he does not care for convention.

▲◀ The idea of transforming Papuans into models for *Lui* magazine seemed interesting in Paris and ridiculous when we got there. I had come across the Papuans through portraits by Malcolm Kirk and didn't think twice when it was suggested I go there. But I would not accept this kind of commission today. That day, after a three-hour walk, we were met by the chief of the village and I was accusingly told: "You promised me a photo." What on earth was he referring to! I then noticed a poster from an exhibition on his shelf—"The Papuans are in Paris." I had taken this man's portrait five years previously. Since then, I've never forgotten to send someone a photo I'd promised.

This same alternative vision with its sometimes-baffling perspective, confronted the prestigious *National Geographic* magazine on reviewing his Tour de France photographs. In 1989, the publication was anxious to mark the bicentenary of the French Revolution with a special edition. Yann was among the few photographers sounded out and offered to produce a project on the Tour; the editors considered him a sports photographer.

"I had never experienced such exceptional facilities before; a wealth of film, motor home, helicopter, and most excitingly, a press motorcycle. It represented a position of real gold in the race as the one person who could stay in touch with the competitors at the front or to the rear." He remembers: "In the morning, at the beginning of the stage, they would start stretching their legs, pedaling for miles without holding the handlebars, and you could hear them talking as if in a coffee shop. They shared views on women, their kids, the washing machine recently bought for the wife. Suddenly the pace would quicken and the talk became less amusing…. Attacks and breakaways, crashes, mountain climbs, the sun, wind, rain, hunger, fatigue, weariness, and emergencies as severe as competitors forced to urinate through their cycling shorts, all combined to create a quite incredible test of endurance.

"I worked like a madman, averaging several rolls of film per day. But I managed to get it all wrong despite the logistics they afforded me." Having been sent to cover the race, Yann returned with a collection of photographs focusing on the spectators. "I was more interested in the French passersby watching the Tour. They would sit in the shadow of their parasols;

▲▼► Working for the legendary *National Geographic* magazine was an exceptional opportunity. In 1989, they pulled out all the stops to produce a feature on the Tour de France, including an abundance of film, motor home, helicopter, and press motorcycle. "I remained a travel photo-grapher; sport in itself didn't interest me. I accordingly produced my own images. I wanted to present other aspects of the Tour, such as the many thousands of spectators lining the roads. But the *National Geographic* had my sports photography in mind. As I hadn't fulfilled my contract, they didn't call me again."

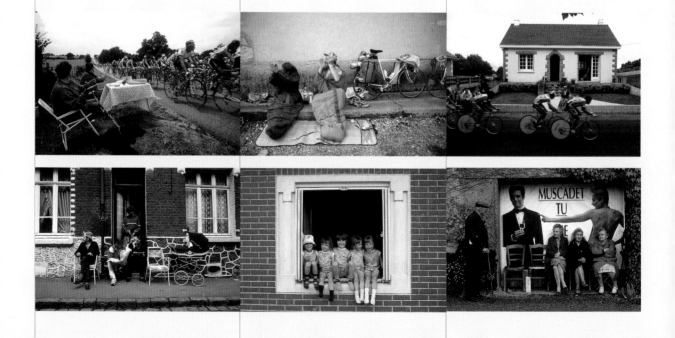

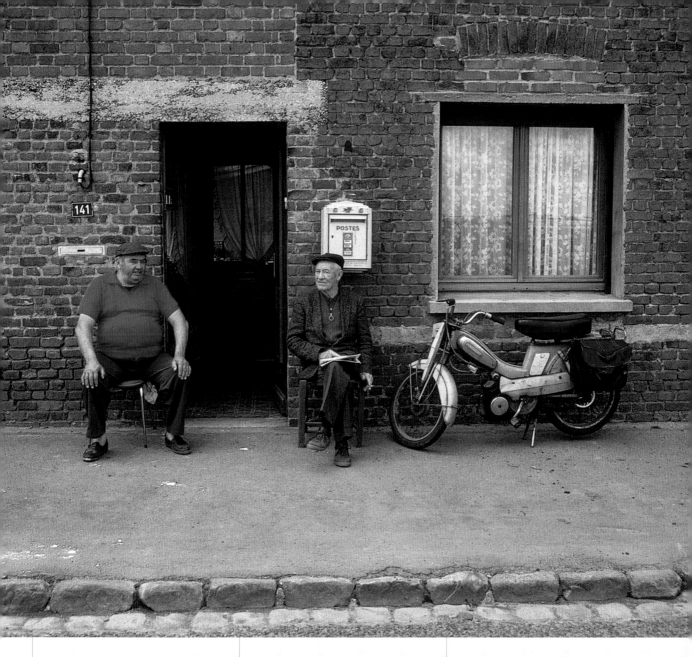

Pernod caps perched on their heads, sausage and a bottle of red on the camping table. However, the magazine esteemed sport, racing, and this great tarmac showpiece above all else." In the eyes of those responsible for the publication, Yann had not fulfilled his contract. "I was well aware of having produced something different, but I was sure that my photographs would convince them." It is interesting to imagine what may have been achieved had this innocent mistake not been made. The magazine still remains a point of reference for many photographers today. With a hundred years of history, boasting considerable resources and with extremely tough working practices, the magazine commands a prestige that exceeds all else.

While he should have concentrated on producing ten or so photographs of an unquestionable standard, Yann took too many. "At the end of the day, they still published four of my photographs! They were not to my taste but very much to the *National Geographic*'s." Nevertheless,

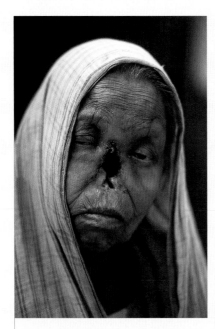

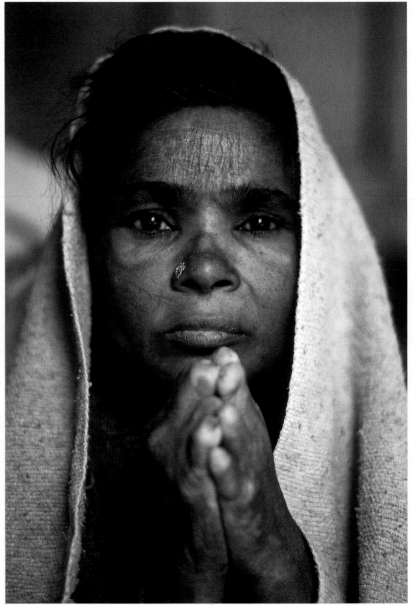

Yann was able to derive a conviction from the experience; he is someone not suited to commissioned work.

When the fundamentals for a photograph are there before his gaze, nothing else is required. This is clear from the images he took of leprosy sufferers at Ahmedabad, in Gujarat, India. There is no need for distance here either; Yann is taking frontal shots of the patients. The reality of the situation grasps us in the same way it grasps the photographer. "The question is how to consider photography and the targets we set in our own lives." *Le Figaro Magazine* agreed to publish the piece. With it, Yann marked his initial training in photojournalism.

He was at the clinic, which was run by two French nuns, when, for the first time, he witnessed a patient die. "One of the two Sisters held his hand and kissed it tenderly. He struggled for breath and passed

▲ In Ahmedabad, India, Yann photographed secluded lepers under the daily care of two French nuns. For the very first time, he witnessed a man dying in the arms of a nun who kissed and helped him pass away. During this moment, he refused to photograph what he observed through his viewfinder. "I felt that the click would have been displaced. Perhaps it would be different today, but at that moment, I didn't want to take a photograph."

▶ While working on a book entitled *One Day in the Life of Vietnam* I needed to fly. As flight clearance was not immediately forthcoming, I asked if I could photograph a childbirth. I didn't use flash so as not to disturb the women. The photos are what I saw: a moment of intense pain in the blood, sweat, and tears, but in the next, an image of beauty to extinguish all else. I would have loved to make a film of it.

away. The Sister helped him through these moments with words and gestures of an infinite tenderness. I knew that this was the end; that this man was about to die before me. Emotions were intense on account of the nun's immense compassion, indifferent to the sight of the maimed face, and also because life was leaving the patient's body forever, just like that. I emerged a changed person after this experience." Death fascinates many photographers. The great human question as to the meaning of life takes on a particular relevance during such moments. The tool they serve provides the means of capturing and suspending an expression of life. It creates the illusion—when committed in this way—of being able to discover something of death's truth, at the heart of a moment frozen in time.

Yann has "an immense fascination for crucial events in human existence, such as these." When stranded in Hanoi due to bad weather, he produced a feature on childbirth. "I was present in the labor room at a small and dubiously clean maternity hospital for three days. I witnessed women patiently waiting until a bed became available. Families would remain outside, yelling to be given news. Inside, some of these prospective mothers cried constantly, others would begin to moan when labor began. I was incredibly impressed by the strength and courage of these women, and by the violence of such intense moments of pain, forgotten with tomorrow. At a crucial moment during one of these births, the physician, already holding the top of the baby's head between his fingers, turned toward me and asked: 'Do you know whether that

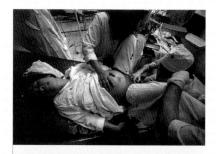

little Parisian restaurant in the rue du Dragon still exists?' With the delivery imminent, the woman screamed and then calmly shared with me her memories from school! I had always dreamed of photographing a childbirth, but found my expectations pale when confronted with the sheer violence and emotion experienced in this maternity ward." He adds: "Even though I felt anonymous behind my camera, I did not feel at all comfortable. I couldn't shake off the unpleasant notion that I was some kind of voyeur." Endowed with this sensitivity, Yann is extremely conscious of the insurmountable mystery governing our lives. He is fascinated by it.

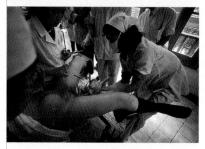

But unlike others, Yann is responding to a need to construct something from this mystery, rather than offering any particular response to it. He remains on the threshold of this reasoning. He is more interested in questions of how than in matters of why, forever unanswered and the subject of infinite speculation.

Once again, the positive aspect of his personality turned toward the physical, and he broached topics such as dissection and anatomical waxworks. When the paths of philosophy are hazardous, science can offer precise answers. Where truth remains remote from understanding, photographing naked bodies, chafed and lifeless, afforded him the opportunity to contemplate his own inescapable reality.

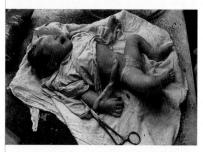

It is an approach that reflects the scientific process he admires. In the light of his work on lions, he makes an extraordinary confession: "I would have preferred to have been regarded as a scientist and not a photog-

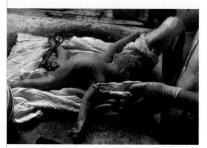

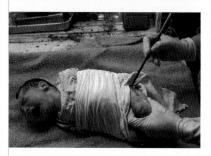

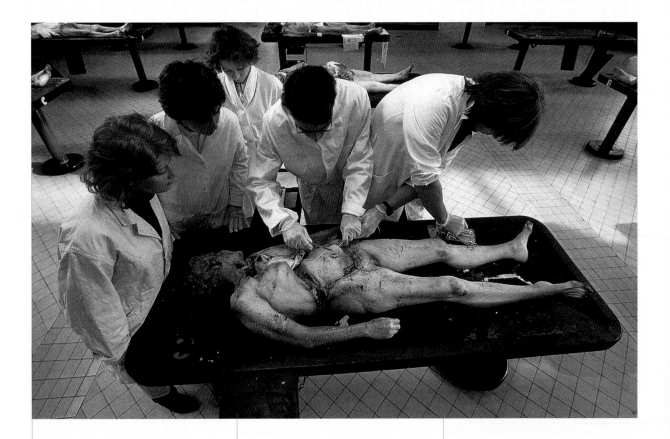

rapher." His reference here is to George Schiller, a scientist and photographer of enormous repute. "Being a photographer is about penetrating to the depths of things. Understanding inevitably requires questioning one's own commitments. How should we make the most of the life that is given to us? I produced work on certain areas (anatomy, dissections, and childbirth) because I wanted to be closer to this aspect of life." Suffering is a different thing entirely. Unlike death, it can be resisted, assuaged and even defeated. And it is precisely for this reason that it can awaken revolt. "Suffering is unbearable. We must fight it at all cost. I am not just talking about people dying of starvation or sick children. I find it beyond comprehension that a normal person could knowingly suffer."

When informed by Allain Bougrain-Dubourg of a laboratory in Japan that was testing drugs on animals, Yann set off to expose the lab in an effort to relieve their suffering. Having entered the laboratory by night, he recorded images of monkeys that had been atrociously treated. *Géo Magazine* subsequently published the photos and the laboratory was closed down. This sort of exposé conveys the concerns and philosophy of the photographer. He denounces injustice to the extent where he is incapable of doing otherwise. Reason without action means nothing to him, just as photographs without captions are devoid of value or interest. Yann's commitment reveals him to be a man of action, and he defines himself by results.

Once an objective has been set, Yann wastes no time in achieving it. "Even after 25 years of experience, there are still times when I mess up a photograph. In such instances, I make everybody come back and we redo it until I get what I want. I refuse to accept failure. It is not serious to be bad at something, but it is to just give up." As an idealist, Yann is sensitive and loves his independence. He chooses projects according to the occasion and his own desires, and he sees them through until the end.

▲▼► Photography enables me to move in many different fields. I had always been fascinated by the body—medicine and death— and worked for one month on dissections and the anatomy. In no time at all, I had lost my enthusiasm; when life is no longer there the body appears just like any other machine. In life, we are all different. I had begun by photographing anatomical waxworks in Vienna and then collections displaying venereal diseases. They were presented in black, surrealist boxes. I was pleased as the subject matter proved impossible to publish!

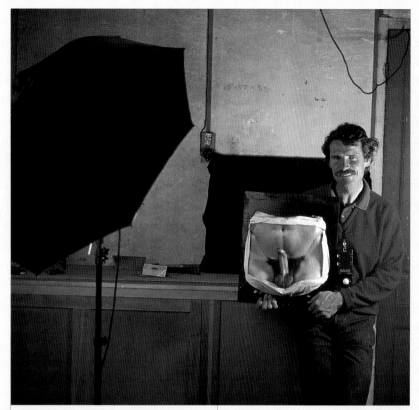

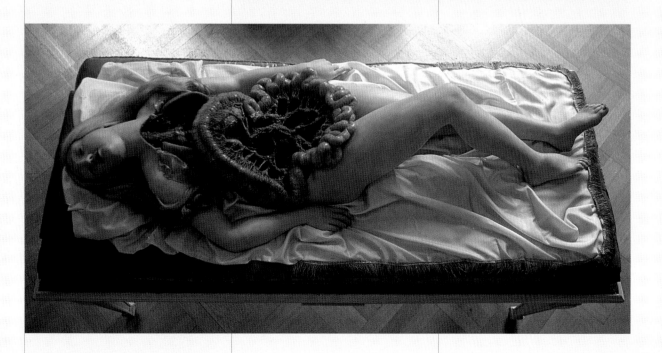

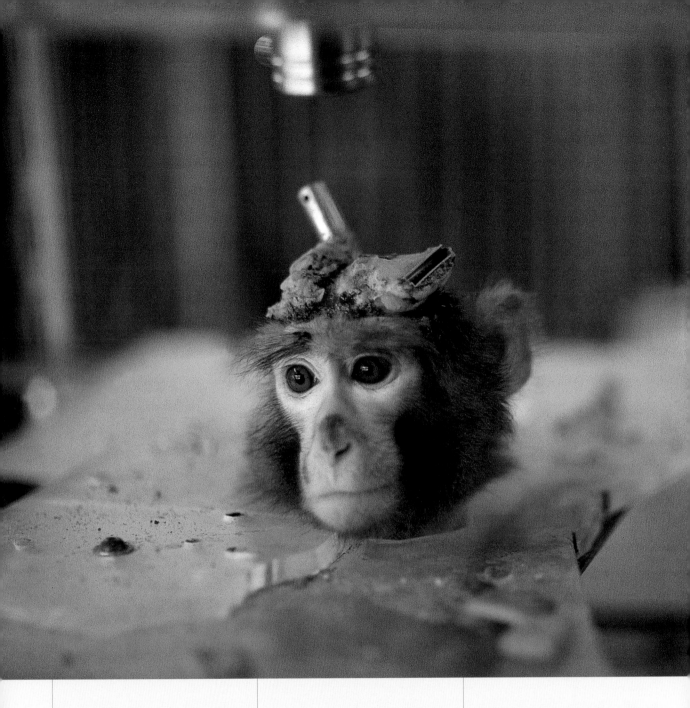

▲ I was contacted to denounce experiments being conducted on animals in a laboratory in Japan. Under the cover of darkness, I took photographs there for three hours. *Géo* made it the subject of a featured story and the laboratory closed down. Today, we carry out a lot of AIDS testing on chimps. Inevitably it must be done even if it forms a part of life no one ever wants to see. It would be far better to reveal such practices so that everything is controlled and out in the open. Those scientists are not ashamed of what they are doing and will explain why such actions are necessary, even if the general public is not necessarily in agreement. These activities must be legitimized and should be photographed in broad daylight. To conduct them behind closed doors just paves the way for abuses.

▶ Not far from the laboratory, wild monkeys from the far north bathe in a snow-covered hot spring north of Honshu Island.

98

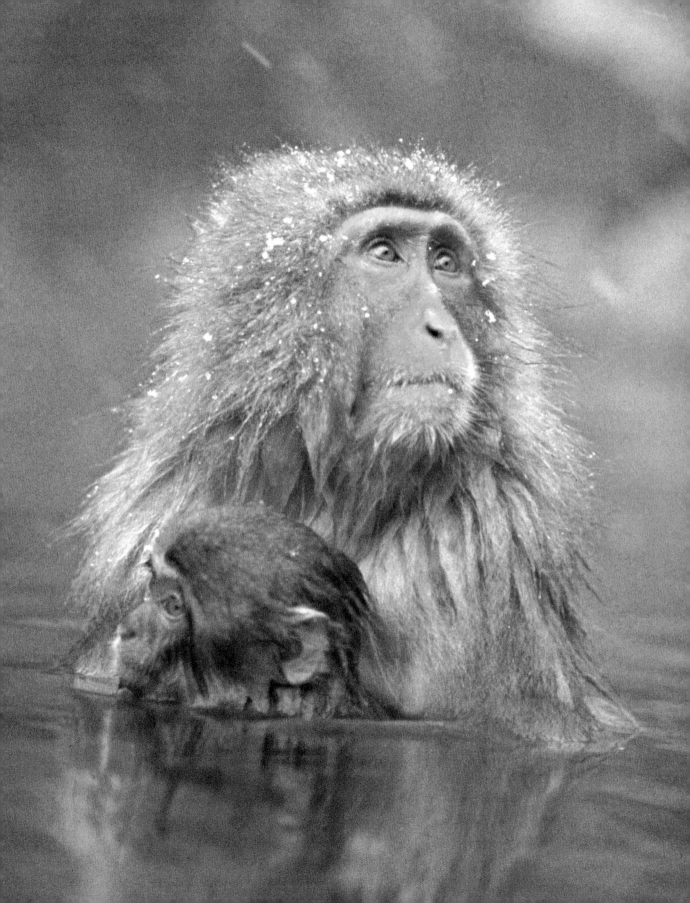

While making these incursions into more sensitive domains, Yann continued to devote his time to the animal kingdom, and it was during this period that he produced a book on deer. He had come across deer, members of the Cervidae family, during his time at the Saint-Augustin reserve, where he would sometimes have to hunt them. Although he gained no pleasure or glory from the hunt, it gave him the opportunity to observe and learn more about them. The passion he has for these animals—"the biggest in Europe"—resulted in a tour of the world to photograph them. He tracked them from England to Scotland, Austria to Denmark, even as far as New Zealand. But contrary to some wildlife photographers who opt to remain on the lookout for hours or even days, during which they hide themselves under nets, behind screens, or perched in trees, Yann prefers above all else to "approach the animals from just a few paces, to be at their level, capture their expressions, and openly record their behavior without stealth.

"The idea that an interesting animal is one that flees the approach of man is idiotic. I prefer to see animals reposing in their environment, rather than a backside taking off because I have frightened it!" The

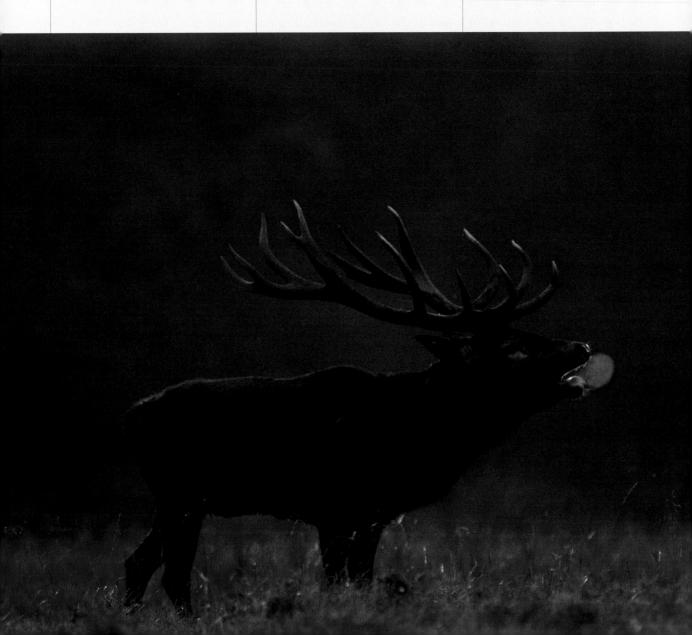

park adjoining the city of Copenhagen best affords him this harmony. As with the Bois de Boulogne, the park is a popular location for walkers and also accommodates golfers. "Amid the golfers, cyclists, joggers, and unruly children, the deer were there, serene and majestic. They were so accustomed to this hustle and bustle that my camera must have appeared unusual and they fled. I came up with the idea of hiring a golf cart.

And so, equipped in this way, they no longer took any notice of my presence!"

With his book on deer, Yann resumed one of his fundamental themes, that is, the bond that unites man with nature through the animal kingdom. The deer granted him the position of a "privileged witness," and through their proximity he experienced some of his strongest emotions as a photographer.

◄▼ I had the opportunity to produce an extensive study on deer, photographing them at different stages of their development, as is customary in the context of such books. It was also a way for me to experience wildlife photography in Europe.

►► Deer antlers grow back every summer and are covered by a velvet skin that dries and flakes off.

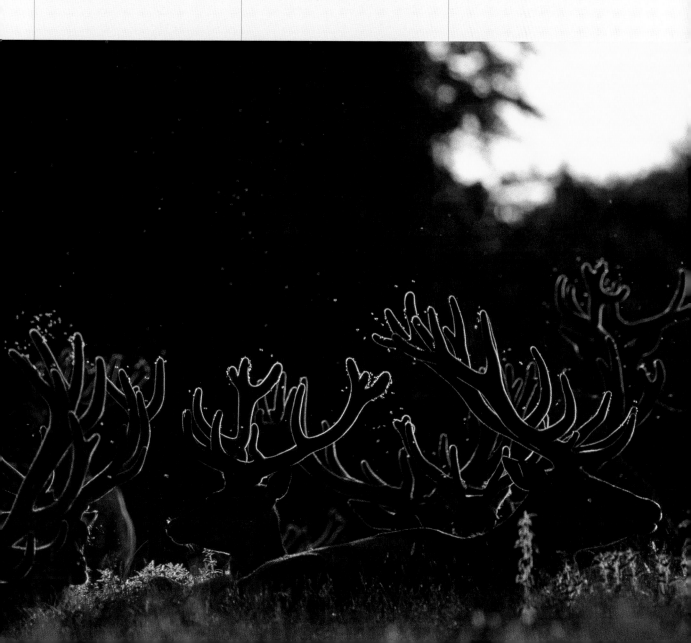

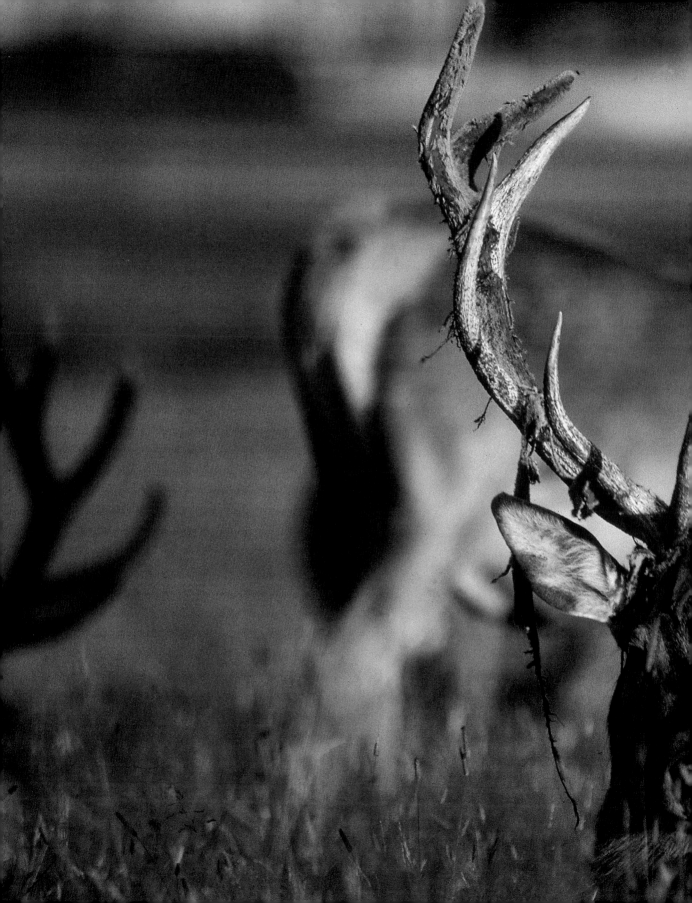

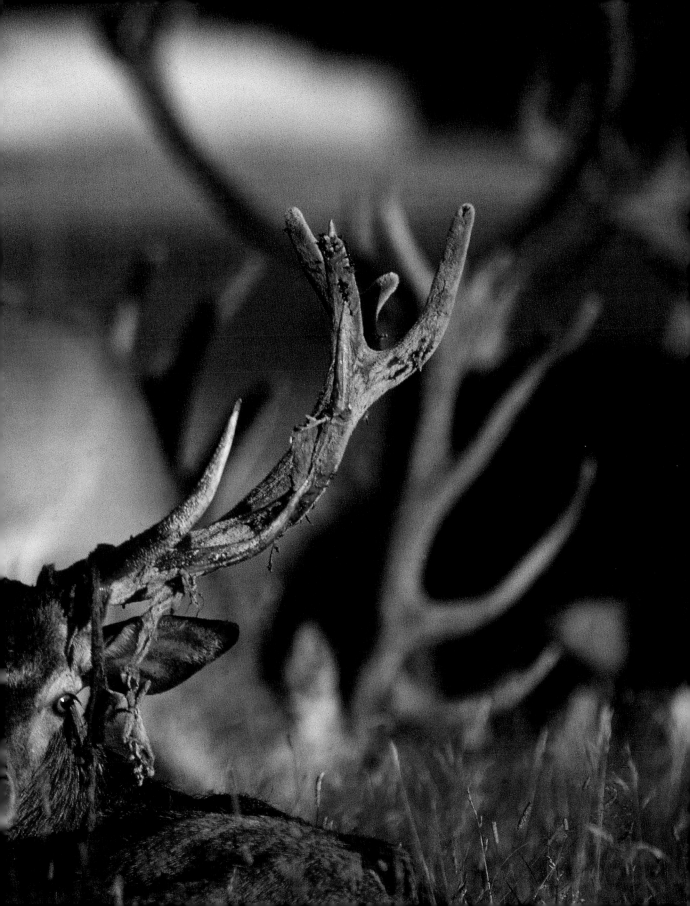

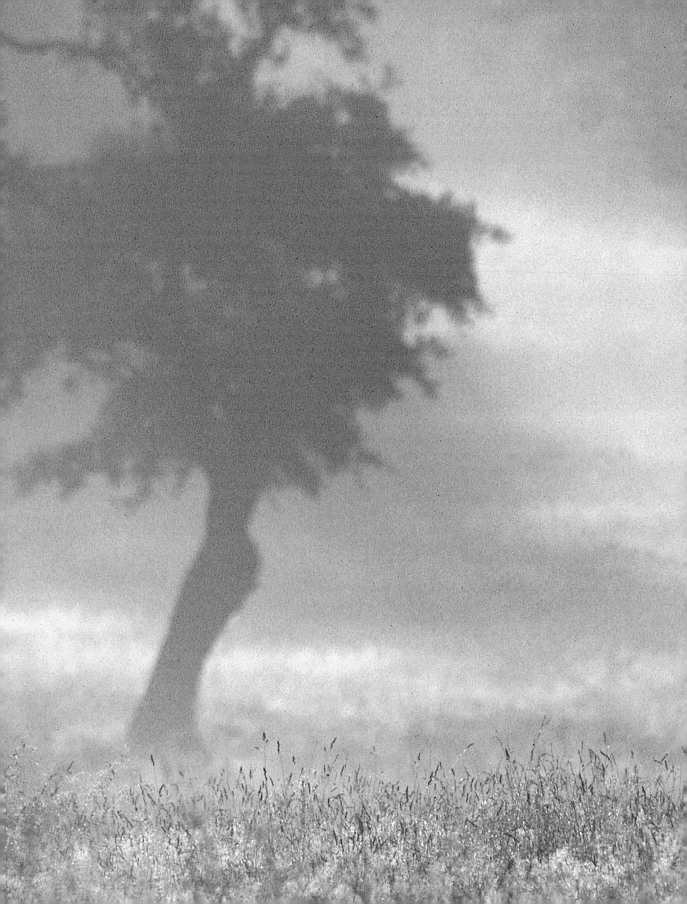

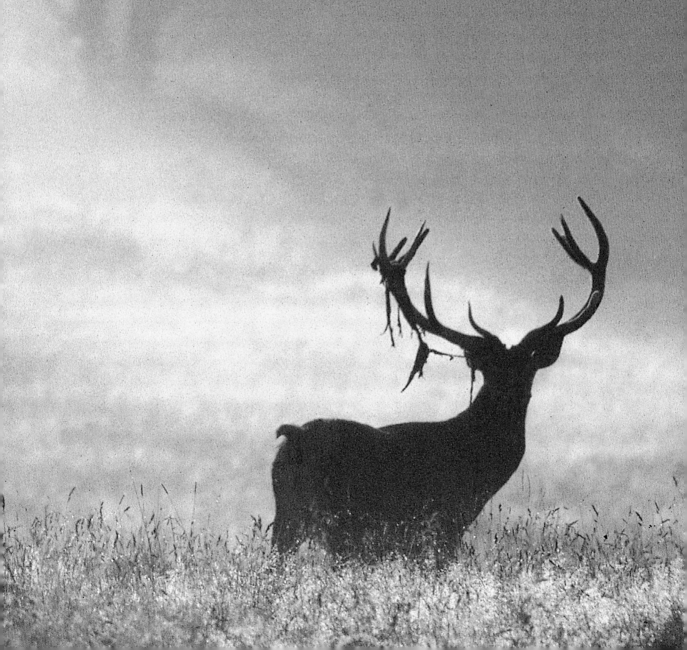

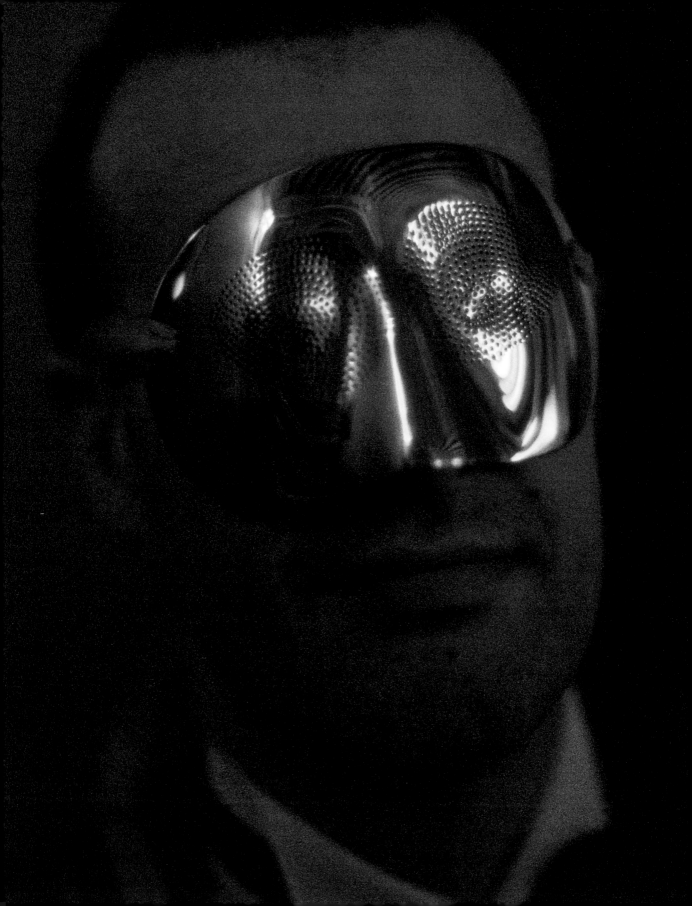

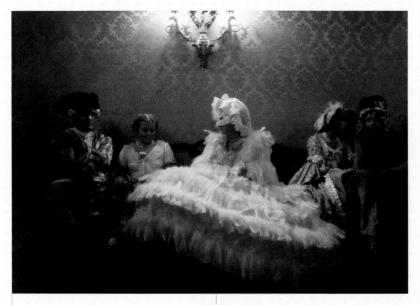

◄ When I photographed the Venice carnival, I was experimenting with nocturnal pictures. I hate using flash in reportage; the light is difficult to control and the effect is not always consistent with what you are actually seeing. Digital cameras have changed all that. Here I was working with some of the first ultra sensitive films, which, with the lens set on a very large aperture, enable the production of color images at night. It was very innovative.

Venice is one of my favorite cities. Without cars and surrounded by water, the city takes on a whole new dimension. Its boundaries are very clearly defined. New York shares this same characteristic. In aerial photography, such cities are particularly detailed.

His book on Venice, however, reveals a completely different approach. "The city invites photography. You can go to Venice for a day and an idea will stick." Yann could not ignore the potential pitfalls of yet another book on the city of Doges. Despite all the warnings, he followed his instincts and went there at the height of carnival. "It is an occasion where man dresses up to deceive others, and can be deceived himself." The Venetians disguise themselves and for several hours walk along the alleys and besiege the coffee shops in Saint Mark's Place, they gather together to celebrate in the palaces, or appear fleetingly behind colonnades, all with their unique sense of celebration and eccentricity. At night, the atmosphere is particularly magical. Yann notes, though, that he had some reservations in covering the carnival; it is an occasion encouraged by the township for obvious economic reasons and it rapidly bears the mark of an overblown celebration.

Nevertheless, he returned there over a succession of three years. The event enabled him to experiment with new and sensitive film, working specifically at night without a flash. "I cannot stand working with flash. To my mind, it kills the image, whether day or night." For the very first time, he adopted the role of a "street photographer" with an unanticipated enjoyment. Armed with his camera, Yann paced the streets alone, looking for photographs. Everything there contributed to the sense of euphoria and exhilaration he experienced in photographing the spectacle. Yann is a photographer of reality, in love with the here and now. Yet he confesses to have "delighted in" taking these photographic shots amid such fancy dress, pretense, and trickery.

With hindsight, Yann attributes these years to over-diversifying his work. This is more the result of a progression "guided by diversion" than by repercussions from an obsessive period of production. His photographic achievements also reflect an aspect or even pitfall within the photographic profession. "Photographers are prompted to travel in the constant pursuit of new ideas. They can go anywhere, achieve anything, and finally lose their way." Beyond the distinction, the framework of his own career is firmly established. Yann has certainly benefited "from having the means to do it." But he is also someone who, guided by convictions, trusts his instinct. He is incapable of working on a project that does not interest him. And he refuses to carry out promotional photography if the manner in which the photographs are used in advertising campaigns is objectionable to him.

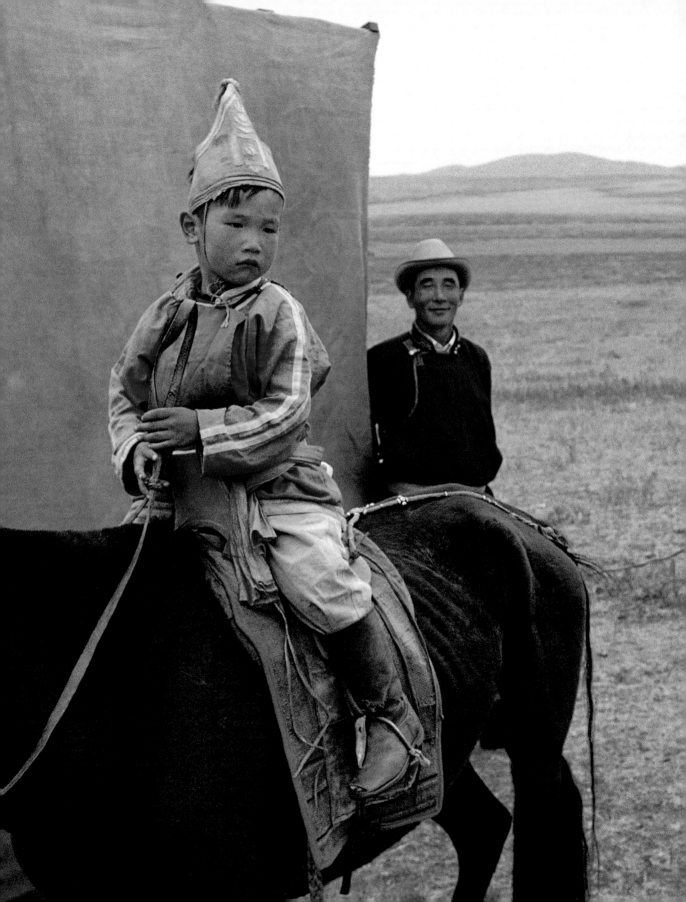

Photography on Canvas

After the first Agricultural Show in Paris, brown canvas became associated with my portraits. I feel at home with this background and wouldn't wish to work any differently. In hindsight, I realize that it unites the scene. I have worked with it for fifteen years and although there have been times when I have felt restricted, I have never found anything better. Taking photographs outdoors with the canvas requires the sort of lighting that comes specifically on overcast days or at sunset. The light from the flash must be stronger than any surrounding light.

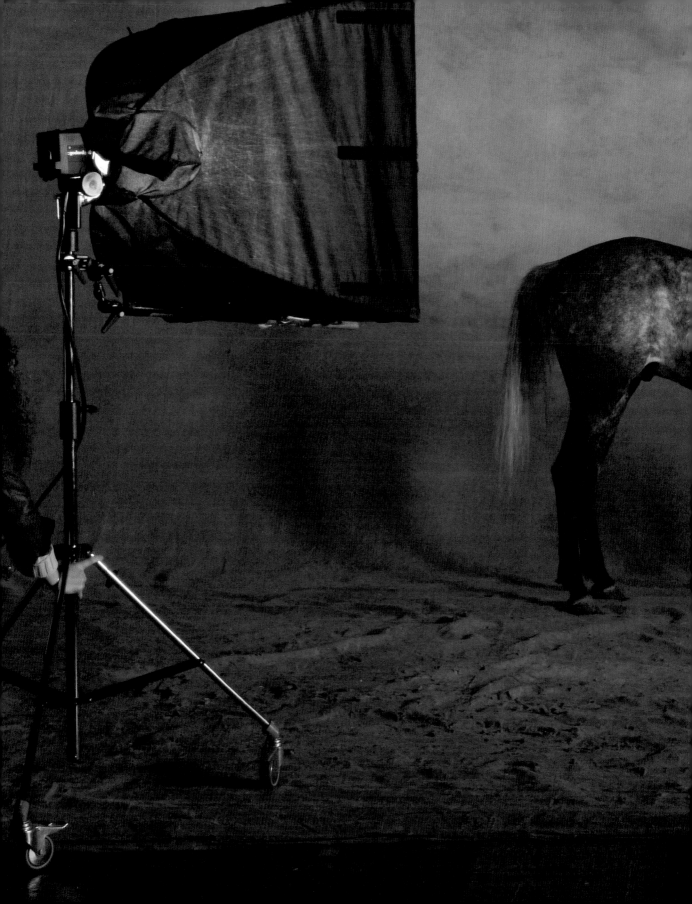

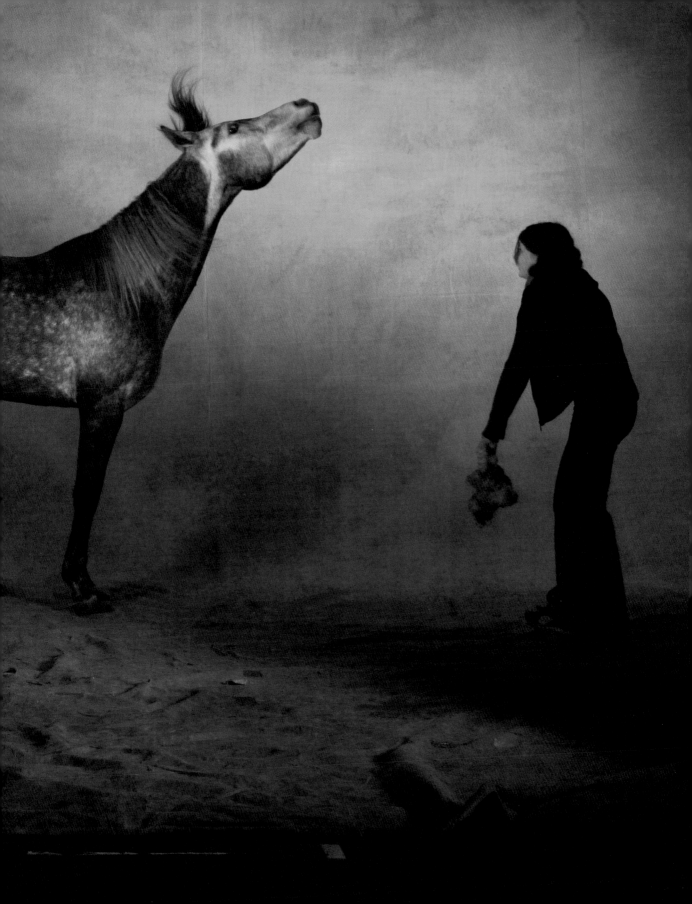

The "magical, easy" side of photography has led Yann to all four corners of the world, "meeting a great many passionate people." Yet, having exhausted all that it had to offer, Yann suffered doubts. "Being a photographer is not at all complicated. The difficulty is constructing something out of its simplicity." And so he attempted to continue with themes closer to his heart. His

photographs of French citizens or cattle at the Agricultural Show enabled him to redefine his work and pursue a path he deemed "instructive." It was in passing by the doors of the show that the idea of photographing animals first came to him. The organizers initially rejected his advances; they already had an accredited photographer. But they were mistaken about what he wanted, suspecting him of nothing more than commercial intent. This was a perfect occasion for Yann to employ his considerable powers of persuasion to help them overcome their reluctance. Within a year of negotiation, the misunderstanding dissipated and the organizers provided him with a space to set up his camera equipment.

Today, the studio represents a rite of passage for the French breeders vying to appear before his lens. The project appeared to have nothing novel about it at the onset; who on earth would be interested in the kind of book he was contemplating? Yet Yann knew he had uncovered "a

niche." The canvas that originally appeared in New Guinea with the Papuans discovered its importance once again. The hessian cloth, slippery to the touch, is frequently painted upon and has been employed by artists such as Nadar, giving his photographs a literal and metaphorical context. It is within "the considerable substance" of this context—solid, authentic, and concrete—that Yann positions himself. He belongs to a photographic tradition, and his methods have left their mark.

"We are all the sons or grandsons of farmers. Our roots exist in the earth cultivated by our ancestors." Yann confesses instinctively, "to love farmers." It is a sincere and significant admission because "these people perform a difficult profession while remaining close to nature and the animal world. They have extremely tender relationships with animals." The bond between man and nature is something that moves and fascinates him, as we have already seen. He continually

▲ Françoise Jacquot has helped Yann since his studio began. "Here we are outside checking the little Normann flashes. It is difficult to locate problems: we take photos from afar, we are partly in natural light.... But there is no divine right over wrong; if a breakdown occurs, it is only on development back in Paris that we become aware of it."

▶ "If an animal makes a mess on the canvas, it takes over half an hour to clean it up. The bucket proved to be a good test for the assistants. When an assistant takes it without a second's thought, therefore anticipating the slightest problem, it is because he or she wants to produce the photograph as much as Yann. This has to be there from the beginning or it just doesn't work," recounts Françoise, here with the bucket.

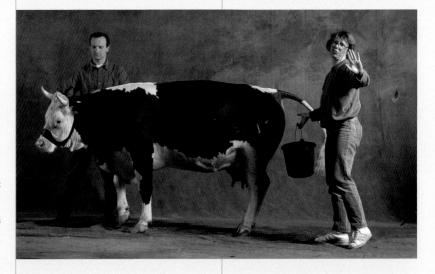

draws inspiration from it, which explains why the initial idea of photographing the animals by themselves was quickly dropped. "The cow called for the farmer," and Yann photographed them together. The success of these innovative portraits resides beyond the production process and in the ancestral bond evoked. Today, these ties are almost old-fashioned. They were established with animals in order that man could survive in his natural environment. It was important for Yann to capture and immortalize these last remaining ties, at the risk of sublimating them. As a present-day witness to an agricultural system "widely unpopular and in disarray," the photographer's work appears to carry a political message.

This new approach to photography consists of working on the relationship between man and animal through the portrait. Yann strives today in pushing the boundaries further and extending them "to the farmer's entire family."

But what would appear to be an enlargement—the individual is surrounded by his children, parents, grandparents, and even great-grandparents—is in fact a consolidation. The animal, consistently present at the center of the photograph, progressively shifts in status, from subject to pretext and then to alibi. The evolution of the photographer and his research gradually shifts the focus upon man.

The evolution of a body of work lies in its progression through whatever detours, trials, and errors it may take. Yann took an interest in the animals of companionship, galvanized by the encyclopedic mind of a realist. Following the success of his book dedicated to cattle, his editor from Éditions du Chêne asked him to undertake a project on cats and dogs. Yann committed himself to this latest venture with the ambition of producing the most exhaustive compilation possible. His photographs united 360 different breeds. Owners, their pets, feline and canine champions arrived from

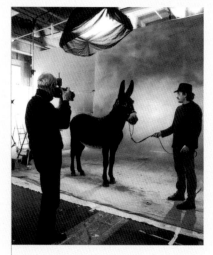

all four corners of the globe, coming and going to and from the studio at a tremendous rate. The photographs were produced in just three months and defy endurance. Despite the difficulties encountered, the range of personalities passing before his lens inspired his sense of human interest.

During a photographic exhibition to mark the release of his book on dogs, Yann became acquainted with Jacques Haillot, the chief photog-

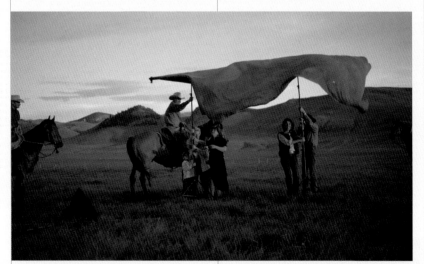

▲ In the beginning, breeders at the Agricultural Show thought we were going to invoice them for the photos, they also wondered why we weren't using an artificial lawn and straw bales.

◄ The wind is a real technical complication when working outdoors. Producing the book on horses, we always used the canvas. People couldn't understand why we were not taking advantage of the landscape. Photographing the canvas through a wider focus, however, enabled us to present the relationship between animal and breeder while relocating them both in their natural environment.

►► The photographer's flight log of March 11 and 12, 2002, in Cameroon. His assistants made note of all of the people they photographed, the type of camera they used, as well as film speed.

11 mars 2002

CAMEROUN

PHOTO. ②

MINDIF - PLAC

S. PDV DIF. DU LAMIDA .

Rapide 200 Joules

2 A - Homme jaune + Turban + Lance
2 B - Homme en rose + chapeau rouge
2 C - 2 personnes + chevaux noirs
2 D - Famille ① -
2 E .
Famille ②
(2 Enfants)

5
Files

2 A ↗
 2 B ↗
 ↗
 2 D ↗
 2 E ↗ Btes 2 sans grilles

NORMAN 400 Joules

SHOOT ∅ 8.5 - 11 500 e

Distance 20 M. =
Pentax N° 1 +
Zoom 45 - 85

Assistants: FJ + Eric Laffitte -
 SB

GOBO - PLACE DU
CHEF DU VILLAGE

PHOTO N° ③

③A. Homme en manteau
beige

3B. Homme chemise
Blanche -

3c. Groupe
6 Hommes et 6 chevaux

Attention. PDV
demain matin

MINISTERE DE L'ADMINISTRATION TERRITORIALE
DEPARTEMENT DU MAYO-KANI
ARRONDISSEMENT DE MINDIF

Sa Majesté OUMAROU MAIGARI
Chef Supérieur Mindif/Moulvoudaye
Commis de la Documentation
Membre du Comité Central du R.D.P.C

B.P. 18

MINDIF

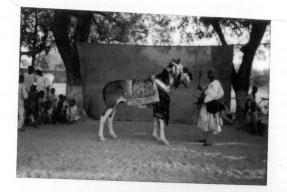

Photo
Soirée

Distance
34 M ~
Pentax N°1
200m 45.85

2 Btes
sans grilles

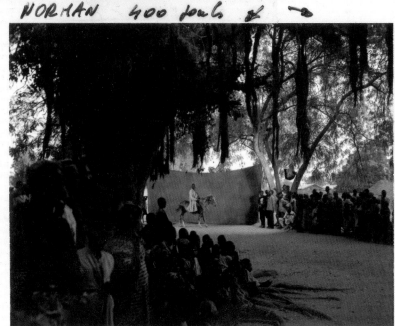

NORMAN 400 Jouls

SHOOT 5.6 ½ Vitesse 250°

Films

3A 1
+ Debut 3B
3B 2

3c 2

Total
5 films

Assistants : FJ + Eric Loffitte + SB.

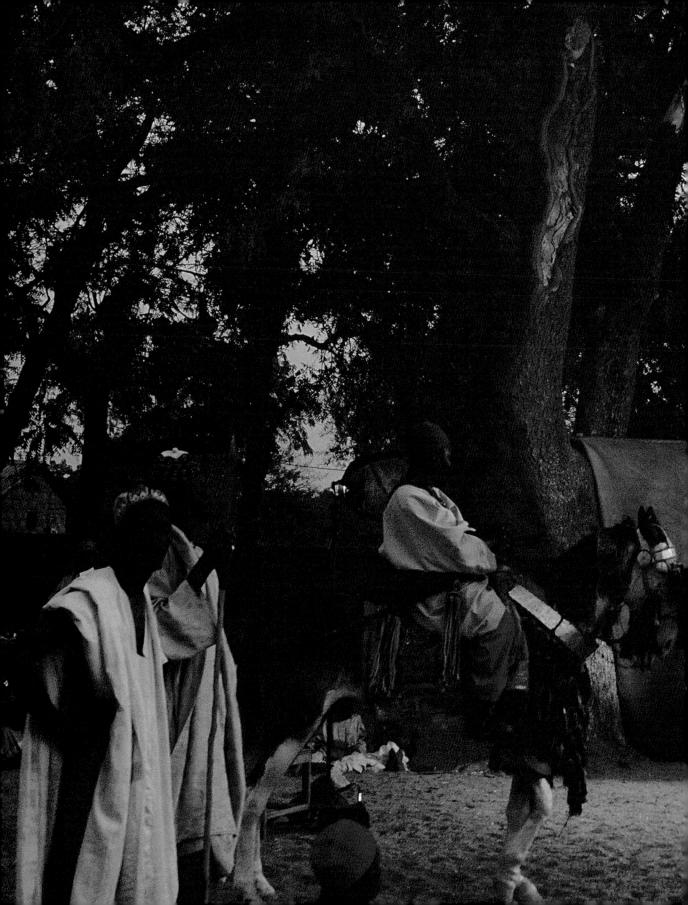

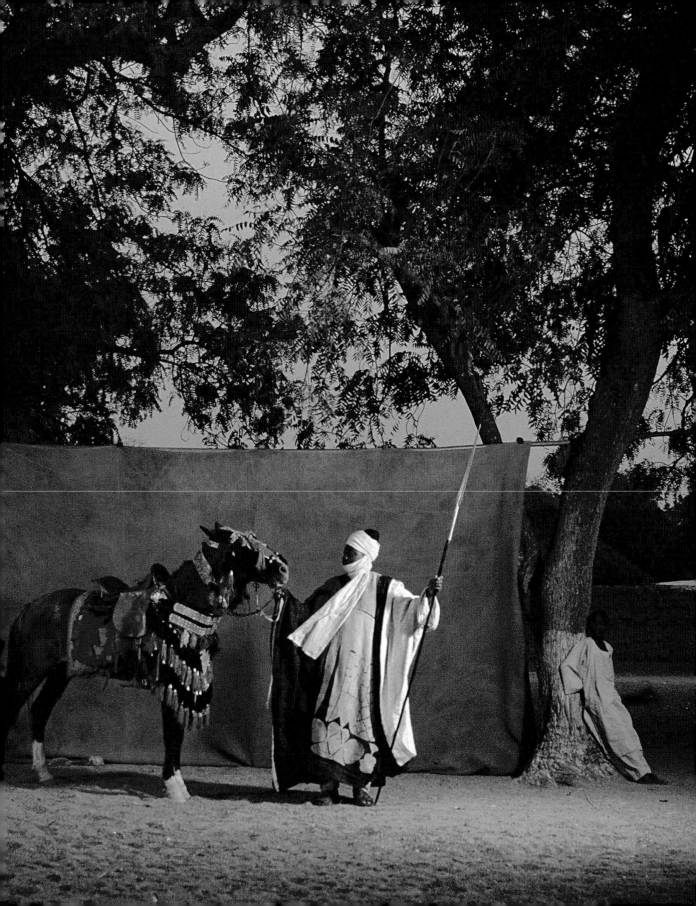

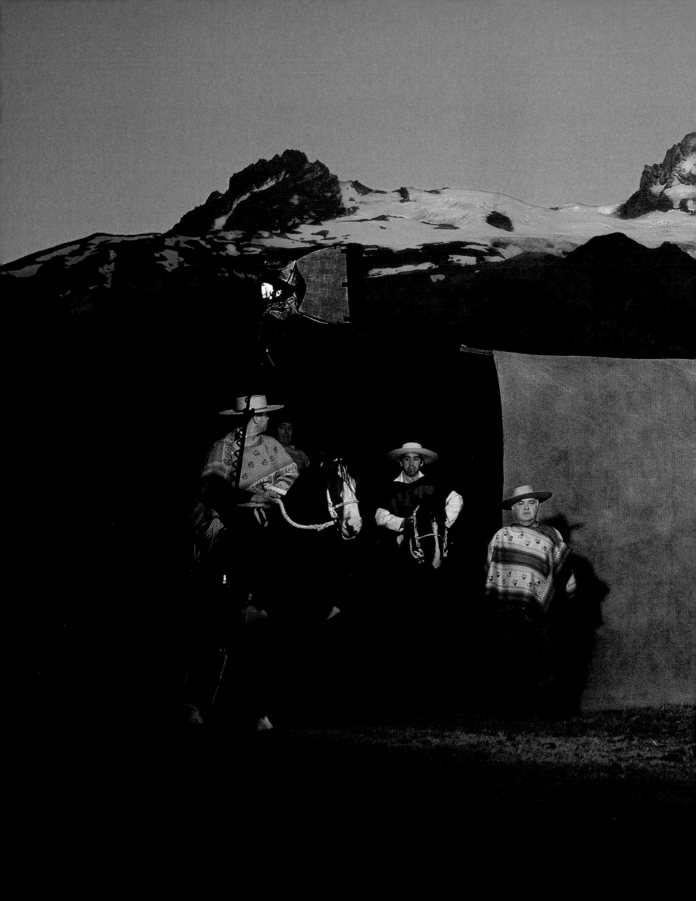

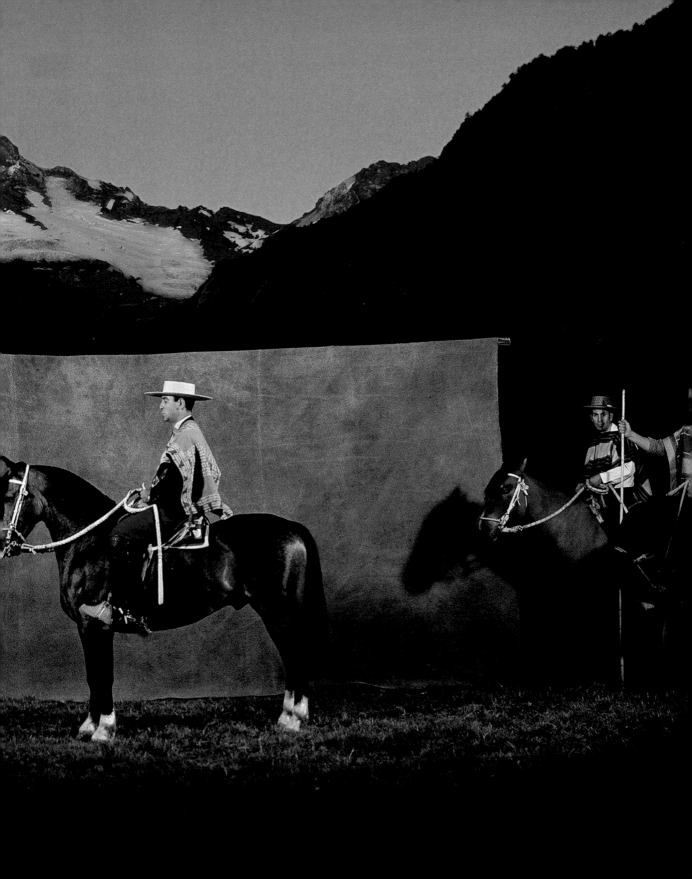

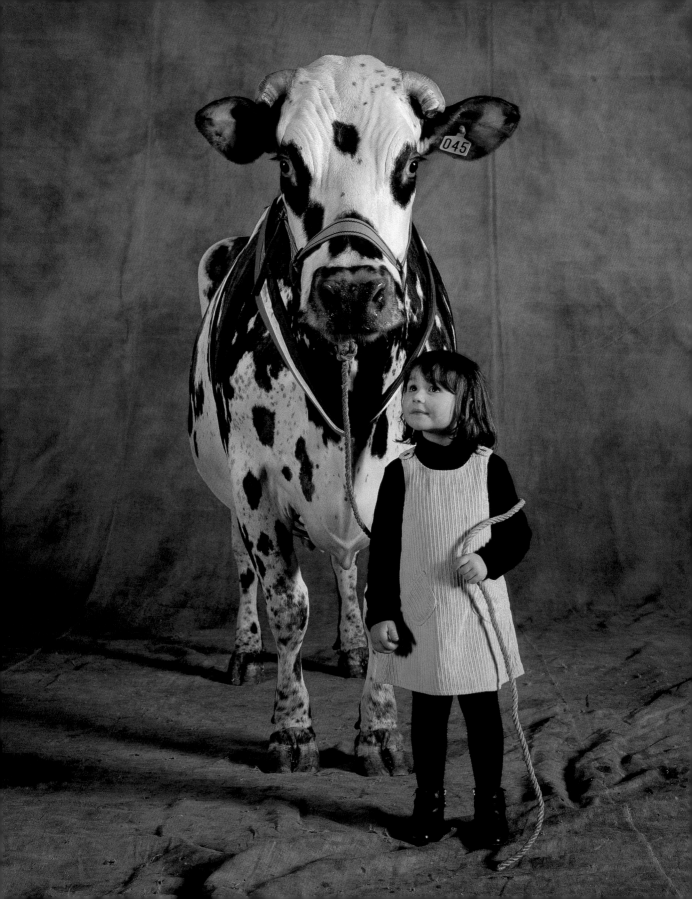

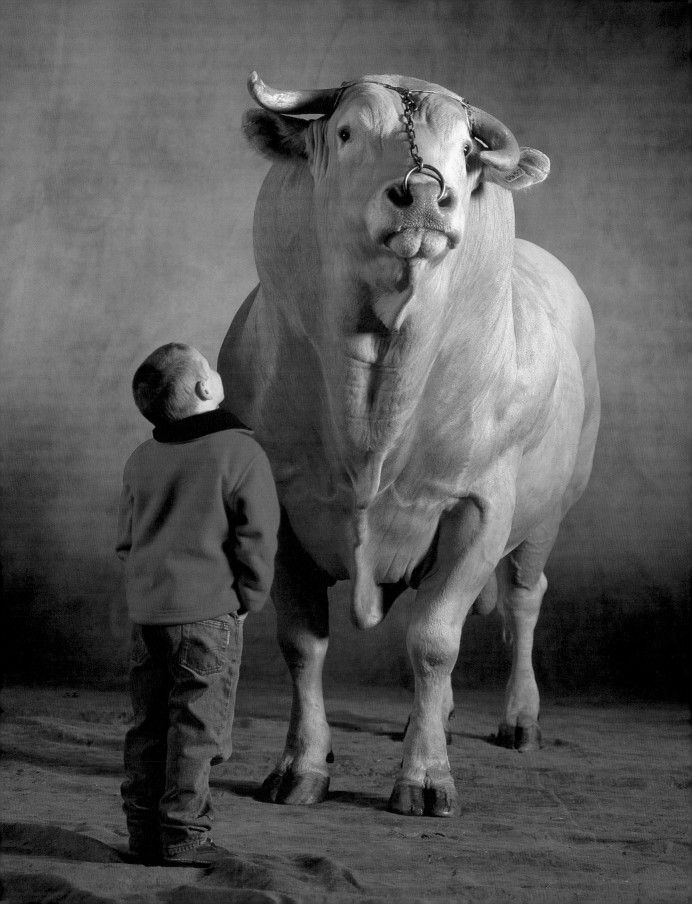

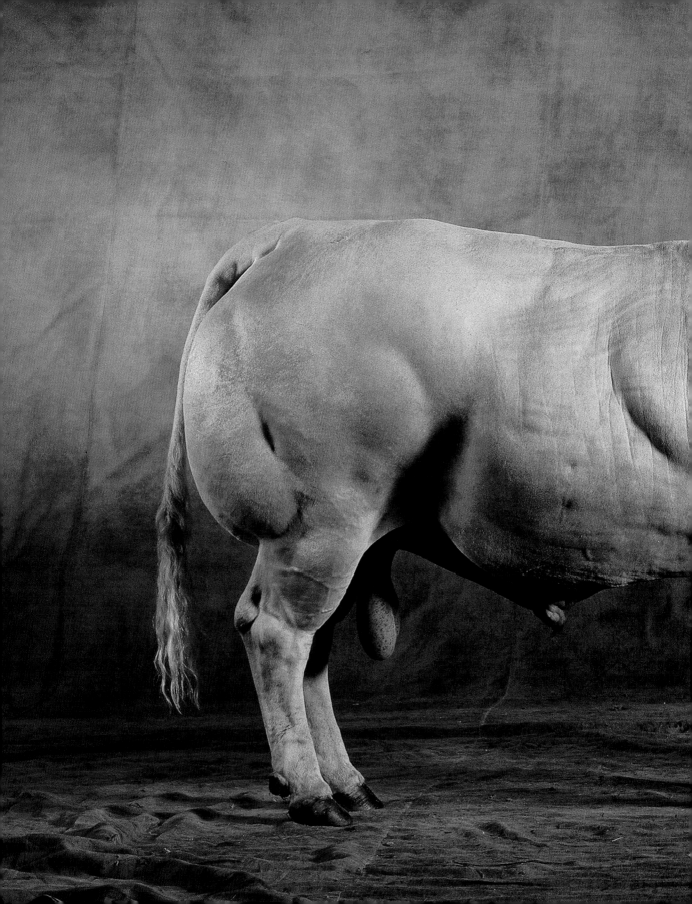

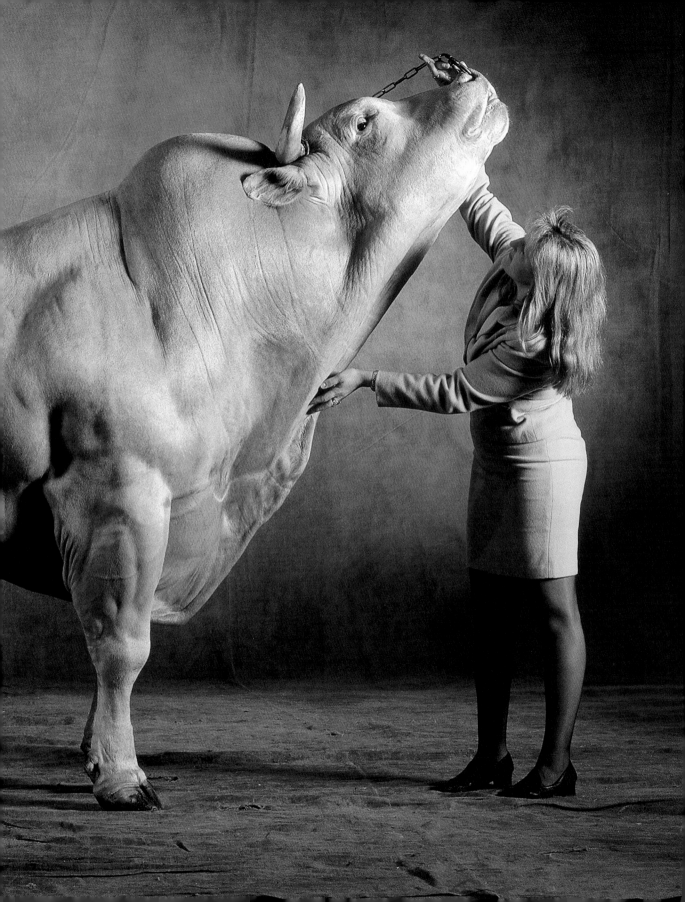

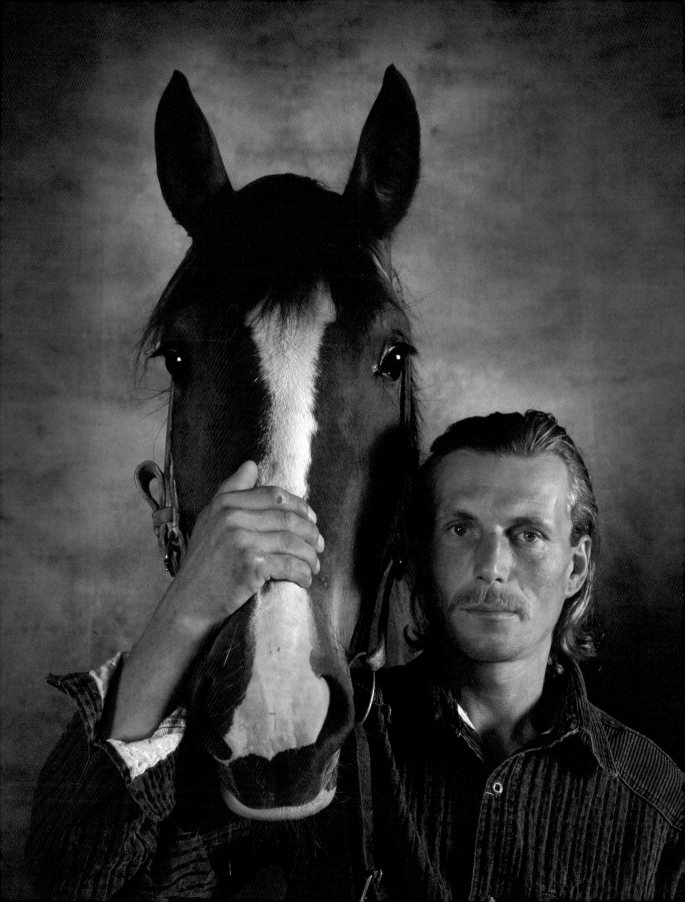

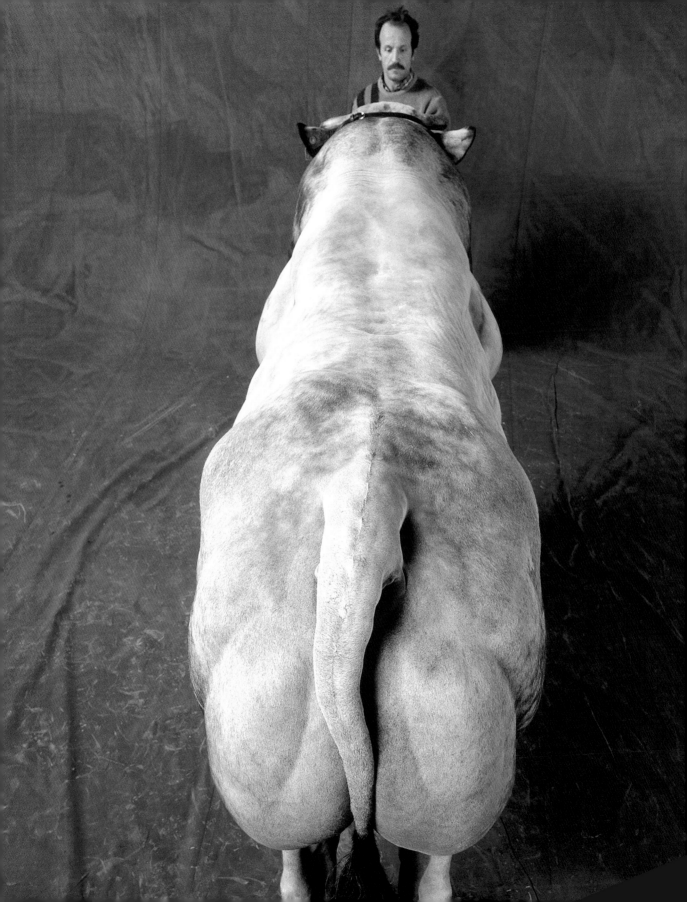

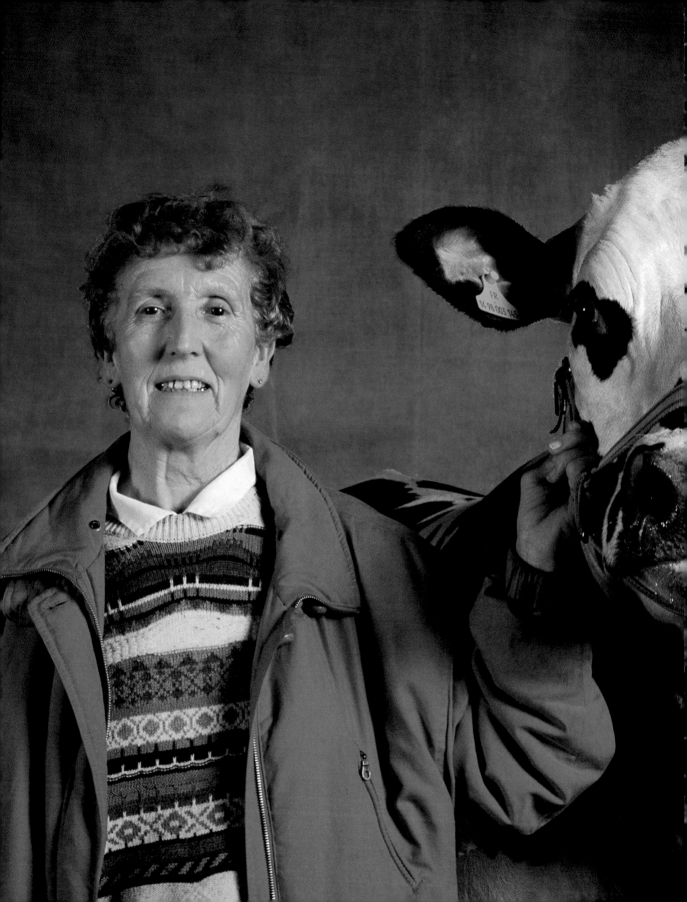

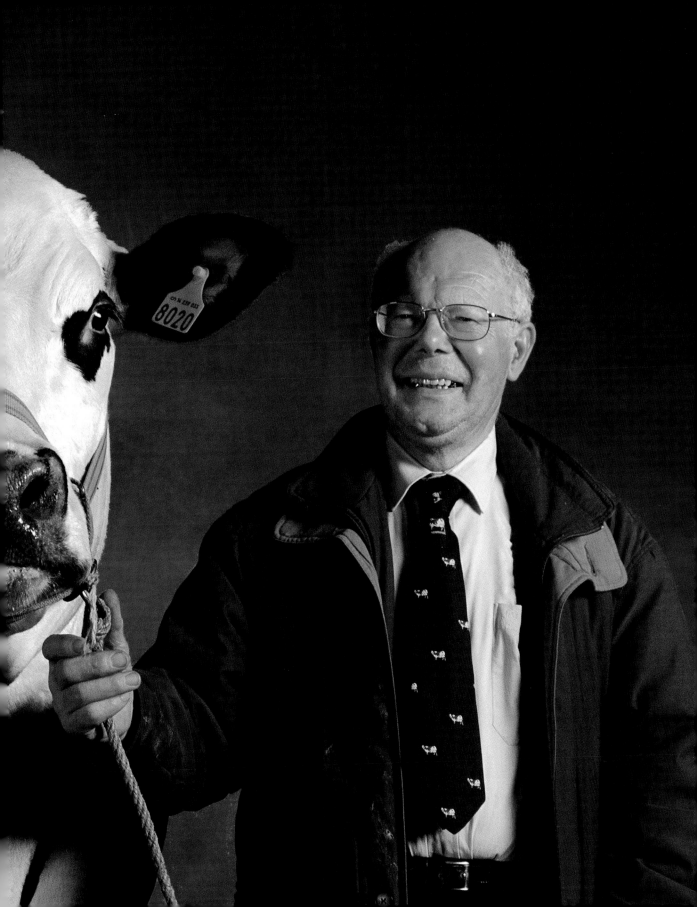

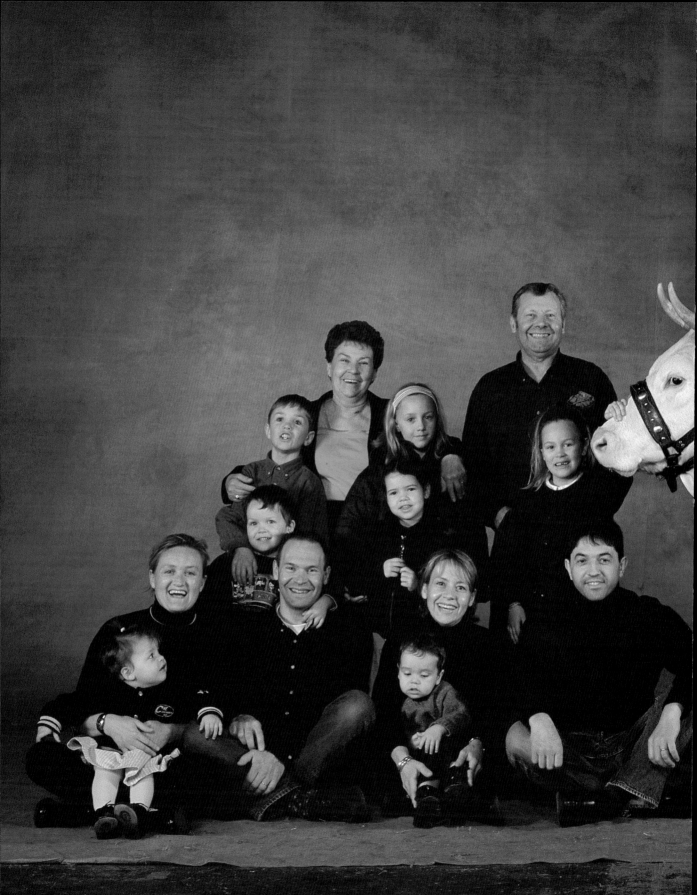

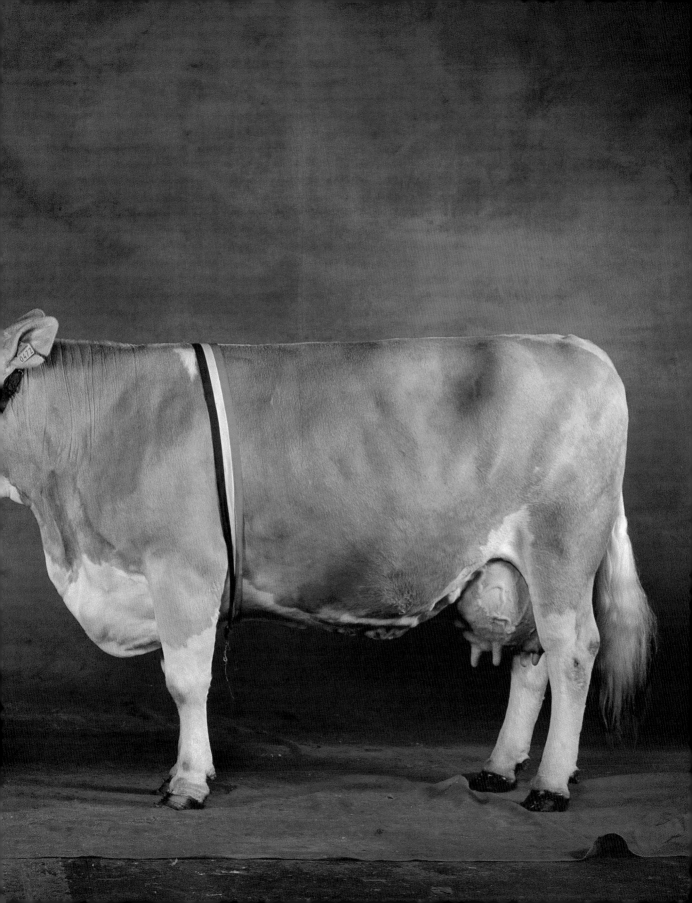

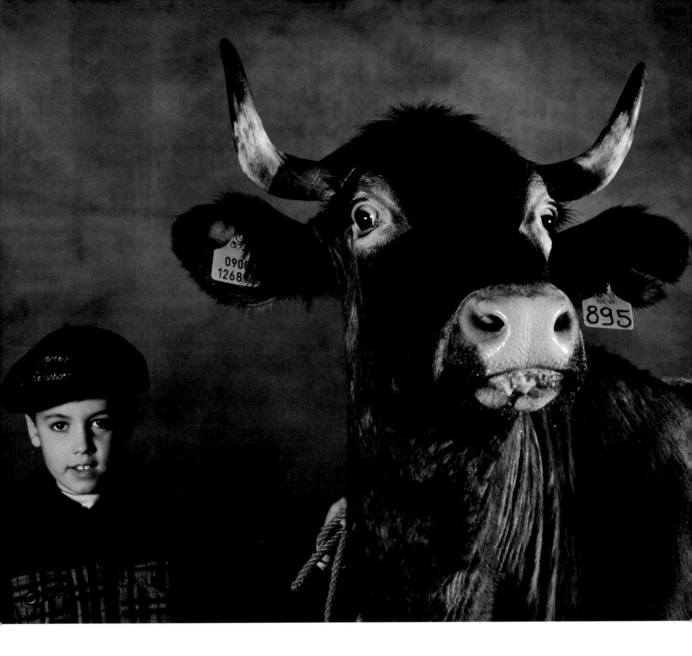

Since 1990, Yann has assembled breeders and their animals at the Paris Agricultural Show and elsewhere in the world. As with some of his other projects, the series, *Good Breeding*, functions as a census and has left its mark over the course of its production. Through the years, genuine friendships have also been made with breeders. The series reveals a changing world in which increasingly larger farms profit from the disappearance of smaller farms, integrating them within huge and complex farm-produce industries. Over the last thirty years, a farm has closed down every twenty minutes in France. Each week, two breeds of animal become extinct in the world. The portraits seize upon the intimate relationship binding breeder to animal and attempt to draw forth an individual awareness of the crisis facing the farming community. Since the first shot was taken, a human presence (whether it be the breeder, owner, or member of the family) has asserted itself in the photograph; the animal, reassured, behaves better and the breeder finds his or her composure before the camera lens. "All the photographs produced at the Agricultural Shows have an optimism

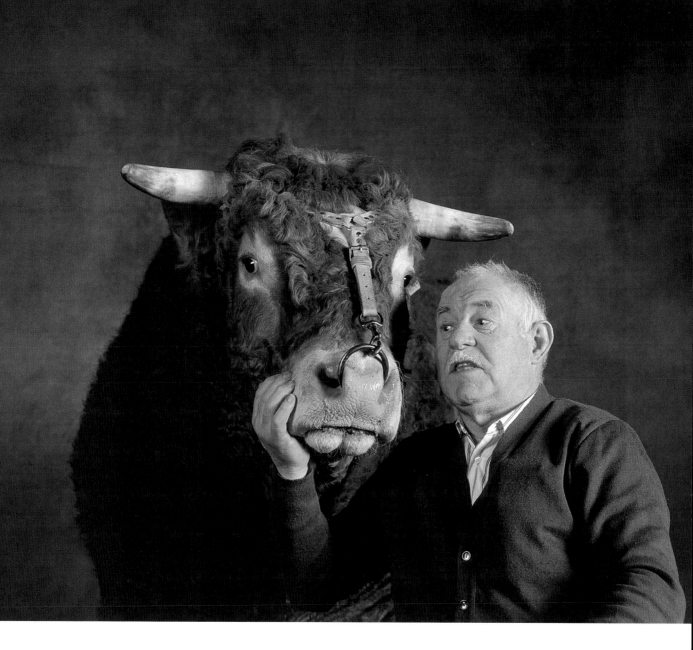

that I adore. It is for this reason that people must feel relaxed, I like it when they seem happy," says Yann. "Our regular presence at the Agricultural Shows enabled us to cover several generations of farmers. The most exciting thing is consciously working to impart something for future generations," explains Françoise Jacquot.

◄ Aure et Saint-Girons Cow: Irma, with the son of the owner, Maxime Dangla from Betchat.

▲ Limousin Bull: Fripon, with owner, Mr. René Guimontheil from Falies.

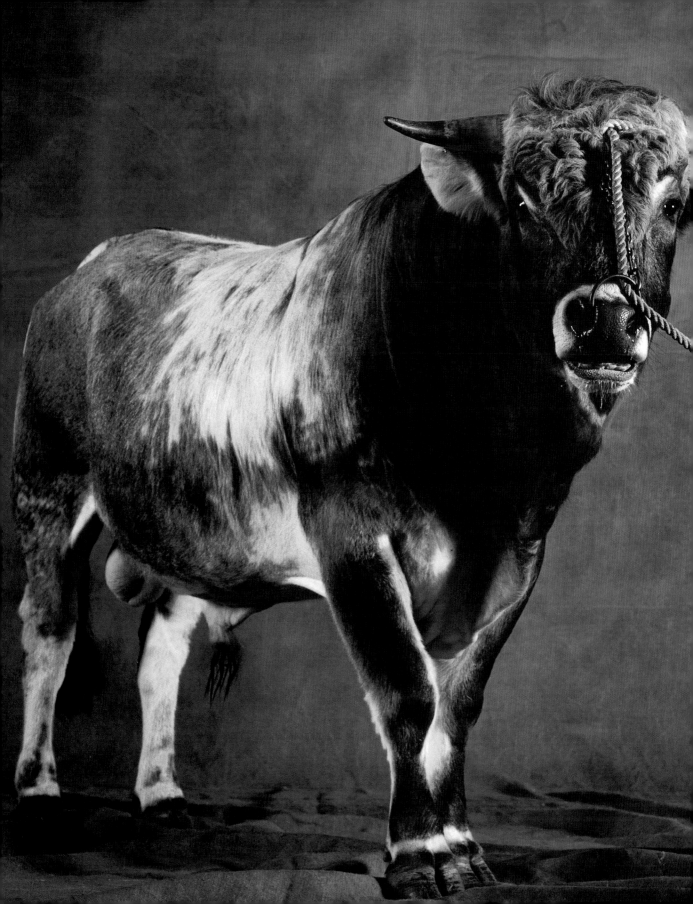

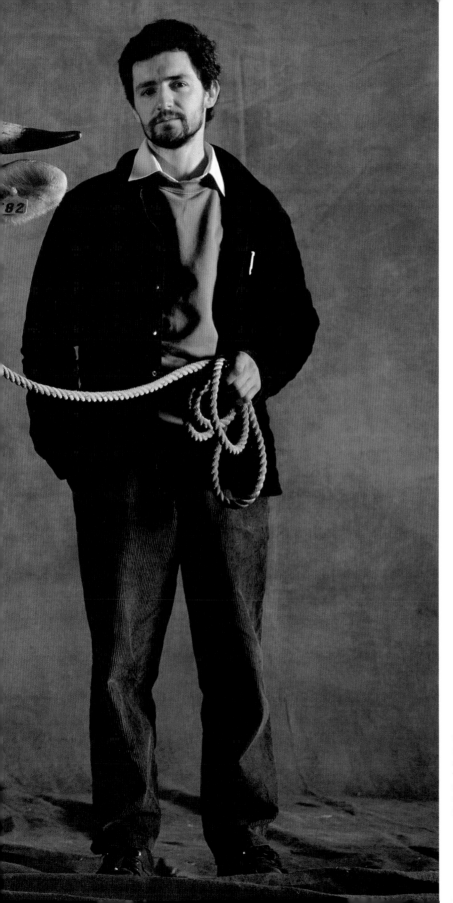

◄ Nantes Bull: Guenrouet, with Régis Fresneau, owned by Rémy Douet of the Bois-Joubert estate. After twelve years at Agricultural Shows: "We don't actually take many new photographs. We will have reached our objective if we can improve upon them, sometimes just by four or five photographs per year."

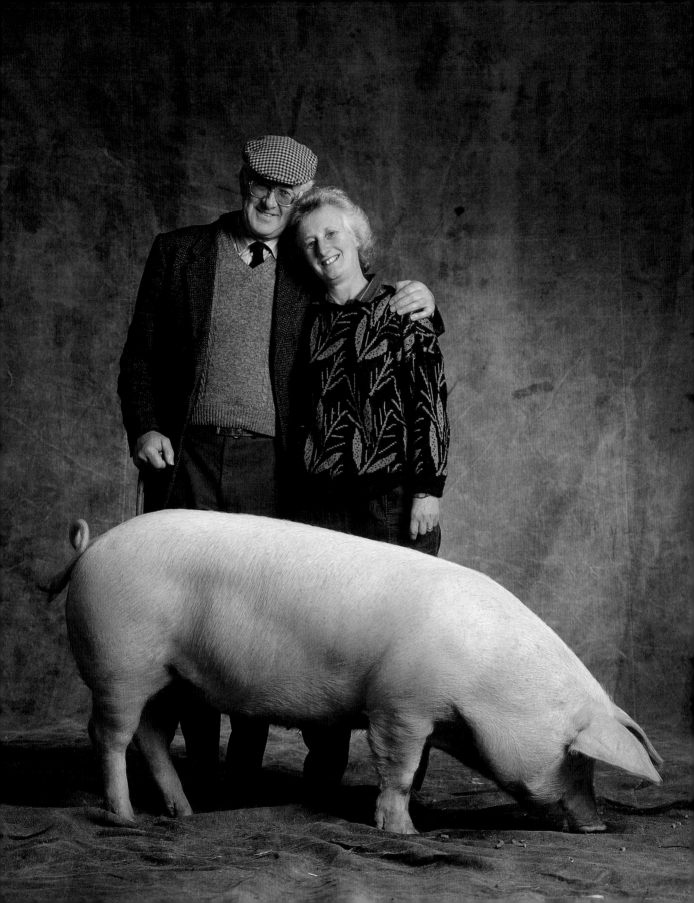

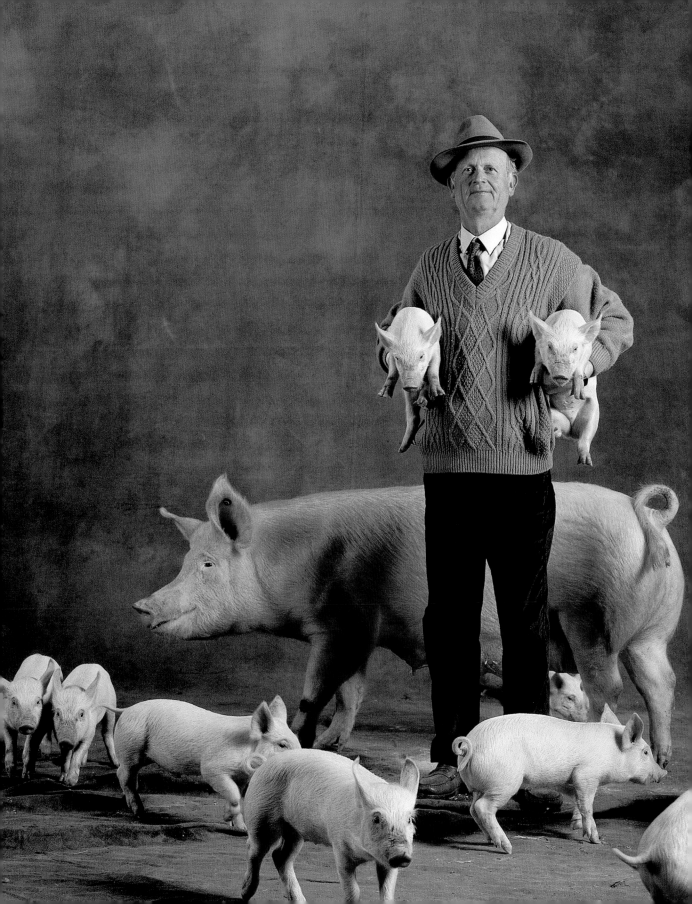

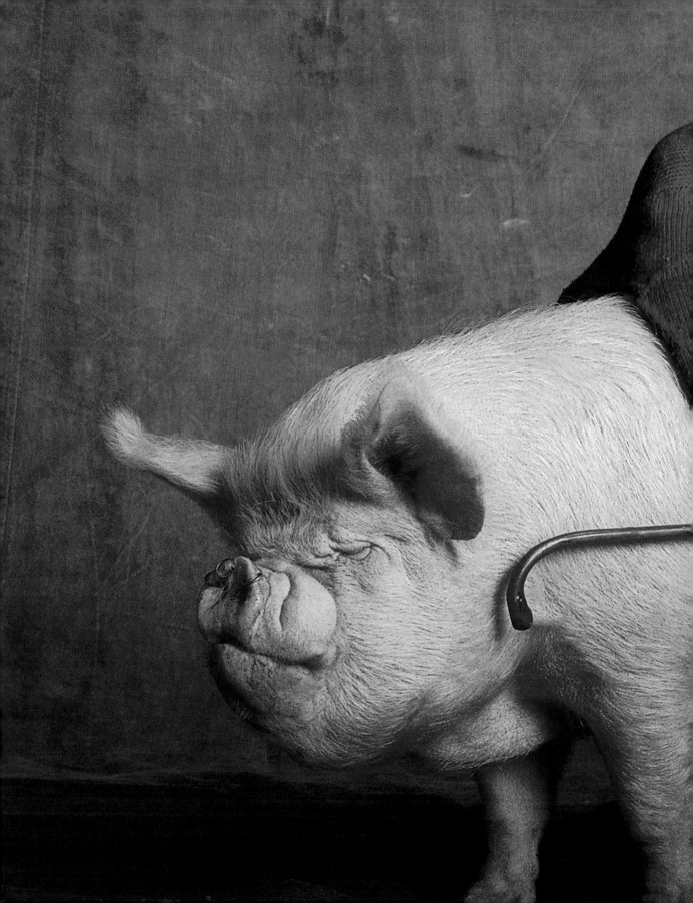

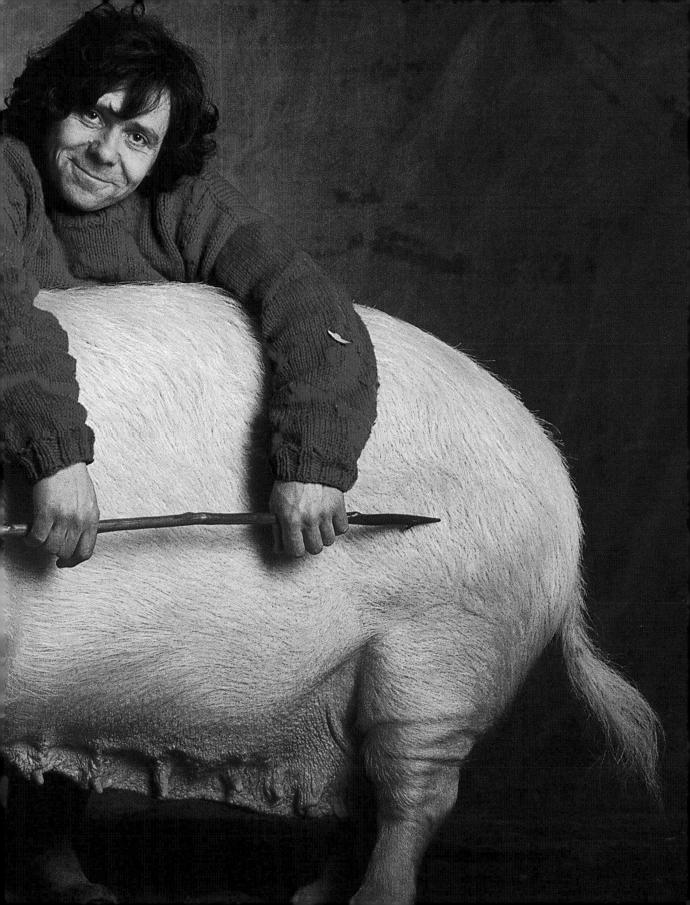

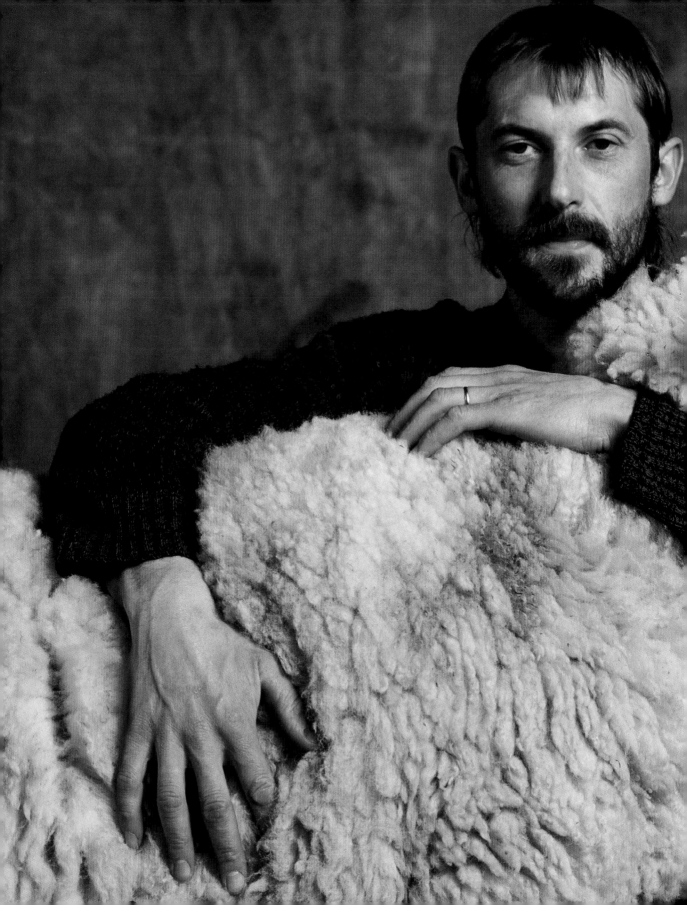

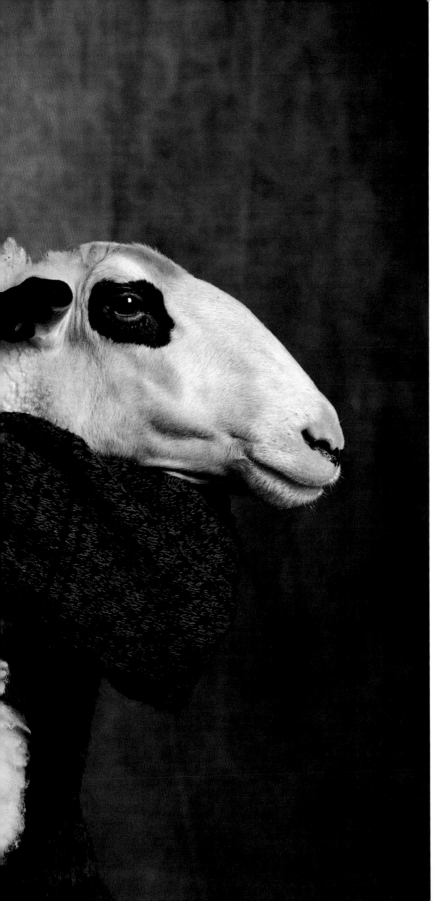

◄ Causses du Lot ewe, a ewe presented
by Pascal Cailleau from Gaec de Chalvet,
Le Bastit (Agricultural Show, Paris).

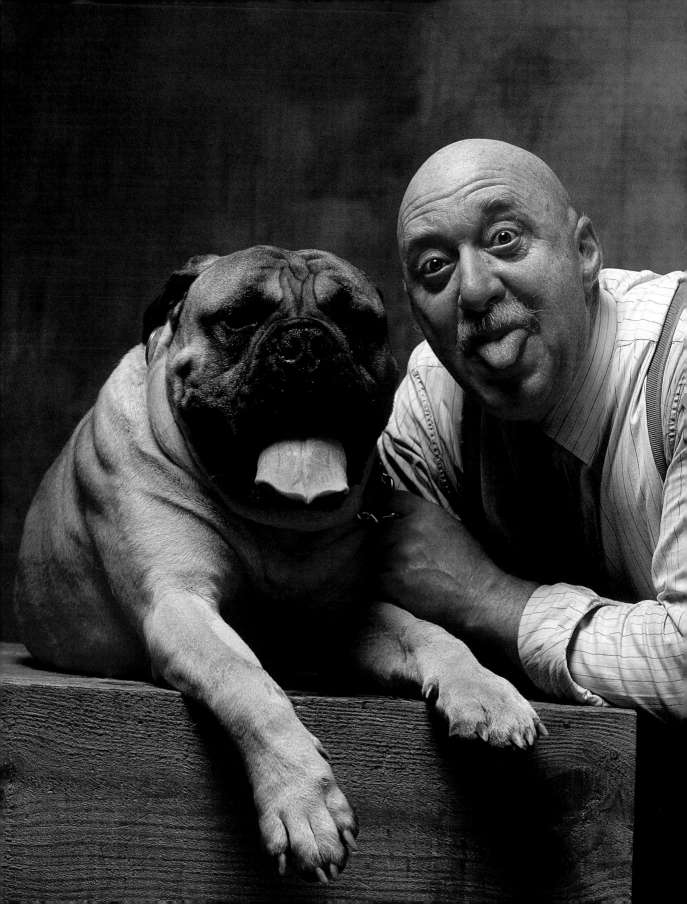

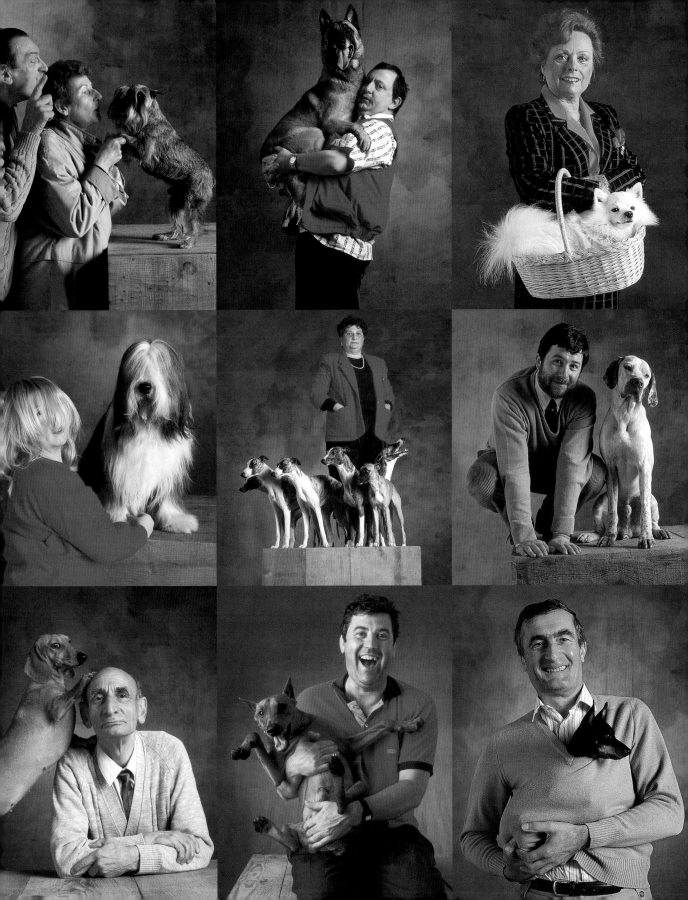

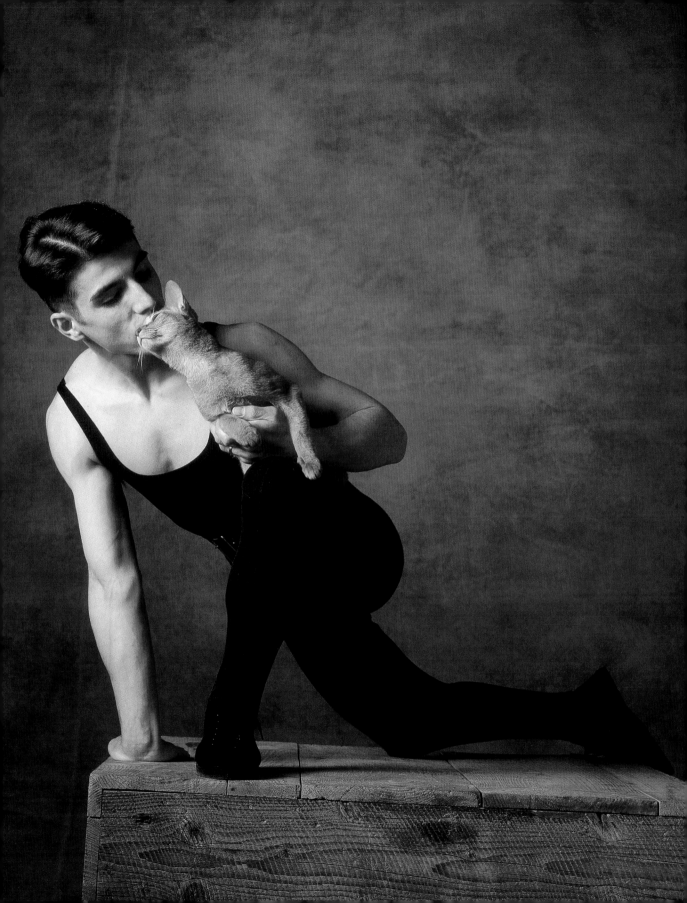

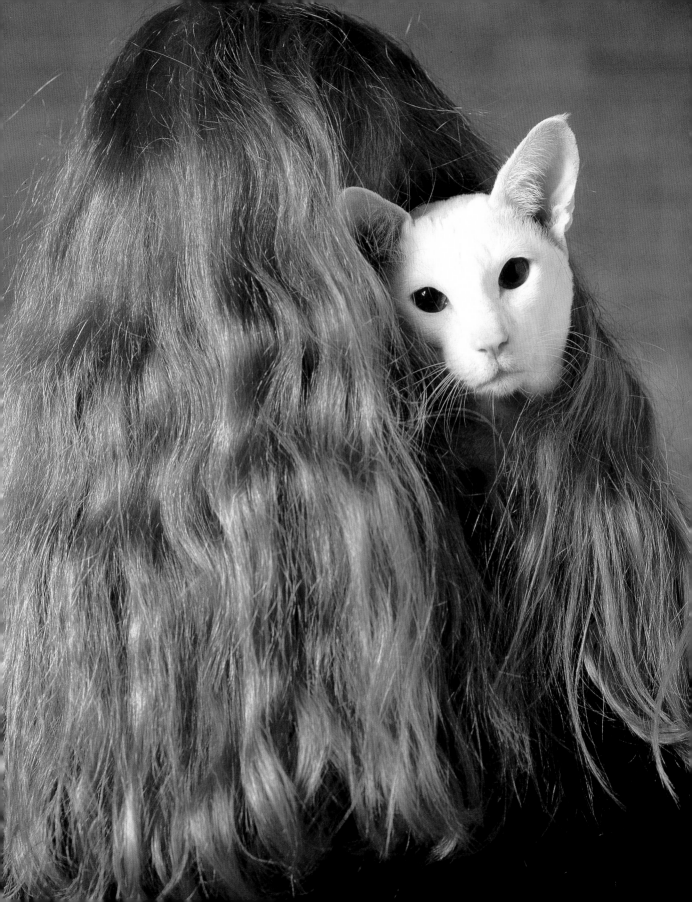

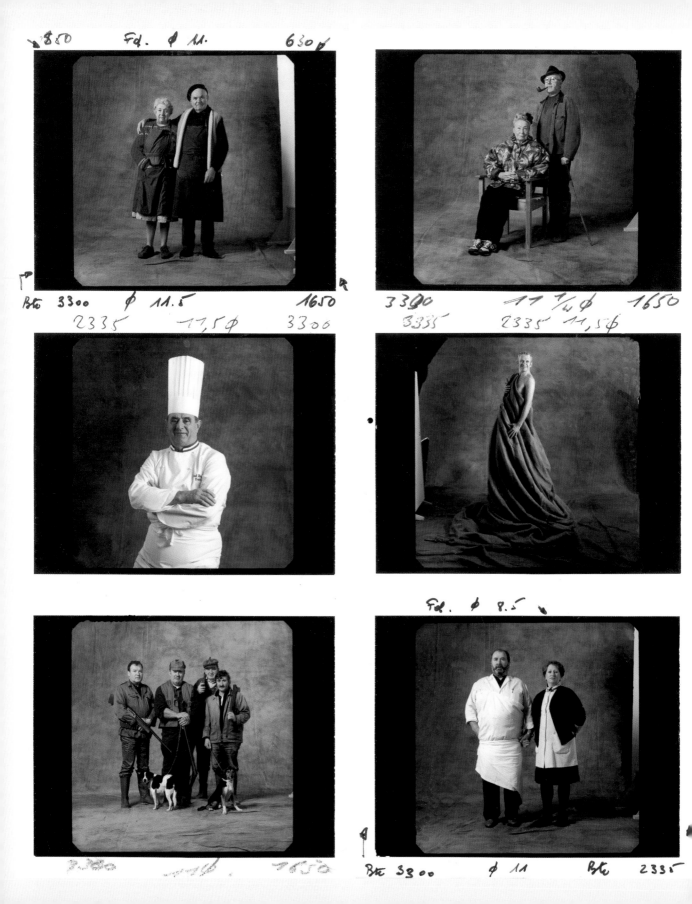

raphy editor for *L'Express*. Interested by the panoramic element of his work, the journalist suggested that he produce a project on the French. The inspiration for this came from *Les Caractères* by Jean de La Bruyère, and Yann was given a carte blanche to produce the piece. It was exactly the kind of work he relished and he began immediately with the aim of "creating something accurate." And so he has photographed figures from President Mitterrand to prostitutes, plumbers, policemen, and bakers, all on canvas. Yann has done so without exception, "because it consigns everyone to the same level, and brings out the distinctions in each individual." The concern for accuracy in his photographic work is reflected in the importance of the captions. His insistence on recording the name, age, and profession of each of the people photographed is a good thing, as they are precisely what is written in the captions. The truth may appear banal or limited, but at least it is honest and unquestionable. Moreover, the suggestion of using models to depict certain trades struck him as "not only stupid but shocking," dishonest even.

It was within his immediate circle that he found the majority of his subjects. The intimacy enabled him to establish the complicity he requires in his work, and it is at the heart of his approach. The need for complicity, friendship, understanding, harmony, or recognition—whichever is the most appropriate term—illustrates a crucial aspect of Yann Arthus-Bertrand's personality and work. Beneath the self-confident appearance and characteristic conviction, energy, and authority reside sensitivities just as real.

His sensitivity is not concealed or overlooked but carefully defined; it invigorates, guides, and illuminates his work. Yann Arthus-Bertrand is a photographer because he is conscious of the compelling and complete aspects of the world around him, and the men and women that compose it. He attempts to reveal this universal and abiding solidarity in his photographs. This is why he prefers to photograph people "right in the eyes." They must feel "relaxed, smiling and happy" in his studio, so that he can receive their emotion "as a gift" and find proof of a possible harmony.

And so the cohabitation of this

great élan of generosity and idealism remains unusual and incomprehensible as an instinctual and perfectly matter-of-fact requirement. Utopia allies itself to the purest materialism. Yann does not harbor illusions but is shaped by them. The purists would argue that this is a major flaw and not the least of his contradictions. Nevertheless, Yann adapts himself completely. In addition, he declares himself an independent, which he has had the good fortune to be.

L'Express magazine was planning a special edition to mark their fortieth anniversary and I was asked to produce a set of portraits on the French in the style of Jean de La Bruyère's *Les Caractères*. From the beginning, a great deal more importance was attached to the written pieces by journalists than to the photographs themselves. They had even considered using models to illustrate the articles, which was something I refused to do as the portraits would have lost their authenticity. I initially turned to my immediate circle of friends and acquaintances: neighbors, tradesmen.... Everyone knows at least one single mother, butcher, or supermarket saleswoman.... When the piece came out, people would say to me: "But it's just a story about your village!" I have continued this project and would like to make a book of it.

◄ We test the light with these polaroids; they help us record the power of the flash and aperture. I like to work in darkness so as to clearly see the flash's impact. The polaroid confirms my readings. Today, digital cameras can immediately confirm all this on a computer.

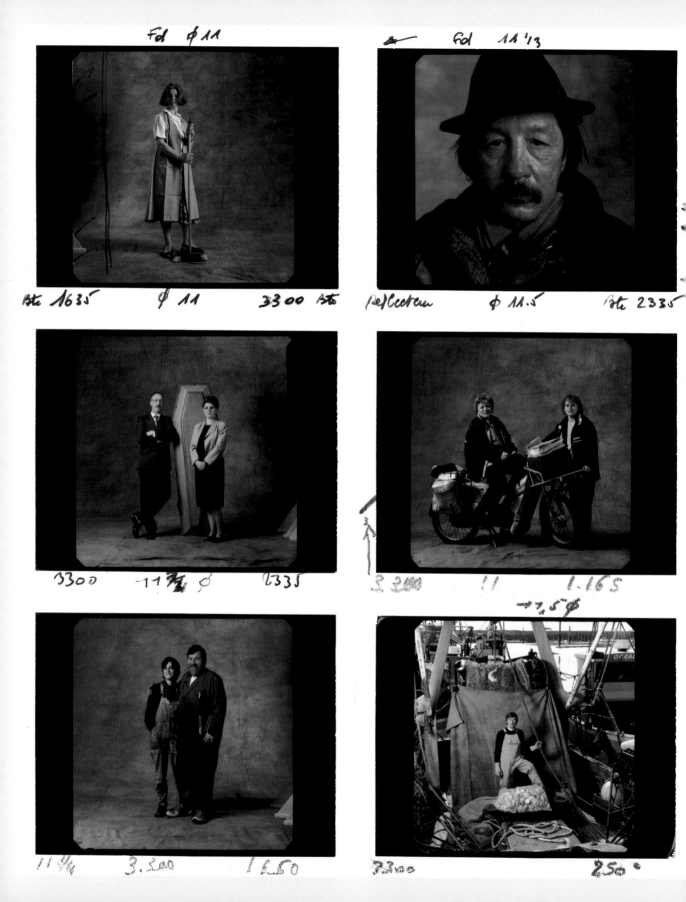

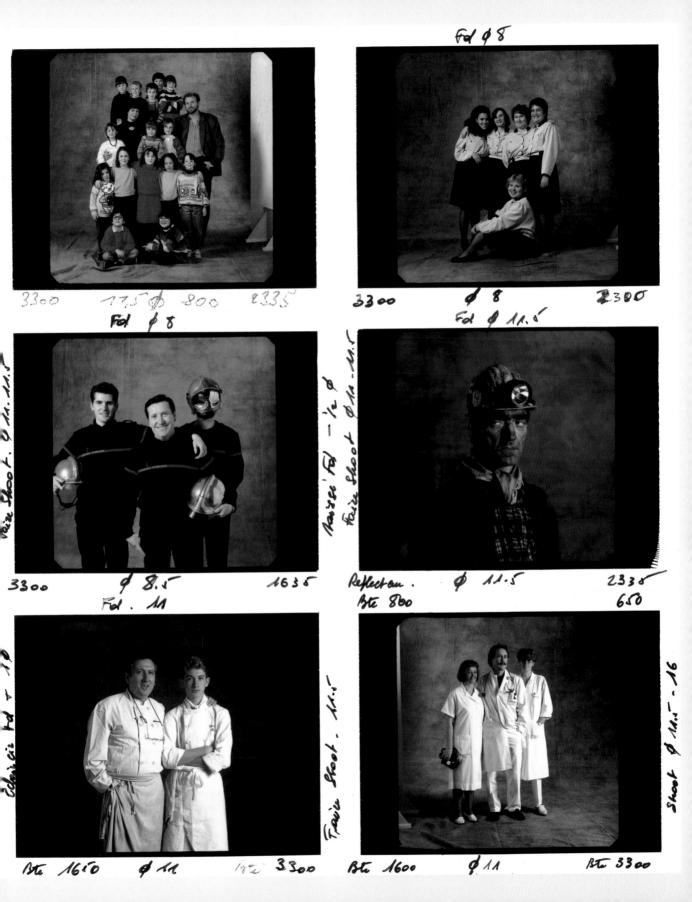

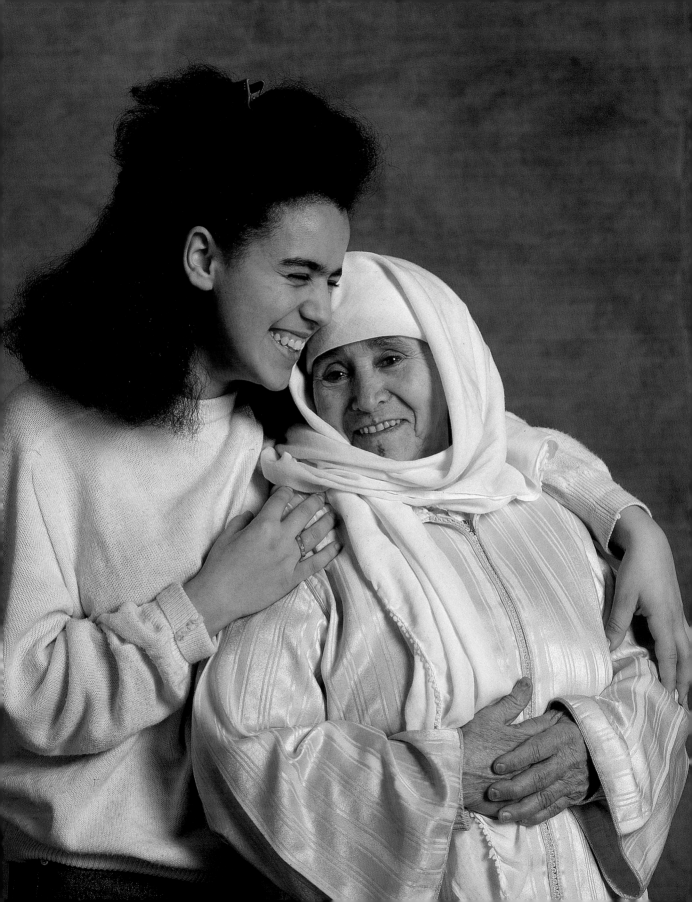

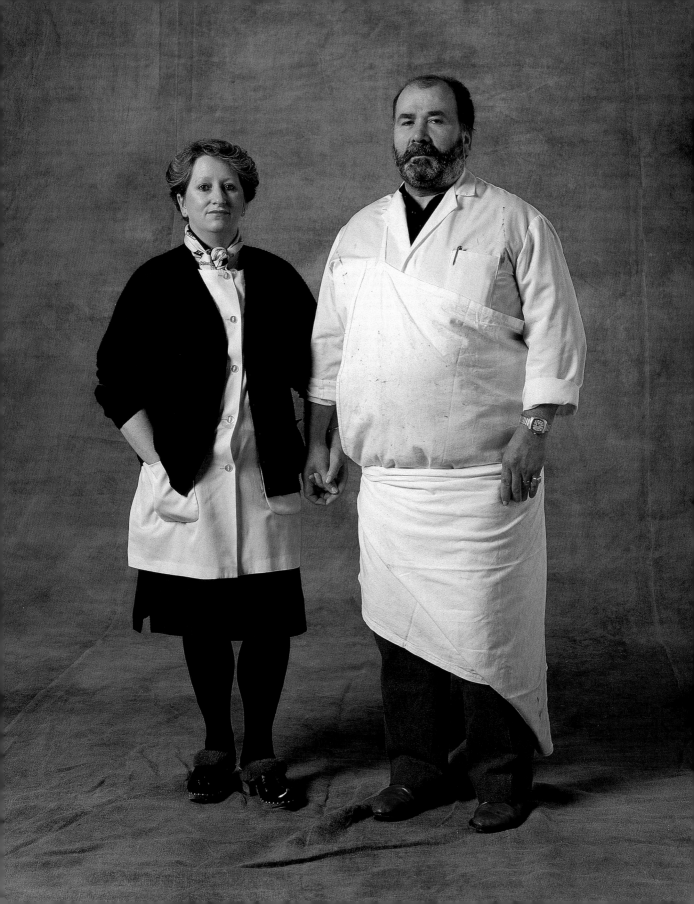

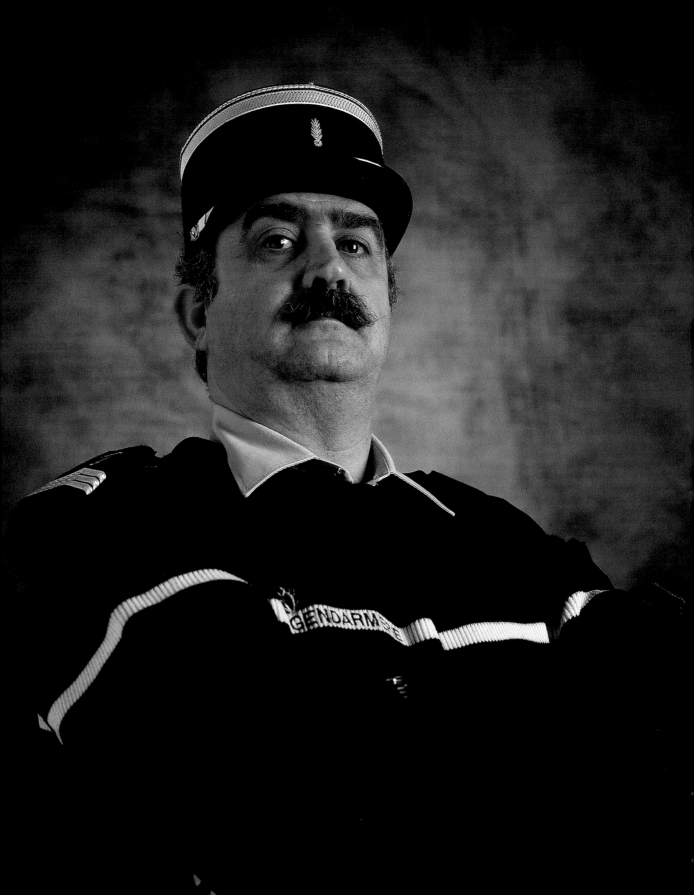

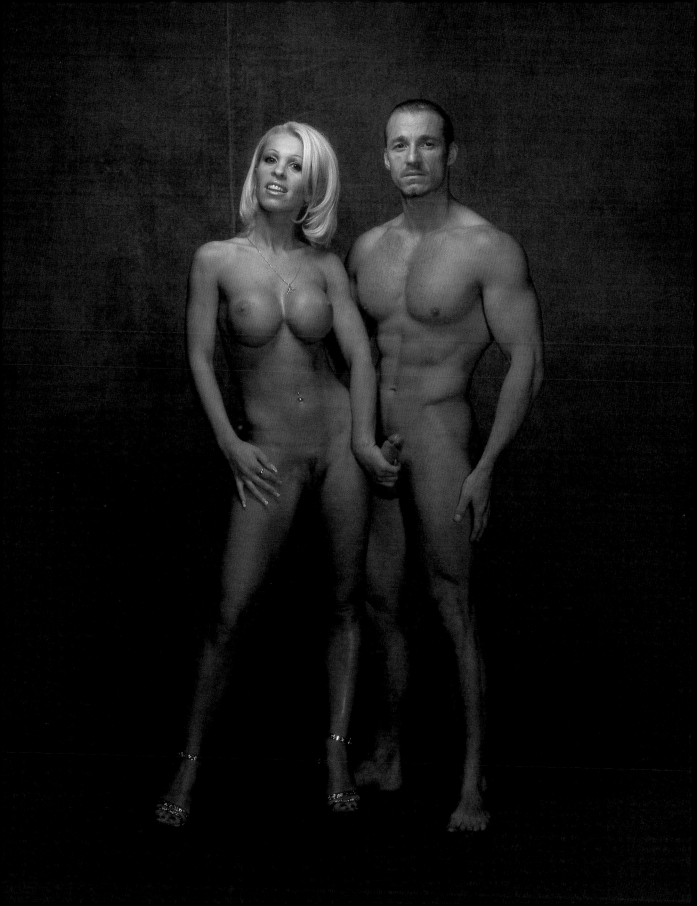

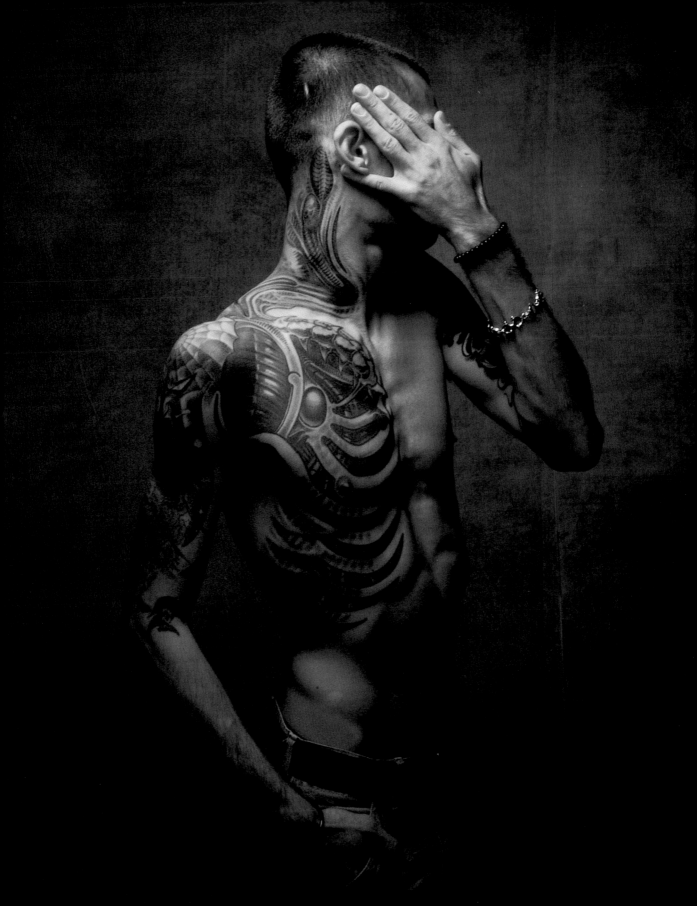

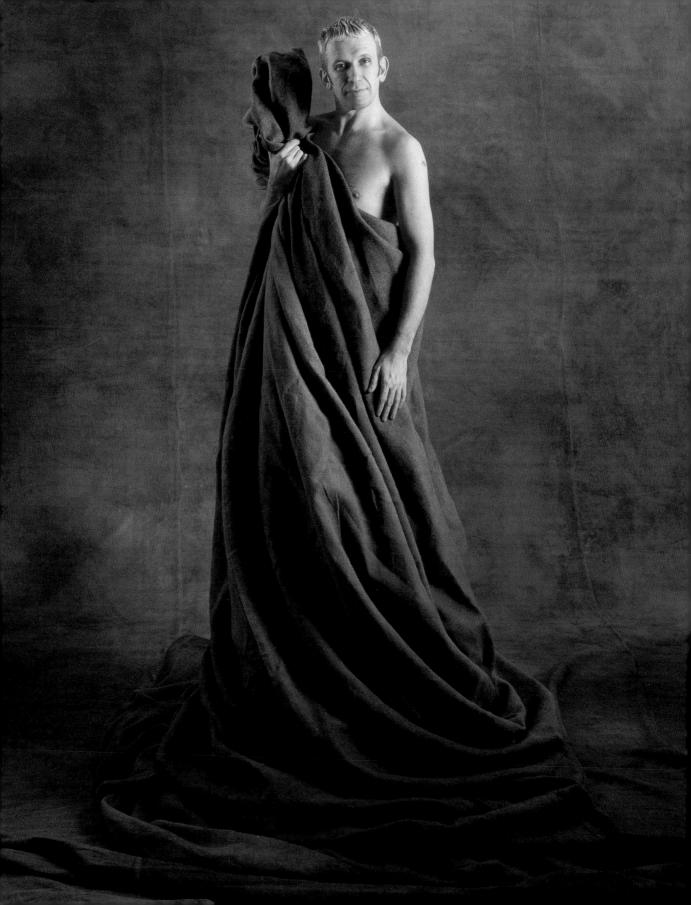

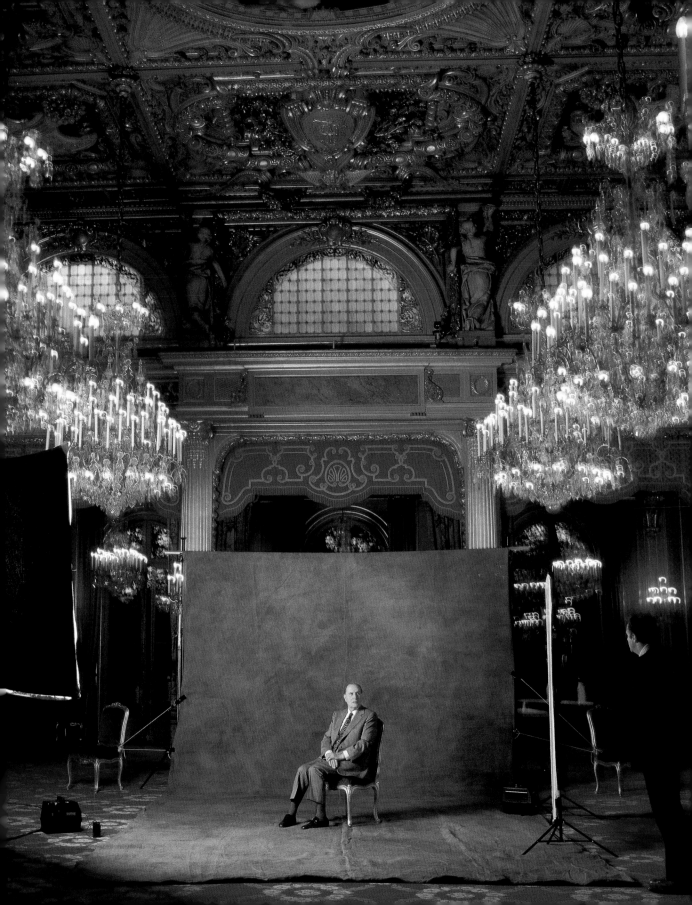

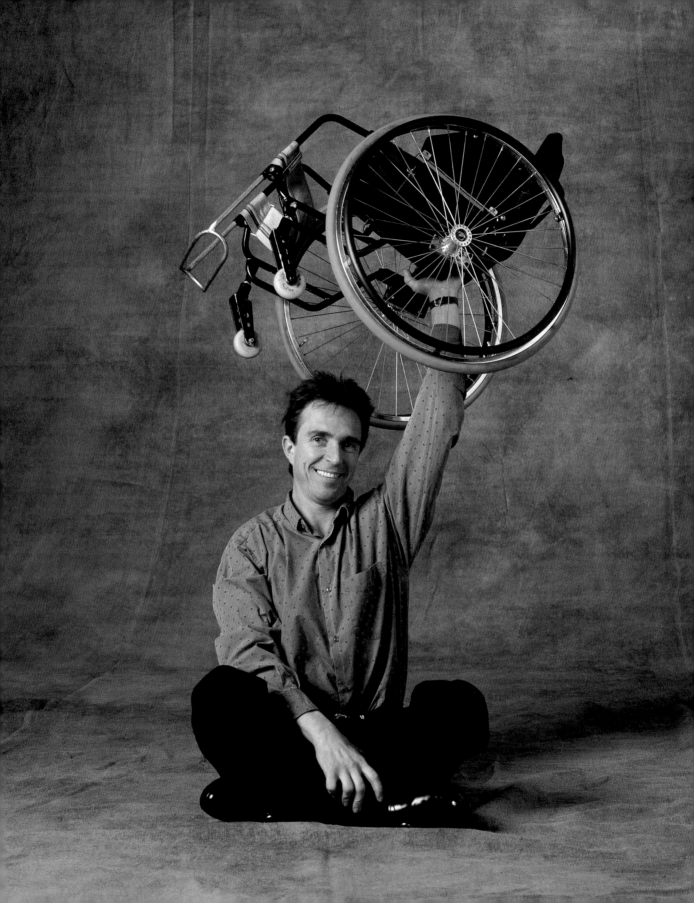

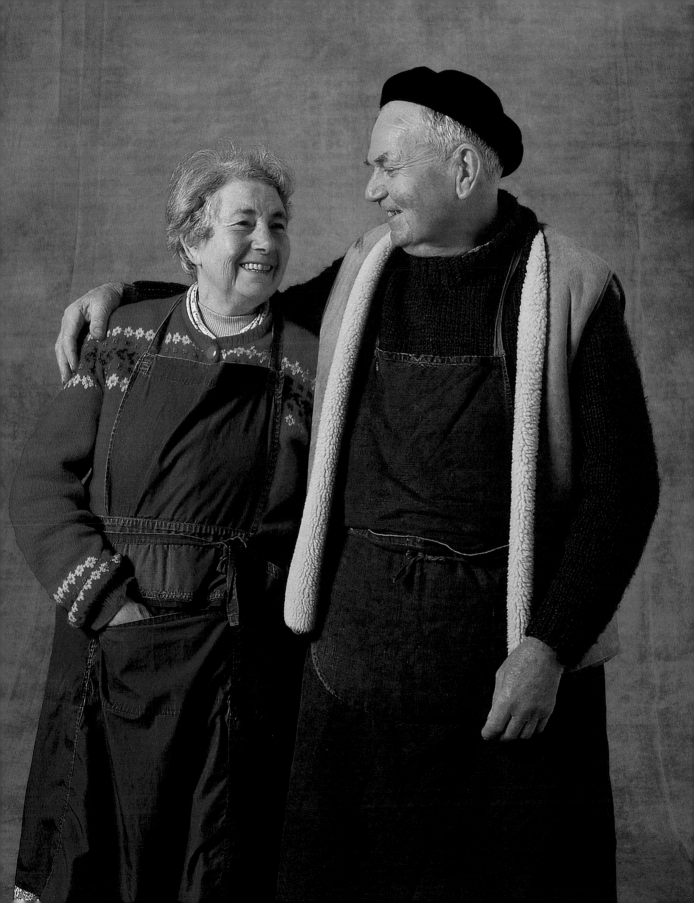

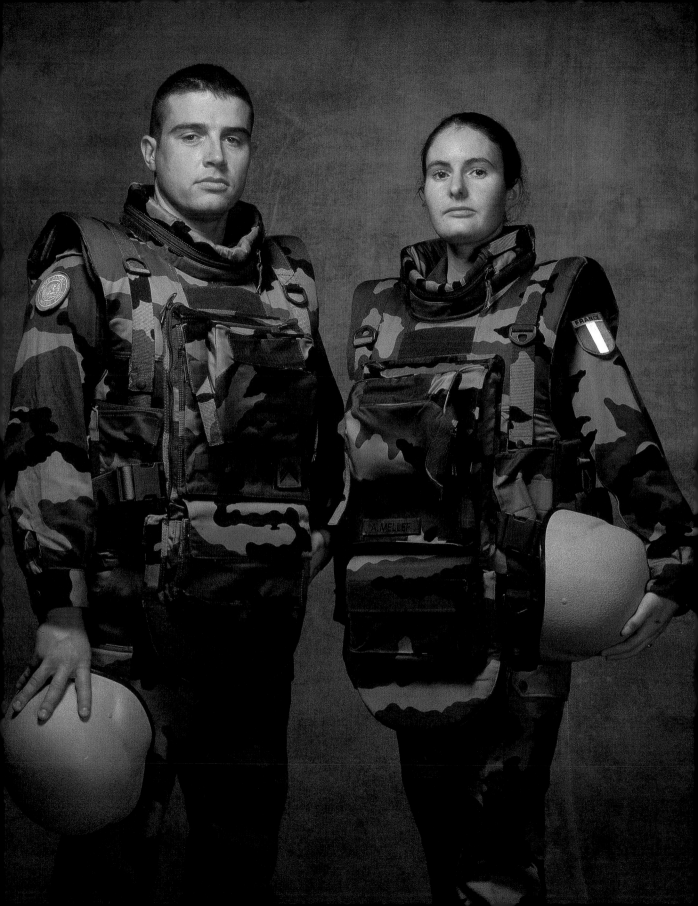

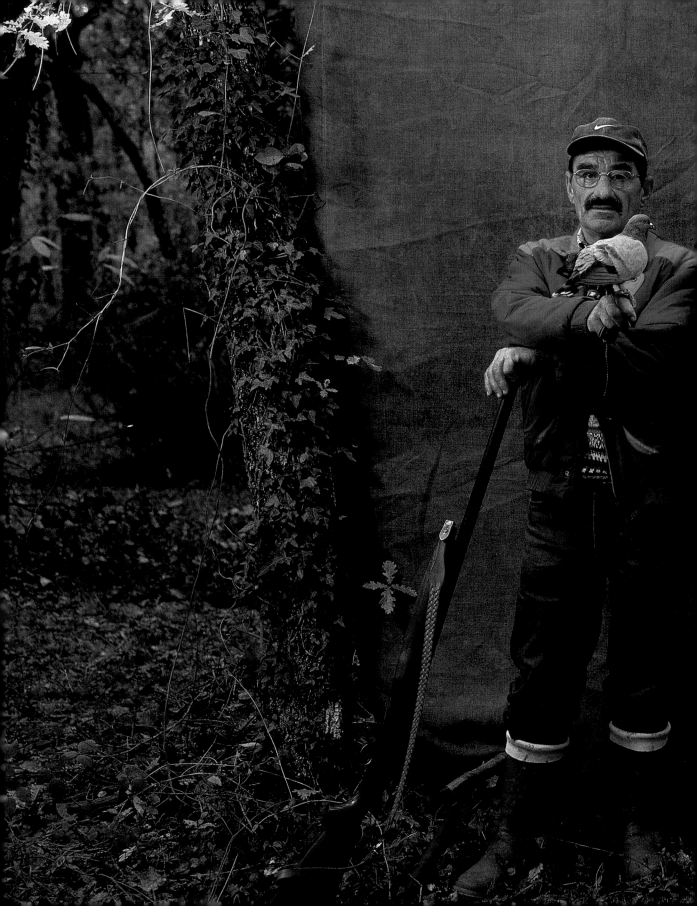

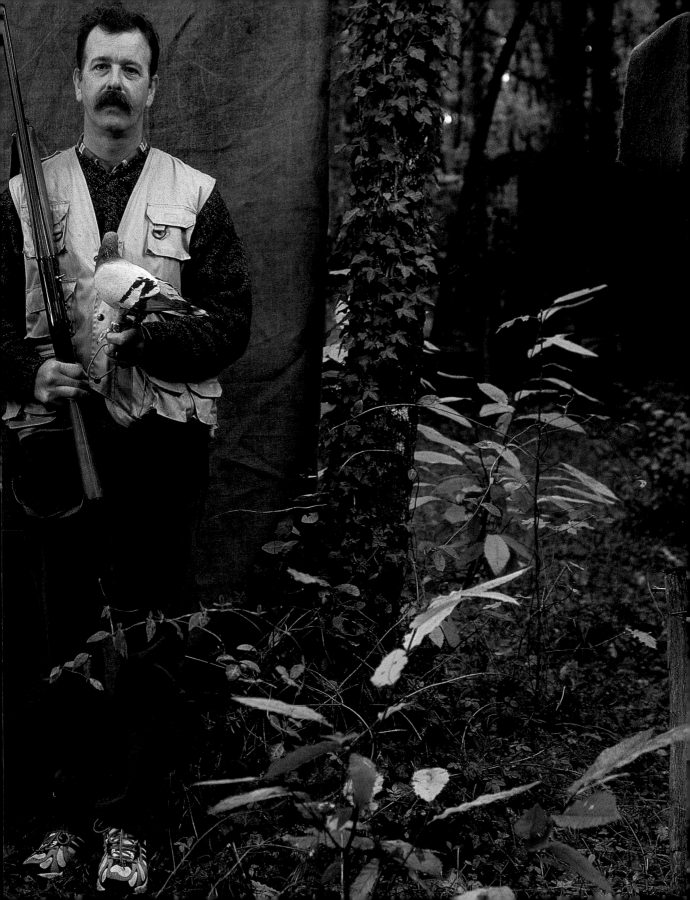

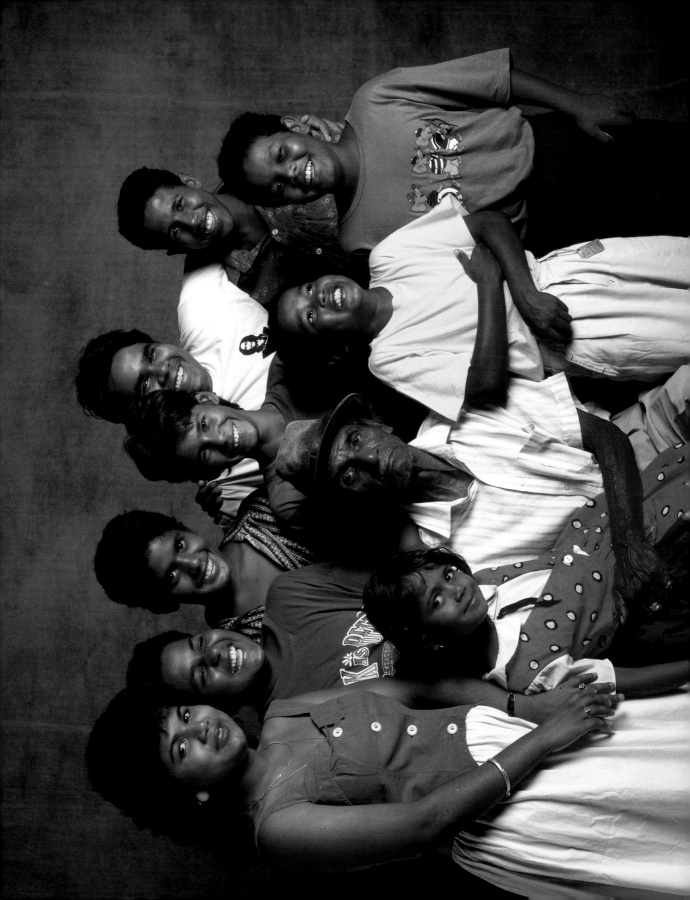

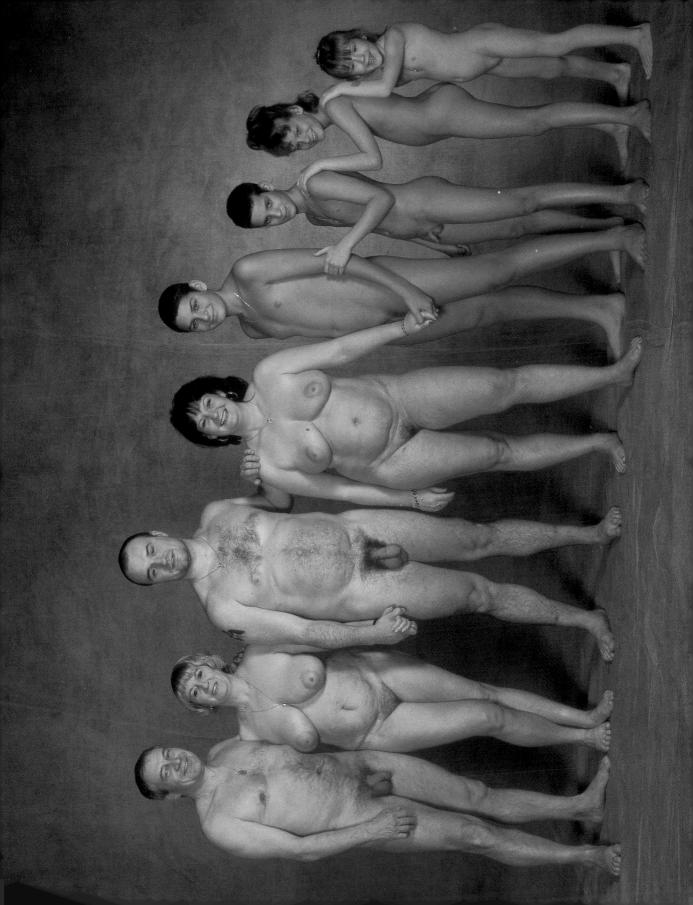

pp. 110–111. Taking photographs of animals in a studio requires at least two assistants. The horse is standing alone. Ambre, on the left, follows the animal with a meshed light box attached to a hood on wheels. On the right, we wave a plastic bag to attract the horse's attention and make it raise its ears.

pp. 116–117. Fantasia Horse, Barbe breed: Bridi Briji, ridden by Abdul Wahabou in the Lamida de Mindif Square (Maroua, Cameroon).

pp. 118–119. Chilean Criollo Horse: Manulo, ridden by Marcelo Rivas-Gonzalez, rodeo rider for Estancia San Lorenzo, and belonging to M. Halo Zunino (Biobio, Chile).

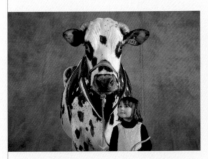 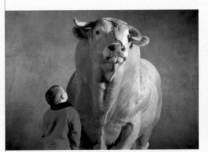 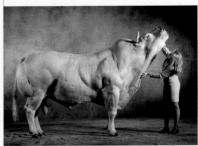

p. 120. Normande Cow: Fusée, age eight years old, with Aurore, daughter of the owner, Mr. Gilbert Parrein from Saint-Nicolas-de-Sommaire.

p. 121. Blonde d'Aquitaine Bull: Gardon, age seven years old, weighing 3,600 pounds (1,631 kg), presented by Jules Claverie and belonging to Maurice Larroque from Fousseret (Agricultural Show, Paris).

pp. 122–123. Blonde d'Aquitaine Bull: Gardon, age seven years old, weighing 3,600 pounds (1,631 kg), presented by Mrs. Váléry and belonging to Maurice Larroque from Fousseret (Agricultural Show, Paris).

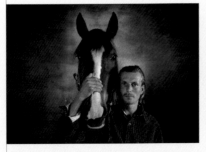

p. 124. Vladimir Mare named Galeteya, born in 1988 and descendant of a long line of racing champions, presented here by Slava Kiceliov (Sokolniki Horse Show, Moscow). "I like to produce photographs of animals as I would portraits. There is a conflict here; you sense both the personality and character of two individuals."

p. 125. Piedmont Bull: Celso, weighing 2,720 pounds (1,234 kg) (Agricultural Show, Paris.)

pp. 126–127. Normande Cow: Océanie, with Mr. and Mrs. Blaise, belonging to the Norman Earl of Englesqueville-la-Percée.

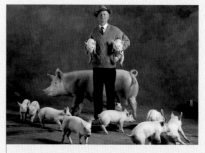

pp. 128–129. Simmental Cow: Lady, with Mr. and Mrs. René Rolland from Vaudremont and their children and grandchildren. "This breeder never got used to posing for a photograph. But to mark his final involvement with the show, all his family made the trip with him. His cow became champion, and when surrounded with those dearest to him, he finally felt at ease."

p. 134. Landrace Gilt Pig: Anslet, presented by its owners, Mr. and Mrs. Uglow from Devon (Royal Show, England).

p. 135. Large White Pig: Felomena and her offspring, with owner Giovanni Ottorino from Fieragricola, Verona, Italy. "Photographing pigs are by far the dirtiest, liveliest, and funniest sessions, too. They run everywhere so we have to close them in with boards and constantly move the lighting."

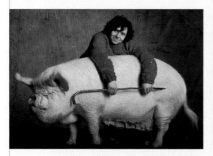

pp. 136–137. Middle White Pig: Gilhouse Fairlady V, known as Little Pudding, presented by John Hurford and belonging to Mrs. Viki Mills from Devon (Royal Show, England).

p. 140. Bullmastiff with Jean-Pierre Guillement.

p. 141. ◄ Dwarf Schnauzer with Mr. and Mrs. Peeters.
p. 141. ► Belgian Sheepdog and Guy Lamotte.

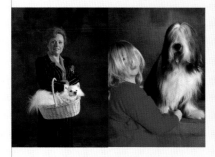

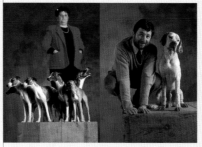

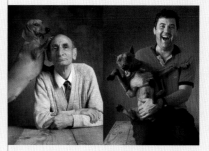

p. 141. ◄ Medium Spitz with Jacqueline Peracini.
p. 141. ► Bearded Collie with Françoise Pouliquen.

p. 141. ◄ Whippets with Jackie Bourdin.
p. 141. ► Ariège Braque and Alain Deteix.

p. 141. ◄ Standard Teckel and Serge Mallet.
p. 141. ► Medium Pinscher with Jean-Luc Bony.

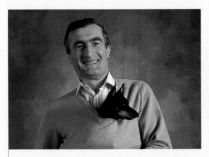

p. 141. **English Toy Terrier and Mr. Gland.**

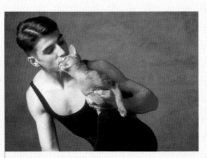

p.142. **Abyssinian Sorel Cat: Cinnamon's Fersen, presented by and belonging to Franck Massé.**

p. 143. **Foreign White Siamese Cat: Genghis Khan of the Sacred Lands, presented by Alexandra, daughter of the owner, Christiane Merckx.**

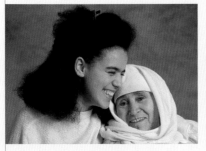

p. 148. **A young North African girl with her grandmother, having just arrived from Algeria. (Photograph taken for *L'Express* magazine, special fortieth anniversary edition.)**

p. 149. **Pierre and Chantal Oger, butchers from Monfort-l'Amaury. (Photograph taken for *L'Express* magazine, special fortieth anniversary edition.)**

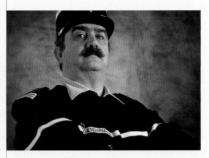

p. 150. **Gilbert Trouilh, a policeman. (Photograph taken for *L'Express* magazine, special fortieth anniversary edition.)**

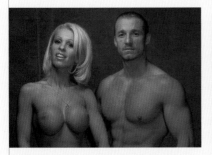

p. 151. **Dolly Golden and Marc Barrow, X-rated film actors, Hot d'Or winners 1999 and 2000.**

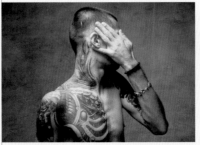

p. 152. **Emmanuel Dauchez, known as "Manu le Malin," international DJ, tattooed by "Tintin."**

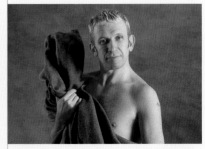

p.153. **Jean-Paul Gauthier, fashion designer.** "Jean-Paul Gauthier immediately took up the canvas and draped himself in it. We recognized the fashion designer in him."

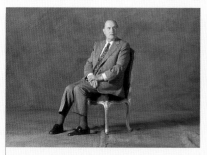

p. 154. **François Mitterrand, President of France.** "When we arrived at the Élysée Palace to take the President's portrait, a shocked officer from the republican guard exclaimed: 'You're not going to photograph the President in front of your pigs' canvas?' François Mitterrand arrived and with a lot of humor remarked, "Let's get started, I am today's animal…".

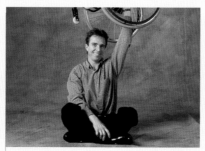

p. 155. **Jean-François Poitevin, hemiplegic.**

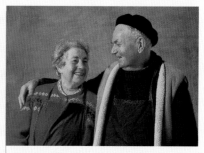

p. 156. **Denise and Robert Virard, sellers of fresh fruit and vegetables.** (Photograph taken for *L'Express* magazine, special fortieth anniversary edition.)

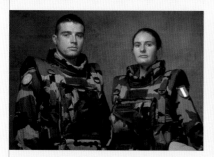

p. 157. **Staff Sergeant Emmanuel Laplace and Corporal Alexandra Mellef of the twenty-seventh Battalion of Alpine Hunters in Cran-Gevrier.** The blue helmets denote a mission in Lebanon, April to August 2000. (Photograph taken for *L'Express* magazine, special fortieth anniversary edition.)

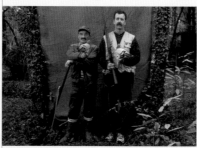

p. 158–159. **Michel Barde and Gérard Breton, woodpigeon hunters.**

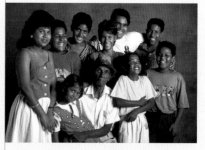

p. 160. **Jules Naminzo, eighty years old, with his grandchildren.** He spent forty-two years at a sugar-producing factory in Stella Matutina Saint-Leu, on Réunion Island. "Something always comes across in a family photo. Love, tenderness, and friendship are communicated. Such emotion enriches the photograph and I often encourage people to make gentle gestures they might not otherwise make."

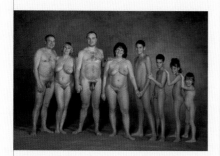

p. 161. **Serge, Monique, Éric, Isabelle, Jonathan, Cynthia, Morgan, and Tatiana** were photographed for a naturist calendar. Yann acknowledged their self-confidence, charisma, and natural simplicity.

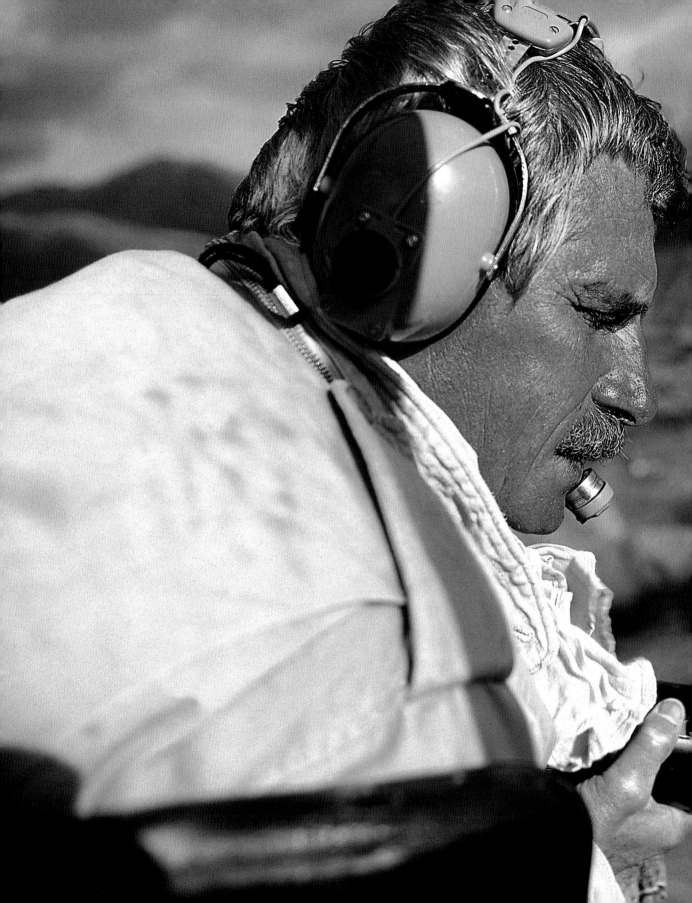

It is hard to believe that ten years have already passed since I first set off on this *Earth From Above* adventure, with my small team of followers around me. We never dreamed in 1993 that the project could take on such proportions ten years later. Our idea was simple; we would raise public awareness of the Earth's beauty in order to better condemn its problems. It was simple, certainly, but ultimately more ambitious than any of us could have imagined.

We have been working under the pressure of an overwhelming success, with the obsession of trying to remain equal to the task. It is an honor that thousands of people have traveled to view the exhibitions or buy the book.

The success has changed us; we are increasingly more demanding of the depth of our knowledge of the Earth and her environment. Feedback from a great many readers, as well as discussions with scientists, has reinforced our understanding, but at the same time has raised certain doubts. We are aware that as time passes, there is always something more to say, show, or prove. The more aware the public has become, the more my commitment has evolved in the face of expectation.

And so I will continue producing photographs of the Earth in order to impart a message to current and future generations on the need for sustainable development.

I believe today, more than ever, that the impact of a photograph is derived from the message it conveys.

Aerial Photography

Yann produced his very first aerial photographs in Kenya, as one may recall, aboard the hot-air balloon he was using to escort tourists. It was on his return to Paris that he learned an American had acquired permission to fly over the capital and take photographs. He immediately made up his mind to obtain the same agreement, which was eventually granted two years later. He was initially motivated by the challenge. "Why could I not obtain something that had been ceded to an American?" But with the challenge came enjoyment; Yann is someone "who loves flying."

He quickly became a specialist of an extremely difficult and expensive field, resulting in many years and books "From Above." Hours spent in a helicopter are costly, while "it is more difficult to center photographs from a plane." There is also a great deal of travel involved in reaching far-flung destinations. Acquiring the clearance to fly over and photograph certain areas remains virtually impossible in some states. Once on location, the meteorological conditions must be right—a cloudless sky is essential—and even when they are, certain authorities can prove fastidious, deciding quite simply that a flight be canceled. These difficulties, however, did not prevent Yann from devising a hugely ambitious project in 1993, based on the idea of producing a photographic account of the planet. "The idea stemmed from convictions made during meetings with people working on our current day health and ecological problems." A future book was planned to mark the passage into the new millennium. During the preceding seven years, the venture benefited from the support of UNESCO, which recognized the scale of the work. Despite encountering numerous problems along the way, a project gathered momentum. One hundred and twenty thousand photographs became listed and hundreds of countries were duly ticked off the planner. This was the result of many flight hours and an exhausting life marked by worry.

It also created nightmares for the assistants responsible for managing the ever-growing collection of photographs. In view of the time limit and material already gathered, the publication soon came back under consideration. But Yann,

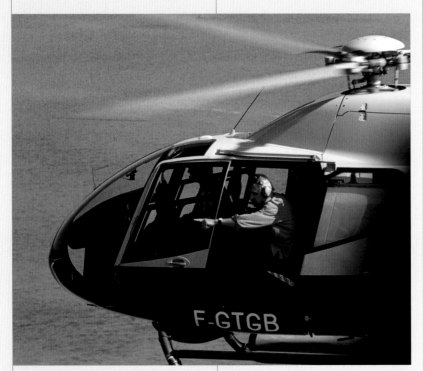

F-GTGB

◄ When flying, I try to really concentrate. I am looking for an image. An *Earth From Above* photograph isn't found every time. You shouldn't assume it just reveals itself to me during each flight! No, I am someone who has had to put in many hours, who has worked in teams a great deal. Of the beautiful photos I have taken of the Earth, I can perhaps find about twenty in a year. It really requires tremendous concentration to find a striking image that can give rise to an emotion and be supplemented by a caption. You can't explain why these photos move you; they need to be accompanied by the text. It is a combination of different things; I am looking for a sense, a style, an emotion. A great photograph cannot be invented; it is a present to be received.

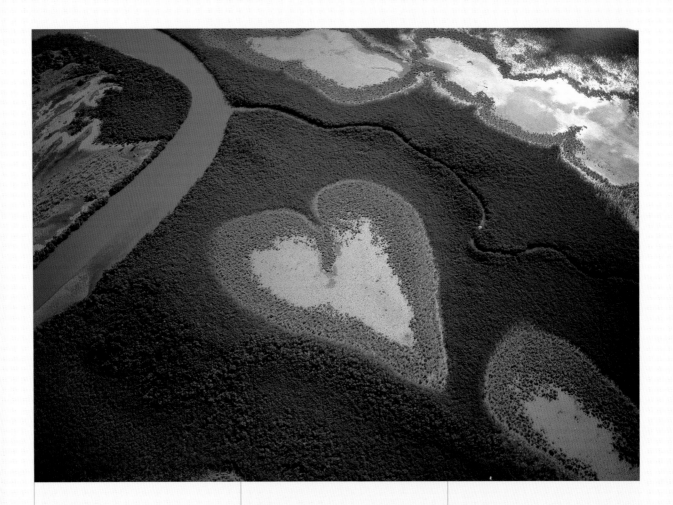

▲ Yann was flying over New Caledonia in 1992 when the pilot said to him: "I want to show you something." Yann came across the clearing in the shape of a heart formed by the Voh mangrove. "I was astounded. I thought the photo would be interesting but never imagined it would become such a significant, enduring message of love on behalf of the Earth. It became the symbol of our project."

▶ Ten years on, the mangrove has naturally reclaimed the heart.

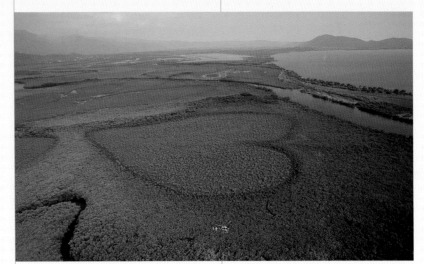

a perfectionist never satisfied, wanted to cover the countries he had not been able to fly over previously, such as China. It took all the diplomatic skill and friendship of his publisher for him to "let it go." Meanwhile, his artistic director went out of his way to accommodate all the captions as they were of such importance to Yann. It was an absolute requirement that his photographs be accompanied by a precisely written text. They lend significance to a study that has spanned many years. Yann, inflexible as ever, rejected the first version of the text because it did not fit within the precise idea of what he wanted. The second version, however, was approved, even if it still did not fully meet with his aspirations. One hundred and twenty thousand copies of the book were consequently printed and the publication entered bookstores at the end of 1999. It sold out in three weeks.

Production had barely covered demand. The success not only exceeded all expectations, but also signaled a revolution. Although a film, novel, or song earning worldwide fame is a commonplace occurrence today, a book of photographs achieving similar acclaim was unheard of. The number of copies sold, in all variety of translations, has risen to over more than two million. And the book, frequently revised, continues to sell.

Earth From Above is the apotheosis in Yann Arthus-Bertrand's photographic career. The success of the book was a personal triumph, while at the same time it continues to flourish because it expresses his ideals with previously unseen splendor. His aspirations and qualities (challenge, demand, and necessity) unite to galvanize and enliven his work. Together, they are intimately and harmoniously

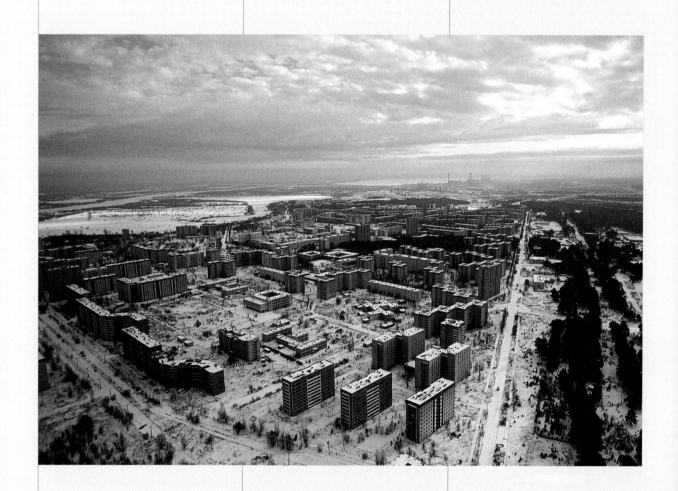

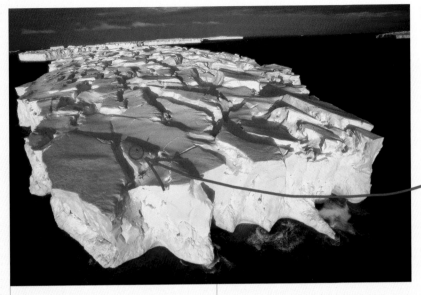

◄ Upon this Antarctic iceberg, a glaciologist gives the photograph scale. The highly skilled pilot accompanying Yann was killed in a helicopter crash four days later. Contrary to a lot of helicopter missions (whether at night, lifting heavy cargo, rescues in very difficult weather conditions, etc.), aerial photography is predominantly conducted in ideal weather and safe conditions.

◄▼ Pripyat, Ukraine: "This photograph is not particularly interesting in itself, neither 'good' nor 'beautiful.' Nevertheless, all this changes when you become aware of what is actually being shown. There is no longer a single inhabitant. All these buildings and houses stand completely empty. Fifty thousand people were evacuated, never to return, because a nearby nuclear reactor exploded at Chernobyl."

entwined, bestowing an ode of love upon the photographer and his glorious photographs. The heart in Voh, on the cover of the book, exists as evidence.

The idea of arranging an exhibition of a hundred or so photographs developed alongside the book's incredible success. Catherine Arthus-Bertrand, Yann's sister and a member of his team, remembers: "The book was just selling and Yann found himself in a slightly helpless position. He considered the exhibition as the best way of prolonging the most significant project he had ever worked on. At the same time, it would enable his images to be perceived through a different medium." But producing an exhibition was far from straightforward. Yann had a very precise idea of what he wanted. Two of his requirements did nothing to facilitate the process; he had uncompromisingly demanded a lively venue

and free admission as two fundamental requirements. The size of the photographs also required that the space be large enough to accommodate them and in any case, "color photographs are often passed over," he points out. "*Earth From Above* images were not scientific enough for La Villette park in Paris and not artistic enough for a photographic museum." The doors to potential exhibition spaces closed one after the other. Yann enlisted the invaluable support of Robert Delpire, former director of France's *National Photography Centre* and the then director of communications at the Senate. "He was a major figure in the photography world, set apart from all others. I was just taking banal landscape photographs and he was able to see beyond that."

Discussions began with those at the Luxembourg museum in Paris. Yann wanted to hang his photographs from the garden railings outside,

so as to reach as many people as possible. The most crucial obstacle was financial, however, and Yann committed himself to finding and investing the necessary money. The exhibition was initially set up on the rue de Vaugirard, and was then moved to the crowded rue de Médicis, where it attracted some two million visitors.

The photographer confesses his pride at "having created such an exhibition—less sacred and academic than most, but more popular and exciting." It was indeed a world first. Yann had reached his goal, and joined the onlookers as often as he could. Catherine specifies that "the exhibition enabled him to have contact with the public, and its environment suited him better than the book. It provided yet another dimension to his work." He experienced a sense of fulfillment because he is a photographer who wants his

171

photographs to be seen, understood, and hopefully appreciated by the major public. "The streets were ideal, although opportunities to speak with the viewing public were rare. When the captions began to supplement the photographs, it reinforced their interaction further. People could participate in our message through the beautiful intermediary of the photograph." It is with endless pleasure that he signs the books, postcards, and posters people present to him. "I have met passionate people so affected by the exhibi-tion's message that they wish to share it in other countries. The project had begun to expand beyond us and I am tremendously pleased to have been aided by such enthusiastic organizers."

The commercial aspect of the project would be wrong to despise and a mistake to suppress. It was the strength of the public's reaction and the emotional experience shared that resulted in the exhibition

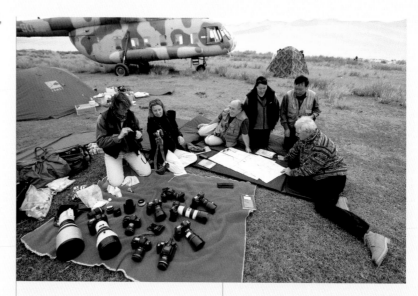

▲ A momentary delay in Mongolia. Yann and his team make the most of it by cleaning all the equipment; this is usually done every two days. "Eighty percent of the photographs result from a stroke of luck," yet this could never occur without the preparatory work done on the maps before each flight.

▼ Once inside the helicopter, the doorway must remain open to take photographs. I have never been too hot, but rather always too cold! Above Mont Blanc, the temperature reached minus forty degrees. Franck Charrel, one of my key assistants on the *Earth From Above* project, wasn't able to load the film because it kept breaking with the cold.

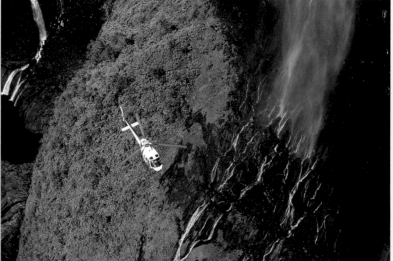

DATE	TRAJET EFFECTUE	DEPART	ATERR.	H. DE VOL	CUMUL
7/09	U.B → ARVAYKHEER	16ʰ31	19ʰ45	3ʰ14	
8/09	ARVAYKHEER → GOBI 2	7ʰ37	9ʰ40	2ʰ03	5ʰ17
8/09	GOBI 2 → DALANZDGAD	11ʰ20	12ʰ07	47 min	6ʰ04
8/09	DALANZDGAD → GOBI 1	14ʰ20	14ʰ37	17 min	6ʰ21
8/09	→ VALLEE FAUCON Alle	16ʰ45	17ʰ09	24 min	6ʰ45
8/09	'' '' Retour	18ʰ34	18ʰ44	10 min	6ʰ55
9/09	→ DUNE	14ʰ35	15ʰ40	1ʰ05	8ʰ00
9/09	retour DUNE	17ʰ46	18ʰ51	1ʰ05	9ʰ05
11/09	→ Vallée d'Yol → Bayanzag	8²⁰	10¹⁵	1⁵⁵	11H
11/09	→ 2-ème base touriste	17⁰⁰	19¹⁵	2¹⁵	13H15
11/09	→ Dune de Khongor	19⁴⁰	20²⁵	0⁴⁵	14H
12/09	→ Dalanzadgad	9⁰⁷	10⁰⁷	1H	15H
12/09	→ Mandalgobi	12H35	13H55	1H20	16H20
12/09	→ Ulan Bator	16H05	18H45	2H40	19H.

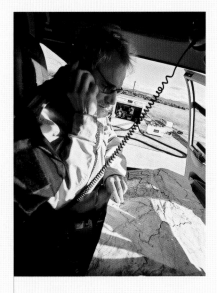

▲ Before takeoff, we are often still resolving flight-clearance problems.

◄ Hours in a helicopter are very costly and all flight times are recorded, as well as their route and destination.

being installed in fifty of the world's biggest cities. The success of the book, translated into fifteen languages, is less important to him than the exhibition, which remains more alive and is constantly renewed. "As with each new edition of the book, the exhibition is consistently updated with new photos and rewritten text. Photographs in relief have even been included for the blind and partially sighted. The last evolution touches me because I am always looking to make the exhibition more accessible and those with sight also attempt to reinterpret the picture through touch."

"I have had the intuition, or perhaps luck, to raise issues that people were anticipating." One may not like Yann Arthus-Bertrand's photographs, understand them, or even accept their message, but the enthusiasm and emotion they ceaselessly inspire remain unquestioned. There is an intensity and mystery about them. Such expression testifies to the fact that humanity, in its many different guises, shares a common adventure.

As with all photographers driven by a vision, Yann pursues his objectives. His energy, determina-

tion, perseverance, and exactingness reveal the sheer extent of this quest. Being a photographer is an expression of passion. "Someone has to stop me. I must exhaust every avenue. When flying above a potentially good photograph, I don't want to let it go and move on; I can't just let it go. It makes no difference that I already know a single image will be selected out of a possible ten. The helicopter pilot becomes uneasy, fidgeting in his seat and indicating that our fuel reserves are running out…. In the end, it is often my assistant who says to me: 'It's okay

DATE : Mercredi TRAJET : Nord Lyon.
HEURE DE DEPART : Beaujo
HEURE D'ATERRISSAGE : VOL A.M.
 VISI BOF...

BOITIERS :			N° PELLICULES
A: 2m	D: 50	G: 70.200 J:	ET
B: ~~20 35~~	E: ~~85m~~	H: 200 —	NOTES
C: →20/35	F: 400m I:		

→ SALLES - ARBUISSONNAS.

[N 46° 02' 23"
[E 004° 36' 26

Église

Beaujolais

← SUD

MONTMELAS - Chateau.
St Sorlin tourelles GPS
 Gd Willy

FILMS POUSSES

→ Violet le Duc.

+ Vignes
autour.

Changement C

C ✱ 15 ✓
G 16 ✓
17 ✓

VOIR
70 - 200
STABILISÉ.

H 18 ✓ VÉRIFIER
H 19 ✓ 35mm

G 20. ✓
21 ✓
22
23 24

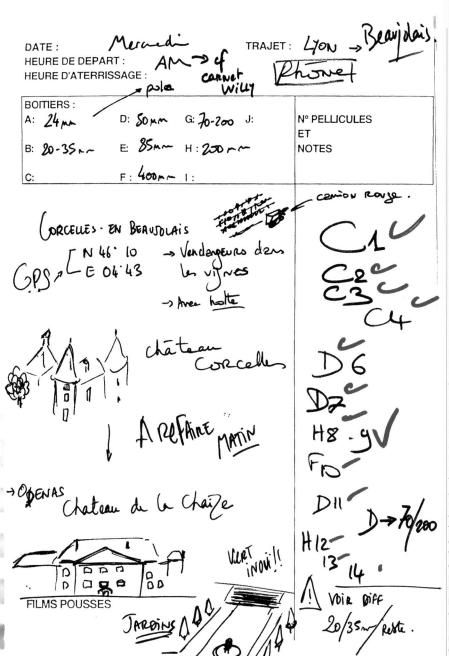

DATE : Mercredi TRAJET : LYON → Beaujolais.

HEURE DE DEPART : AM → cf Rhône

HEURE D'ATERRISSAGE : carnet Willy

→ pola

BOITIERS :

A: 24mm	D: 50mm	G: 70-200	J:	N° PELLICULES
B: 20-35mm	E: 85mm	H: 200mm		ET
C:	F: 400mm	I:		NOTES

camion Rouge.

CORCELLES · EN BEAUJOLAIS

GPS [N 46° 10 → Vendangeurs dans
 [E 04.43 les vignes

→ Avec hotte

C1 ✓
C2 ✓
C3 ✓
C4

Château Corcelles D 6

D7

↓ A REFAIRE MATIN H8 · 9 ✓

F10

→ ODENAS Château de la Chaize D11

D → 70/200

H12

13 14

⚠ VOIR DIFF

FILMS POUSSES VERT INOUI !!

JARDINS 20/35mm / Reste.

◄ Each country we fly over has its own flight log. Here we have that of the Rhône, used by Sybille, an assistant. Everything photographed is carefully noted. You are moving very quickly in a helicopter and can lose your bearings in no time at all. There aren't any signs in the sky to tell us the name of the town we are flying over, nor people to ask which way we are going! The task is a lot simpler when the helicopter is equipped with GPS, but a flight log is always invaluable. We sometimes go through hundreds of rolls of film per week. The rough sketches, and location points of villages that we mark on the map while flying, are also crucial when writing the captions once we are back in Paris. A photograph without a caption is unusable. In the helicopter, an assistant juggles between at least eight different cameras on which different lenses are mounted. Each film is carefully labeled with a number recording the particular flight and a letter corresponding to the appropriate camera it came from. This enables us to detect any subsequent technical problems.

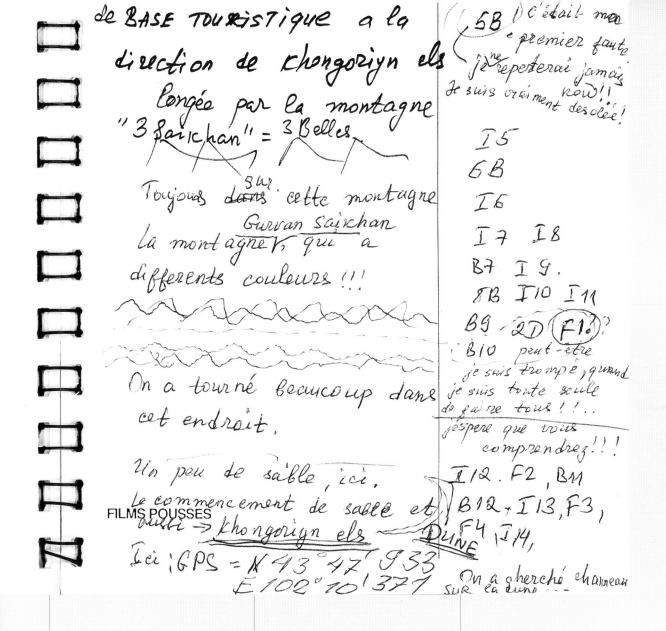

Yann, you can stop now.' In any case, the results are never as I had hoped. I am one of those people who always wants things done well, but this can detract from the pleasure of the moment." His passion is absolute. "It is the sign of an engrossing character and an obsession with photography. At the *Aventure Festival* in Val-d'Isère, children were inundating me with questions. They proved a great deal shrewder than the adults. One of them piped up with: 'Monsieur Arthus, how do you feel when you see something beautiful without your camera?' The youngster had hit the nail on the head; to miss out on an image in this way or because I could not react in time would infuriate me. I cannot just accept it and take another one, another time. At such moments, I feel extremely angry at the situation or myself. I would rather not see something extraordinary if I am unable to photograph it." But when all the elements are there—the timing of the shot and the click—the happiness he experiences is astonishing. "Moments when everything comes together are rare and magical. A few thousandths of a second can remind me why I am a photographer."

BOITIERS :

A:	D:	G:	J:	N° PELLICULES
B:	E:	H :		ET
C:	F :			NOTES

La rivière Tuul

B19

I20 B21
820 I21 I22

Khustain nuruu

B22 A4

I23

GPS = N 47° 40' 307 I24
E 105° 52' 190 F4, F5

Vol
SUR ULANBATOR. I25
28-70 = x3

FILMS POUSSÉS A5
I26
B23

▲ Yann prepares a flight with Willy, his helicopter pilot. After obtaining clearance and supplying the relevant authorities with the flight plan, researching locations on the map marks the final stage of the process before takeoff. Flights occur during sunrise or sunset to capture the best light, one that accentuates patterns and the surrounding landscape. Hours in a helicopter are very expensive and there are rarely any research-based flights. "The relationship I have with my pilot is essential. The pilot effectively stands between me and the photograph I want to take. They must understand exactly how I want to be positioned and what I am attempting to do."

◄ Sometimes a guide from the country helps us to complete the flight log. These pages communicate useful information to those who will subsequently work on the photographs; it is a difficult task for those not accustomed to it. It occasionally provides us with unusual material, as the annotations in the margin show here, taken from the flight log on Mongolia. The assistant mistakenly wrote the wrong film number, but that is forgivable considering the tremendous amount of responsibility she shoulders.

Through her beauty and fragility, the Earth viewed from the air reinforced the underlying beliefs at the heart of Yann's work. These beliefs center on the need to promote sustainable development, to raise public awareness of earth conservation and the sensible management of natural resources.

Ten years of travel and flying have taught him about the world and its borders, although it remains an awareness that he finds, in some ways, restrictive. Pleasure in itself is no longer enough. "With the means I have at my disposal, I cannot afford to take the project lightly." It is a kind of moral obligation that continues to drive him even further. He finds expression today in "the fundamental need to be of use; to instruct and to inform."

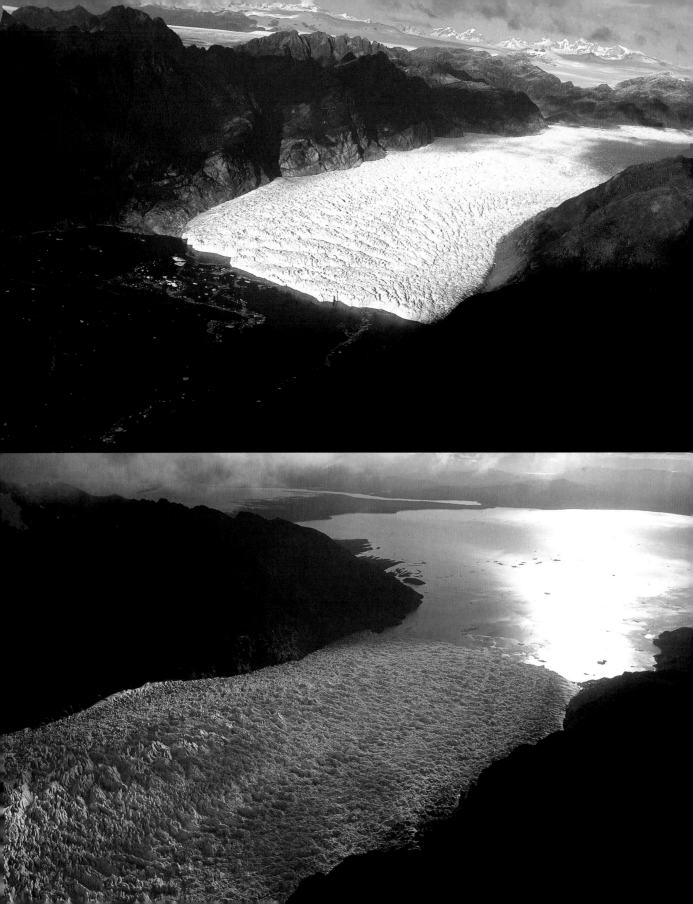

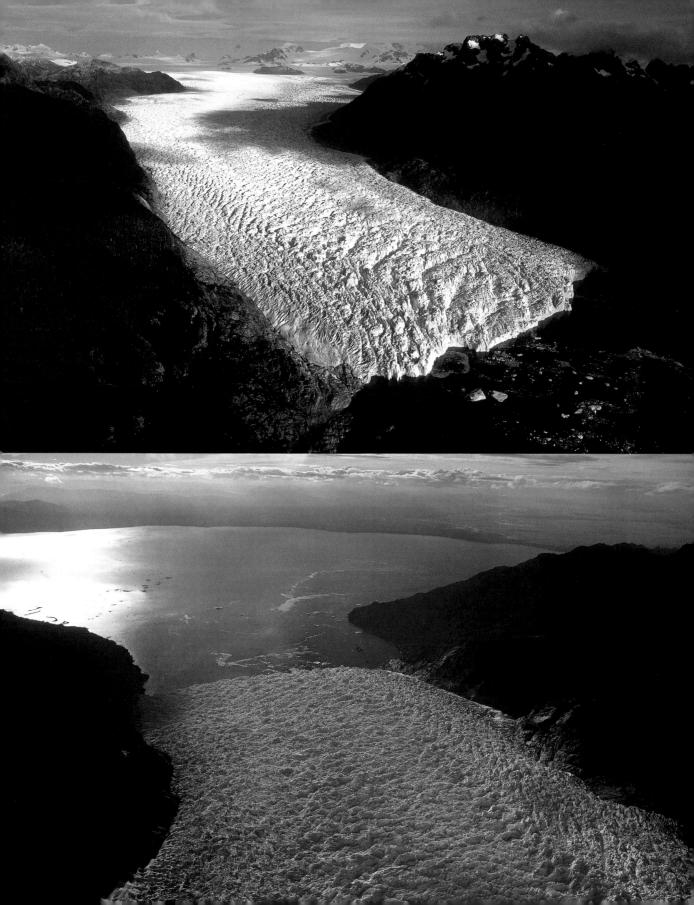

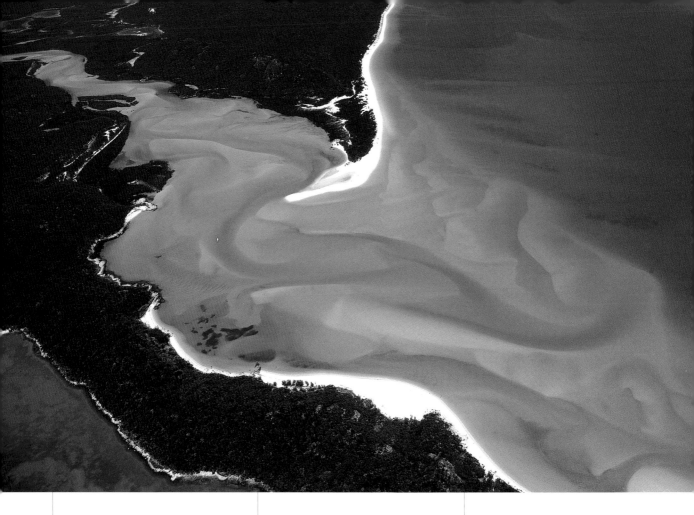

All *Earth From Above* photographs are supplemented by a scientific text, explaining the image and describing the ecological or social problems encountered in the region or even the world. This text is critical to the image, as it lends it meaning. The emotion touched by the photograph prompts you to read the accompanying lines. Once read, you return to look at the image for a second time. When producing the first edition of *Earth From Above*, I initially found it difficult to accept that the texts should occupy such a large space next to the photographs.

◄◄ In March 2003, Yann was flying over Chile's San Rafael glacier that borders the Pacific. "When circling above the ice in the helicopter, I noticed it was turning from white to sky blue, a blue that seemed unreal against the sunlight. It was magnificent and impossible to have predicted before setting off."

▲► Two shots taken at high and low tides, with and without a polarizing filter. This coastal photograph of the Whitsunday Islands in Australia is, for me, aerial photography par excellence. You have the brilliant detail of the sand banks, the vivid assortment of colors, and, adrift amongst it all, a boat to scale the photograph.

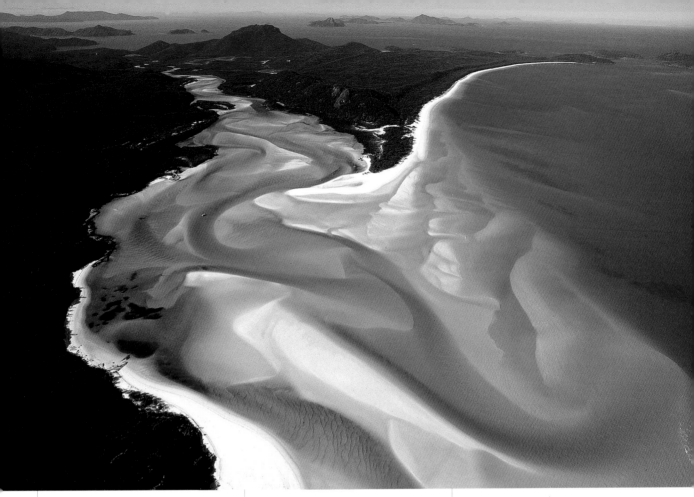

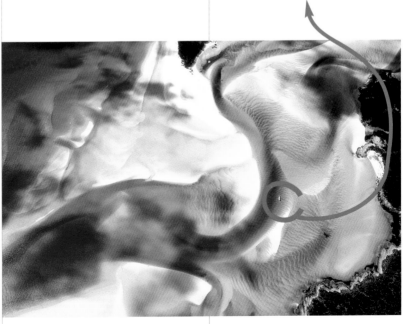

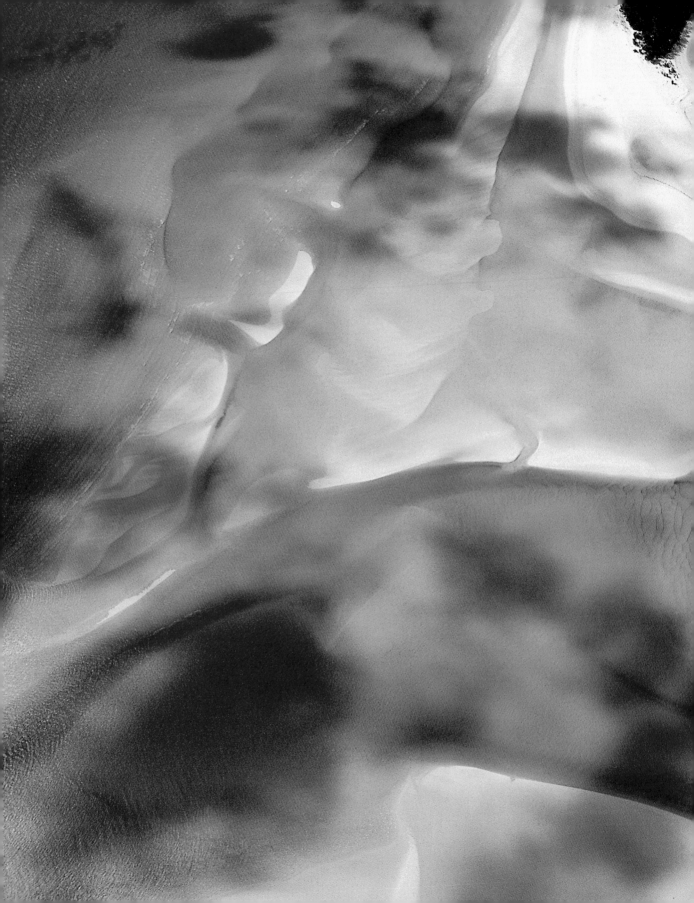

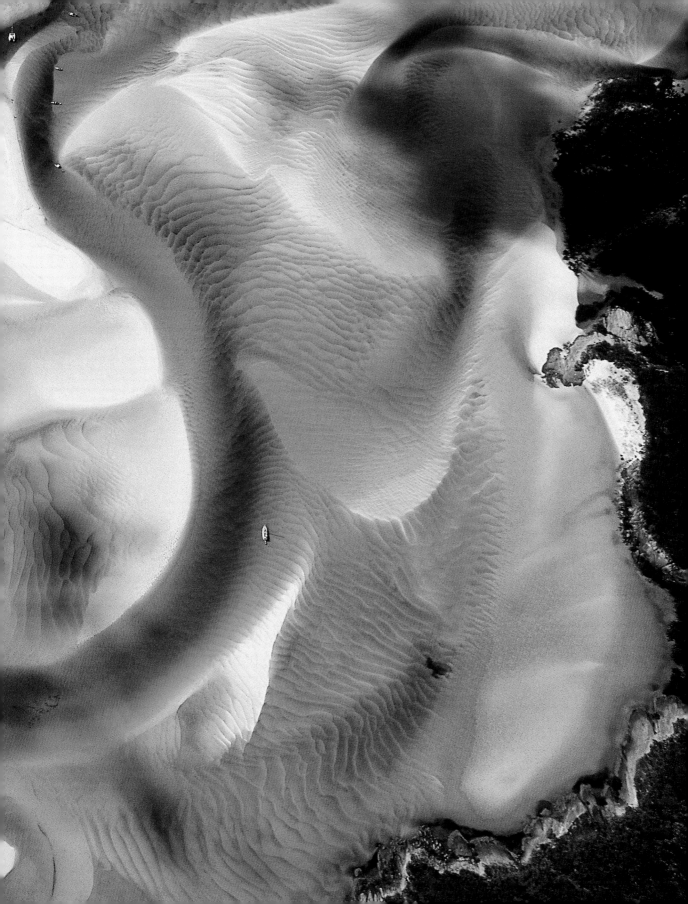

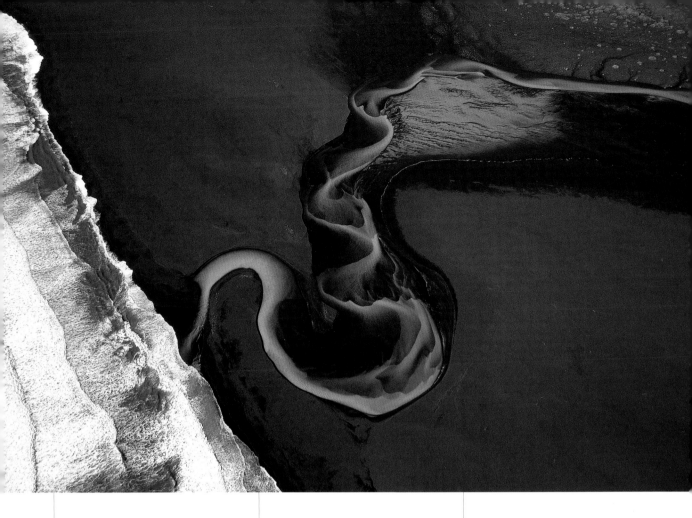

▲▶ Iceland is a tremendous country for aerial photography; you have the impression that this is where the world was first created with its water, fire, volcanoes, ice, lava flows, and black sand. Here, I photographed the mouth of the Markarfljót River in the Myrdalsjökull region using the same camera, at the same time. I simply approached the river from two different perspectives. The first of these is where the water reflects the river—you can't see a thing. The other shows the rich colors of the water carrying organic residues and basaltic sediment stemming from erosion by volcanic lava.

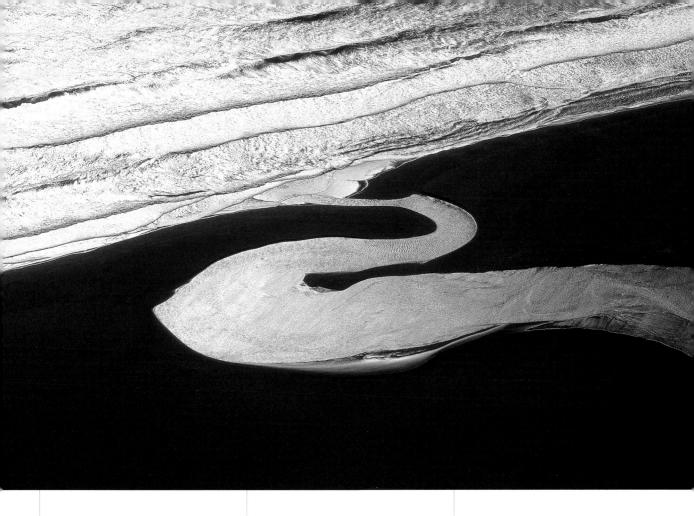

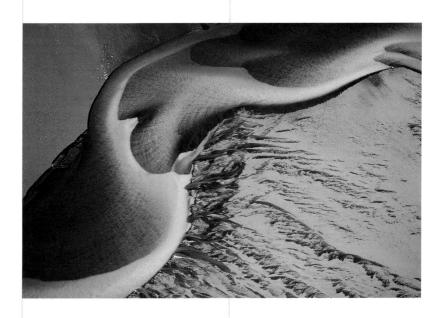

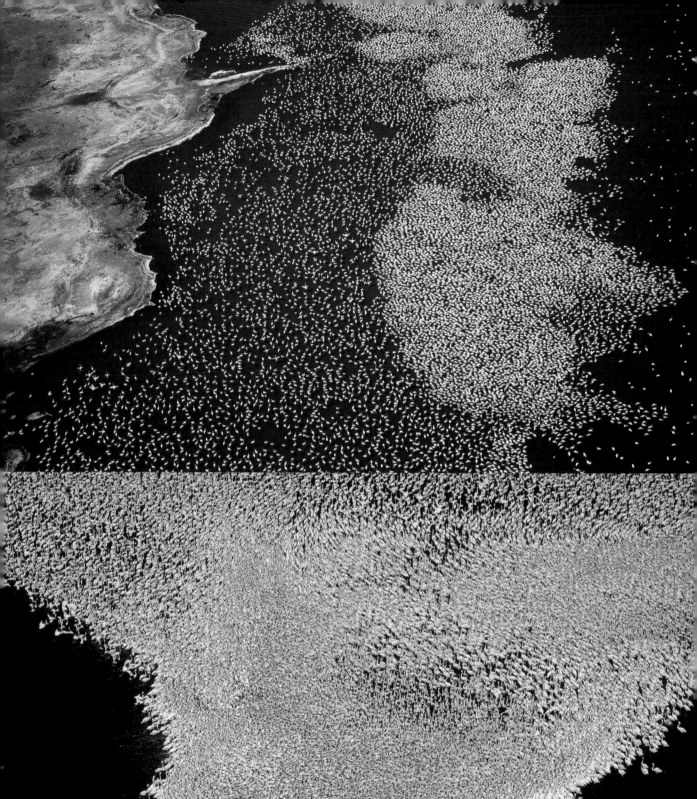

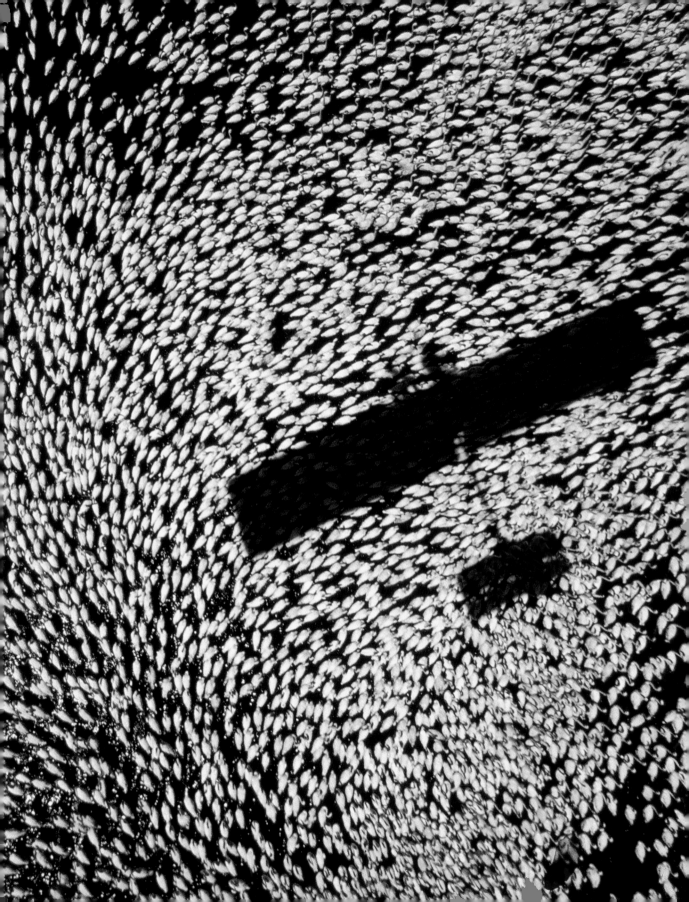

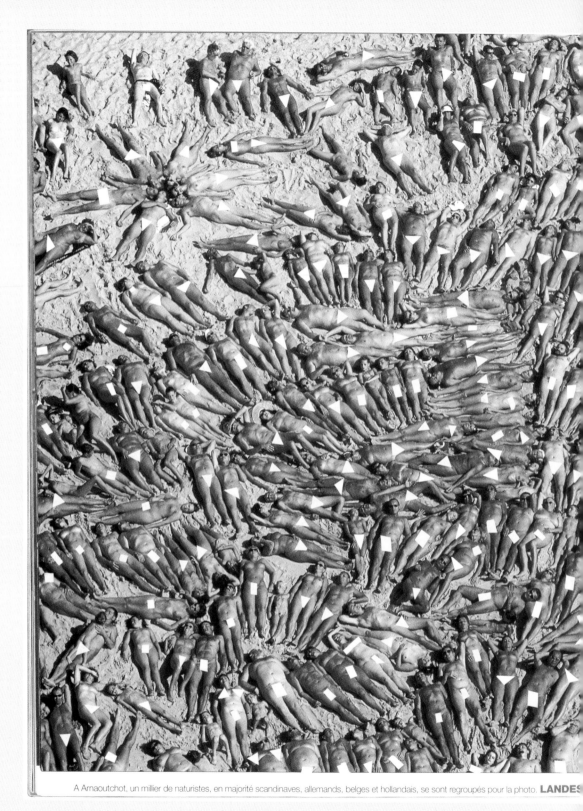

A Arnaoutchot, un millier de naturistes, en majorité scandinaves, allemands, belges et hollandais, se sont regroupés pour la photo. **LANDES**

I wanted to take a photograph on the subject of tourism, the connection between the human body and nature, and the problem of the sun with the hole in the ozone layer. Nudists from the centre d'Arnaoutchot, in the Landes region of France, kindly agreed to come together again to make this photograph. *Paris-Match* published it in an article about Europe. But in

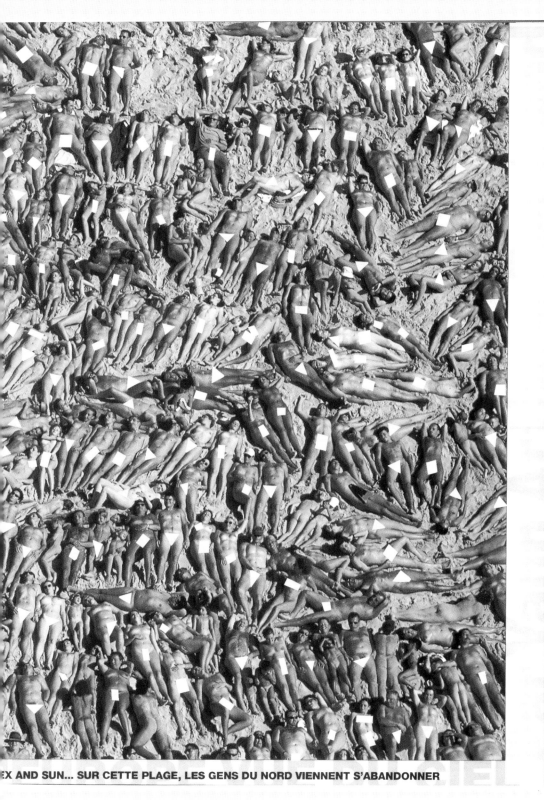

EX AND SUN... SUR CETTE PLAGE, LES GENS DU NORD VIENNENT S'ABANDONNER

Malaysia, the government censored it. And for all the *Paris-Match* copies distributed in the country, a government official spent hours pasting white pieces of paper over the breasts and genitals of each person gathered in this image. Different countries, different cultures. My thanks go to Didier Millet who sent me this copy of *Match* from Singapore.

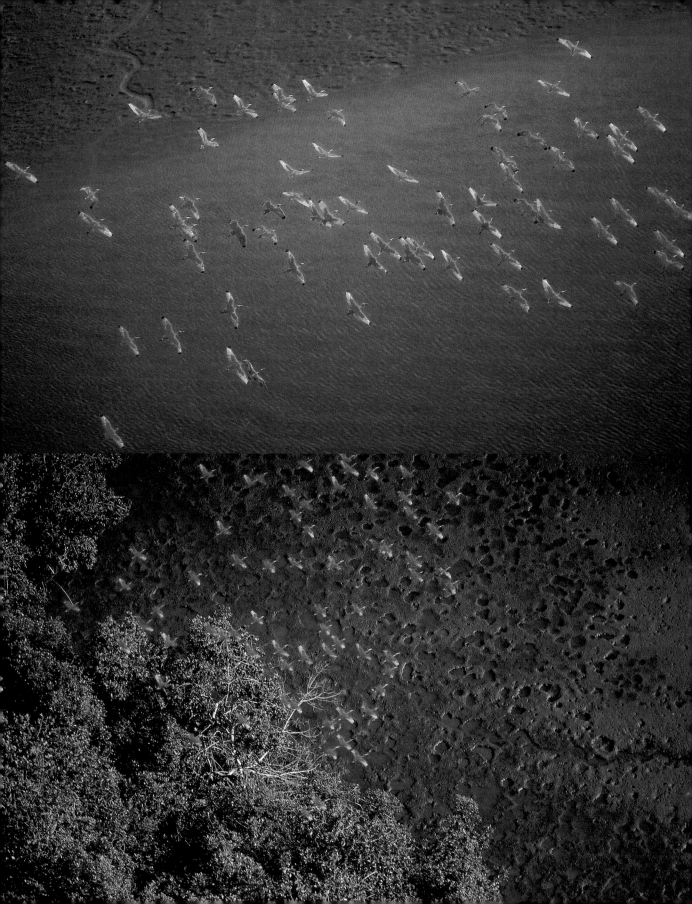

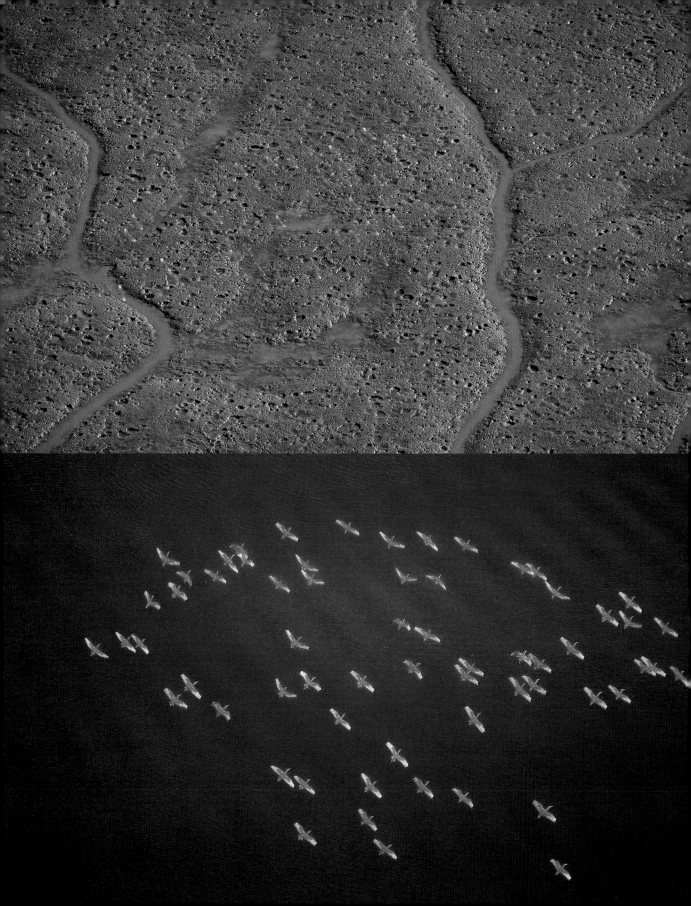

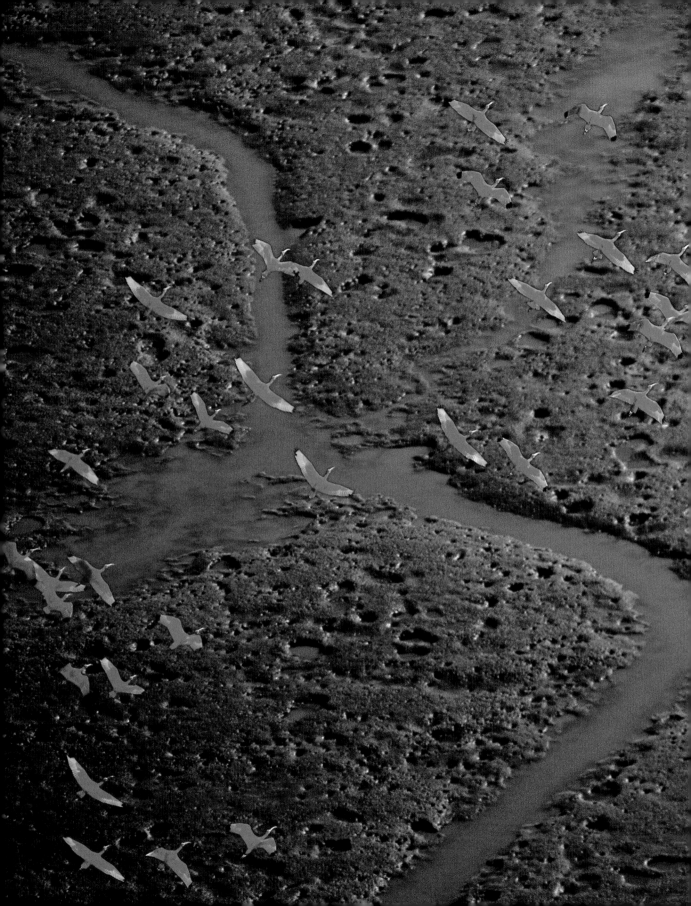

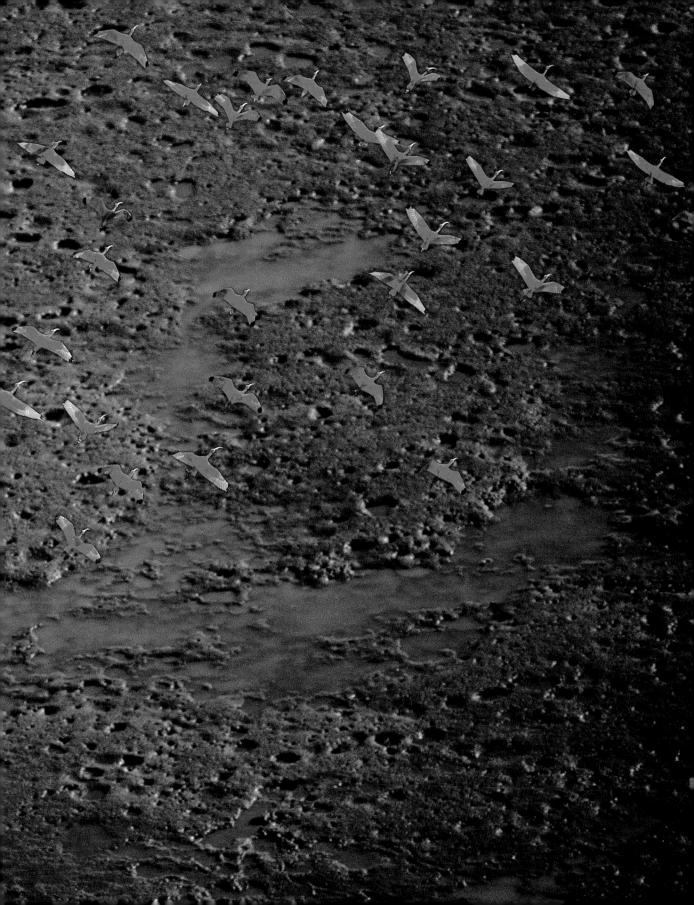

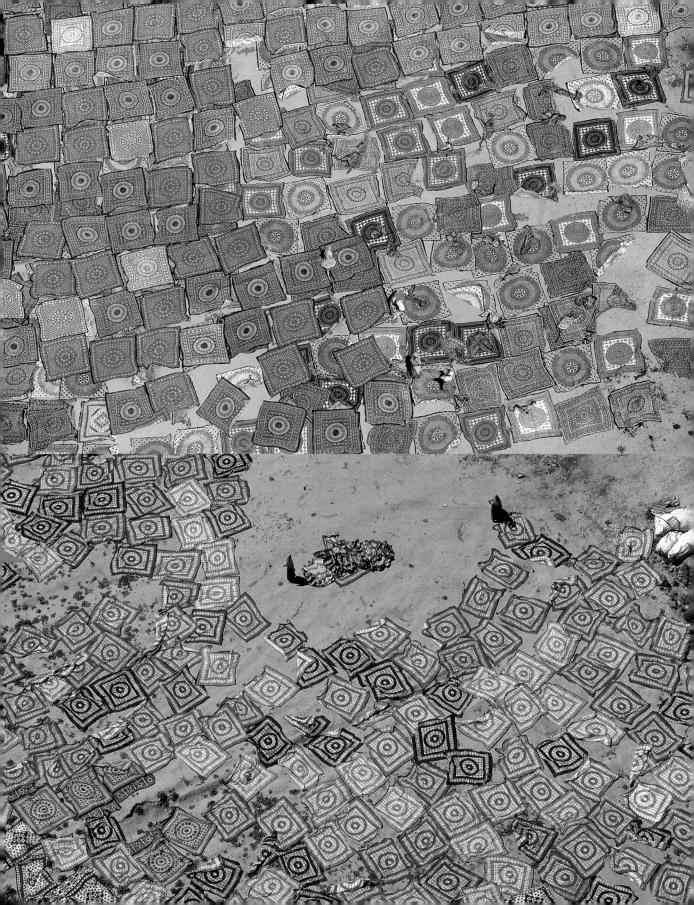

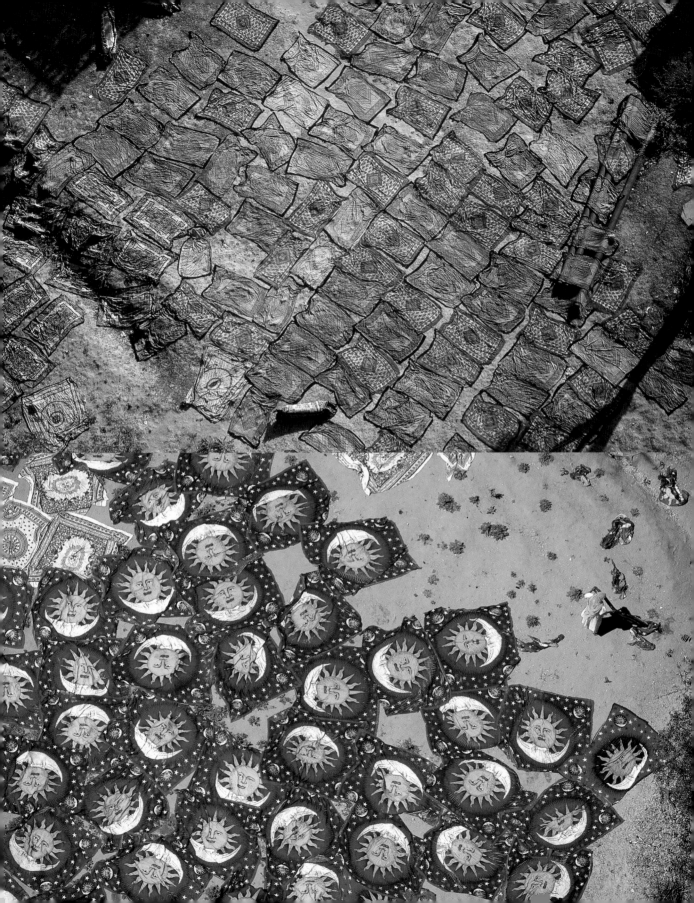

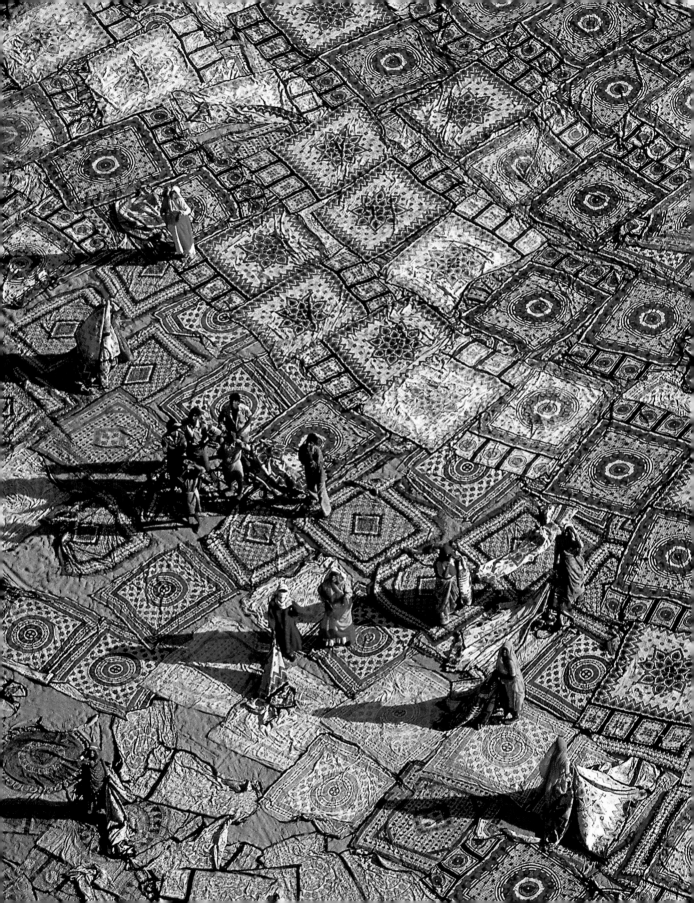

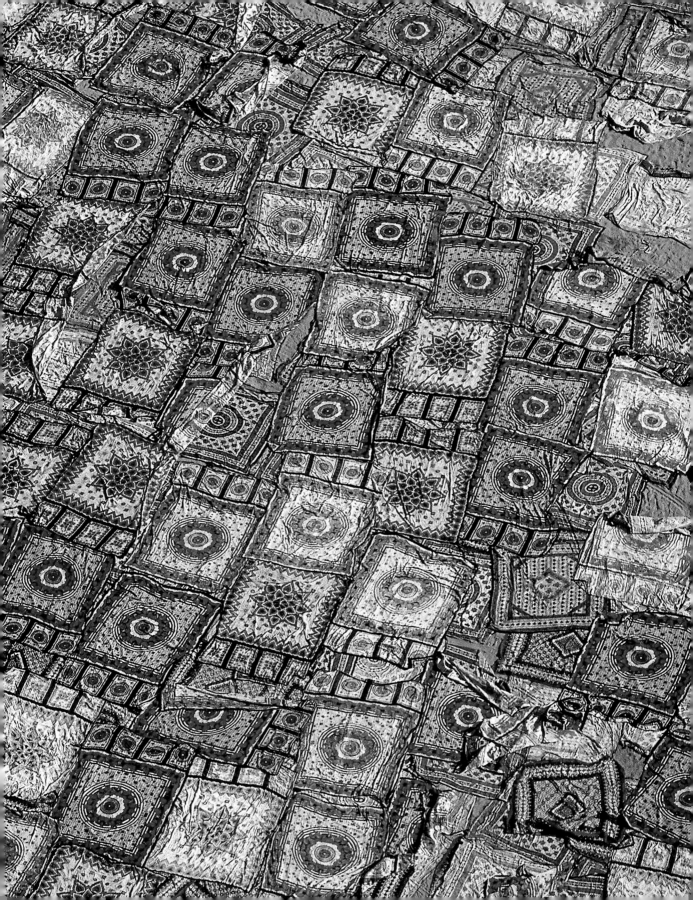

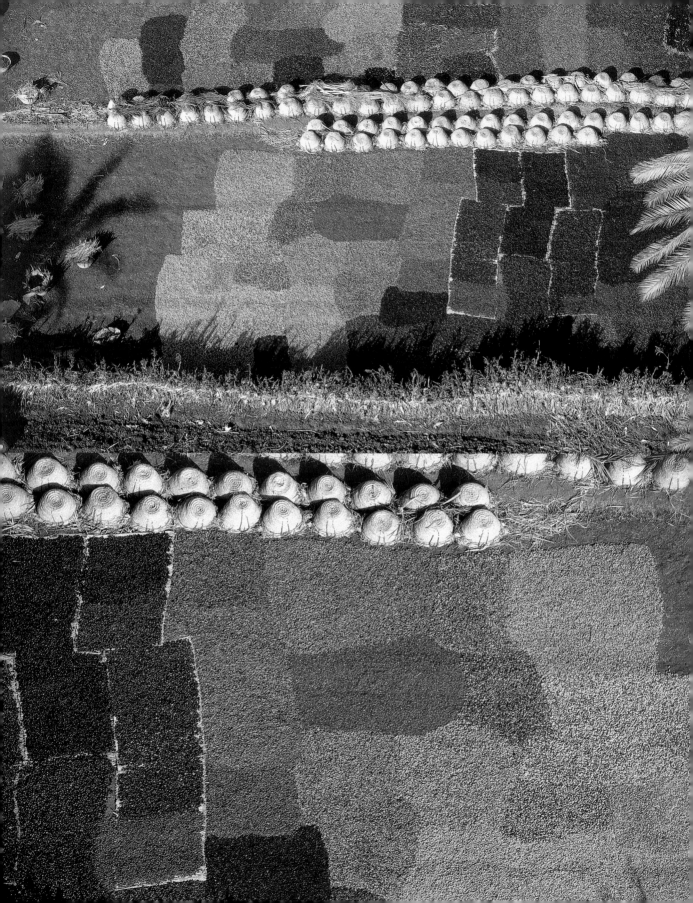

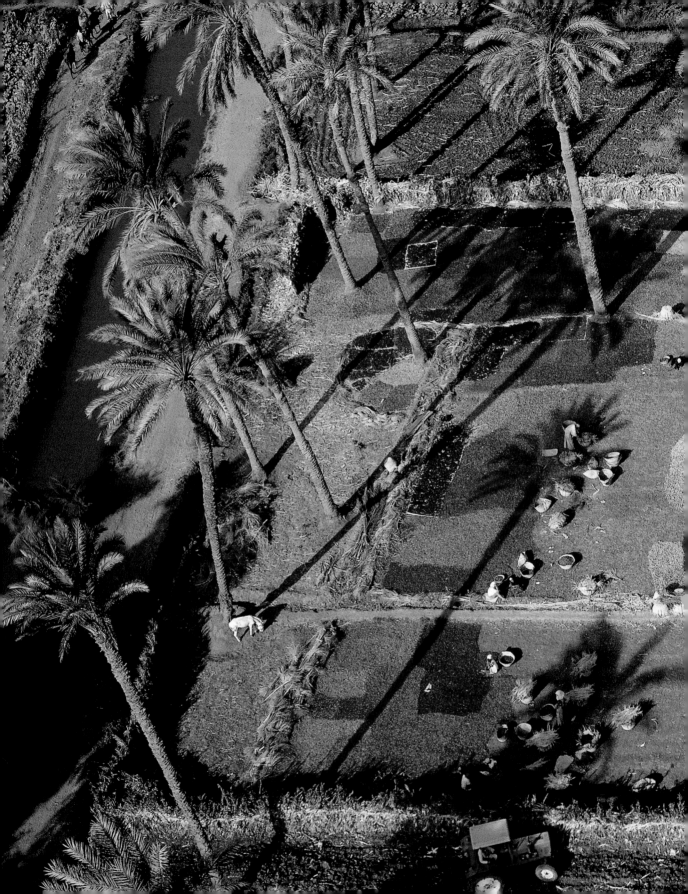

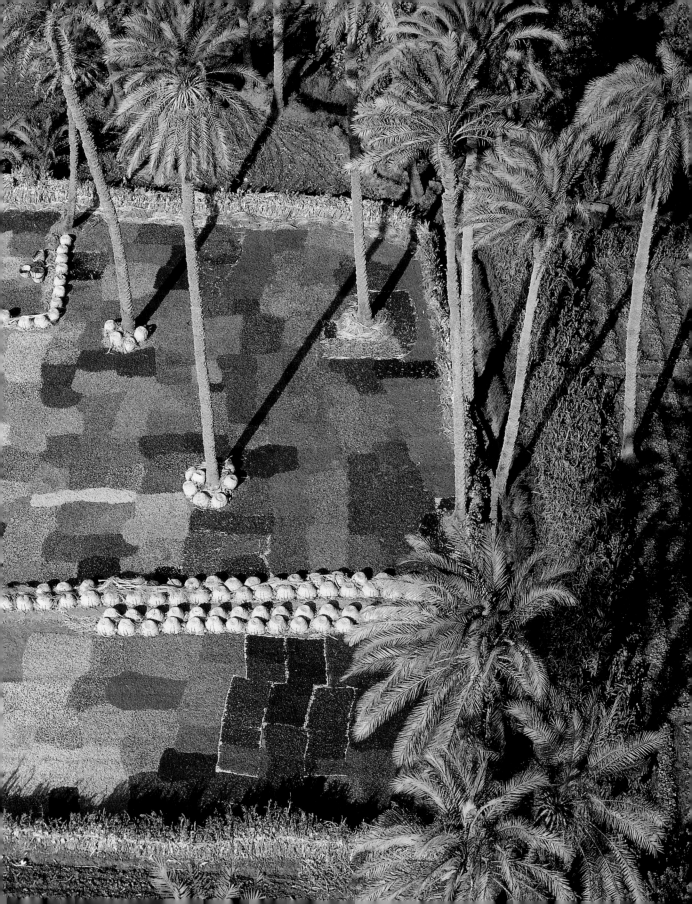

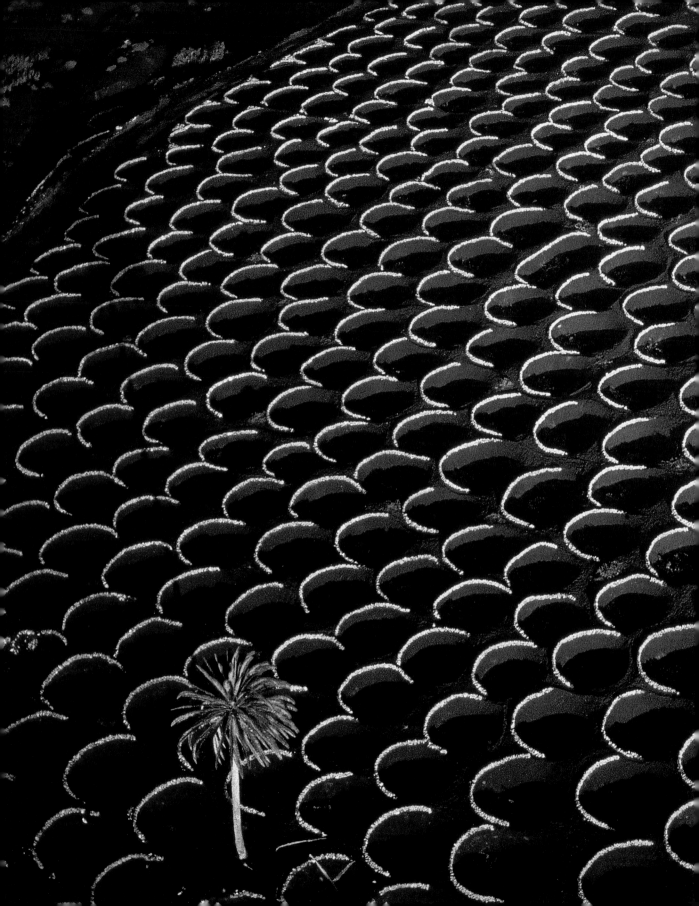

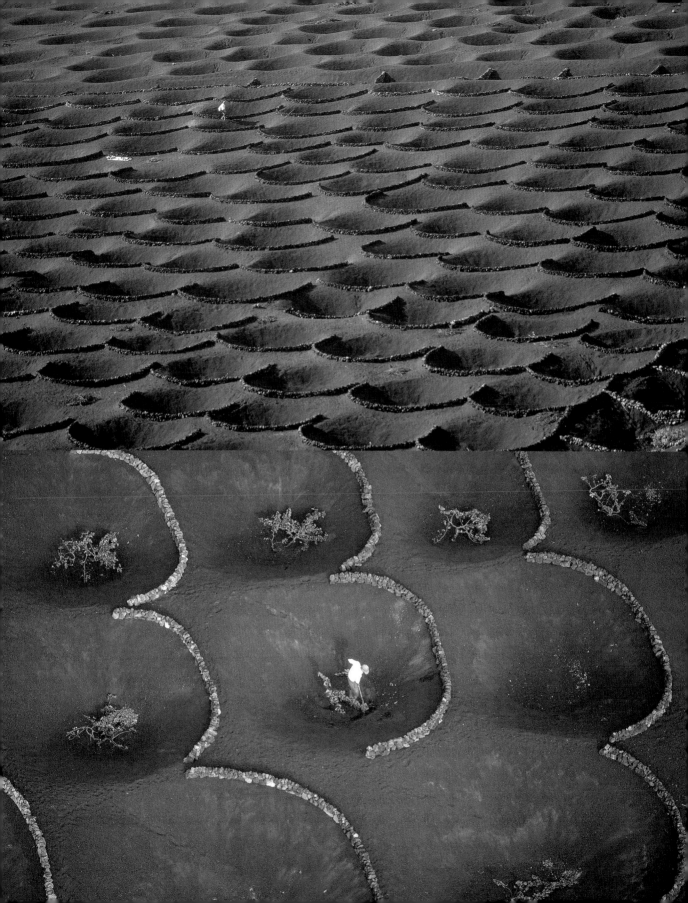

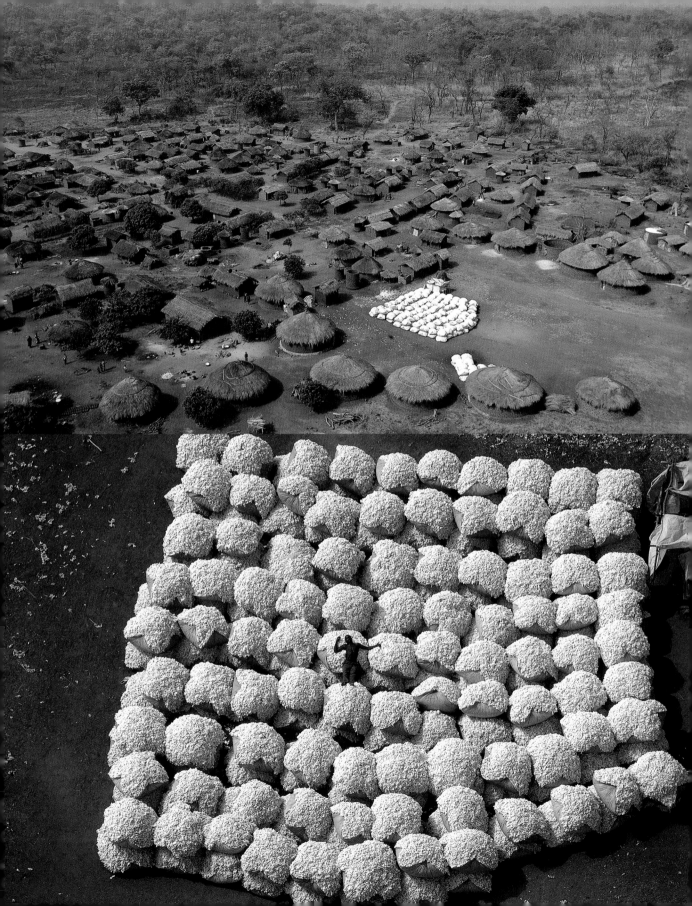

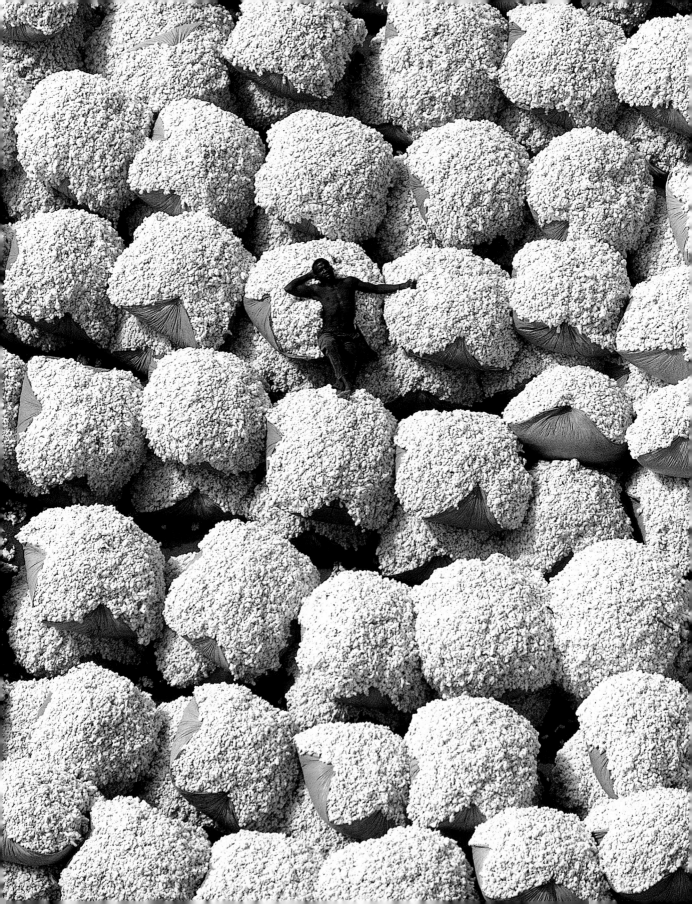

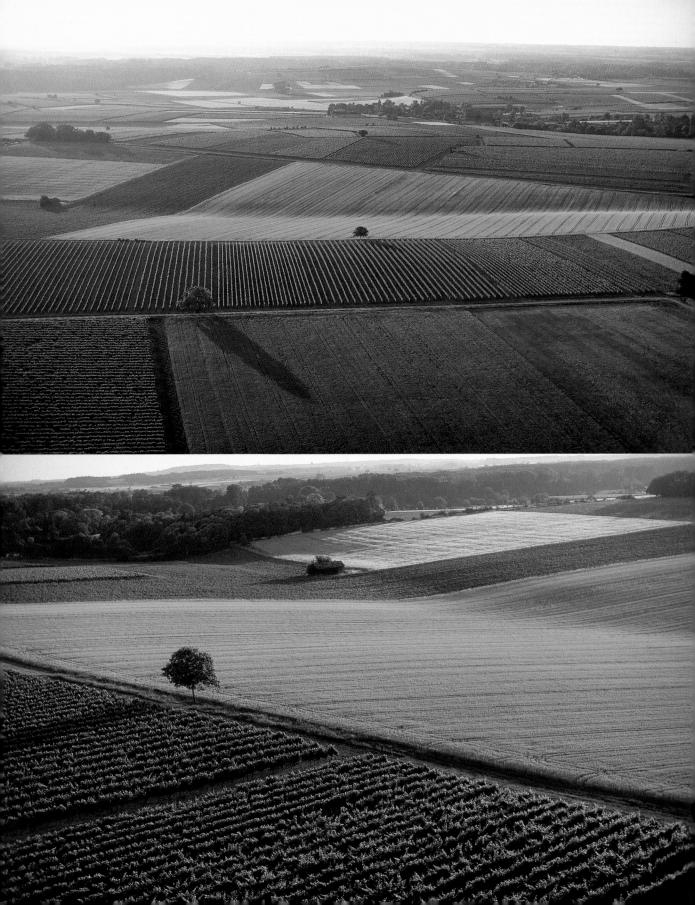

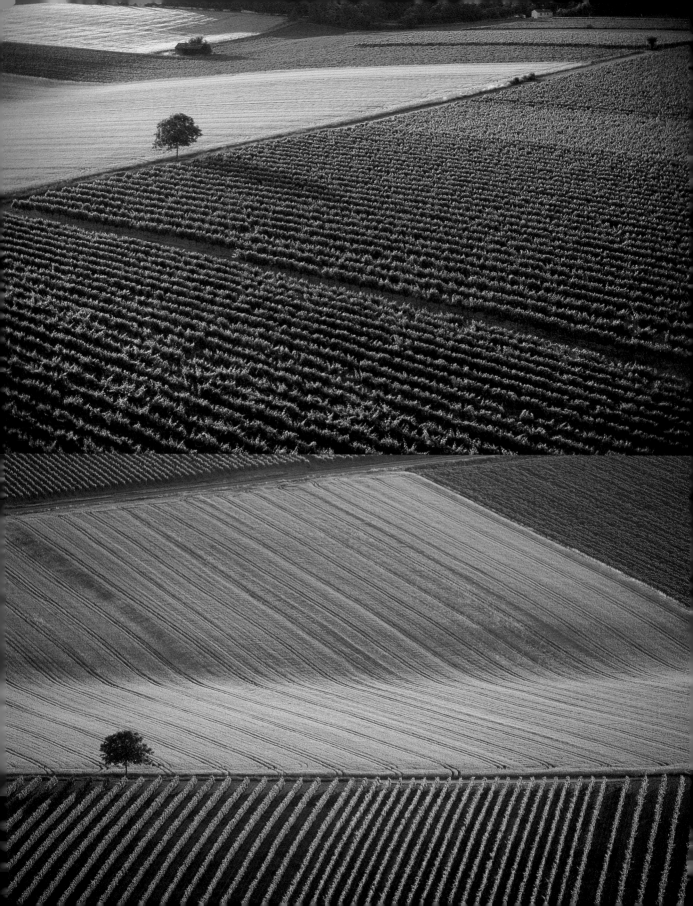

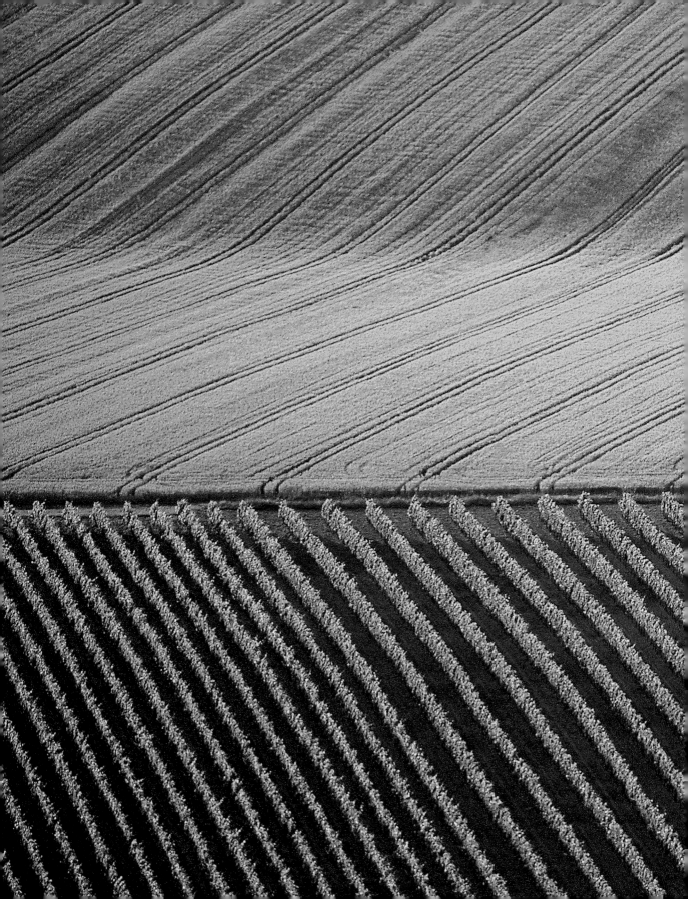

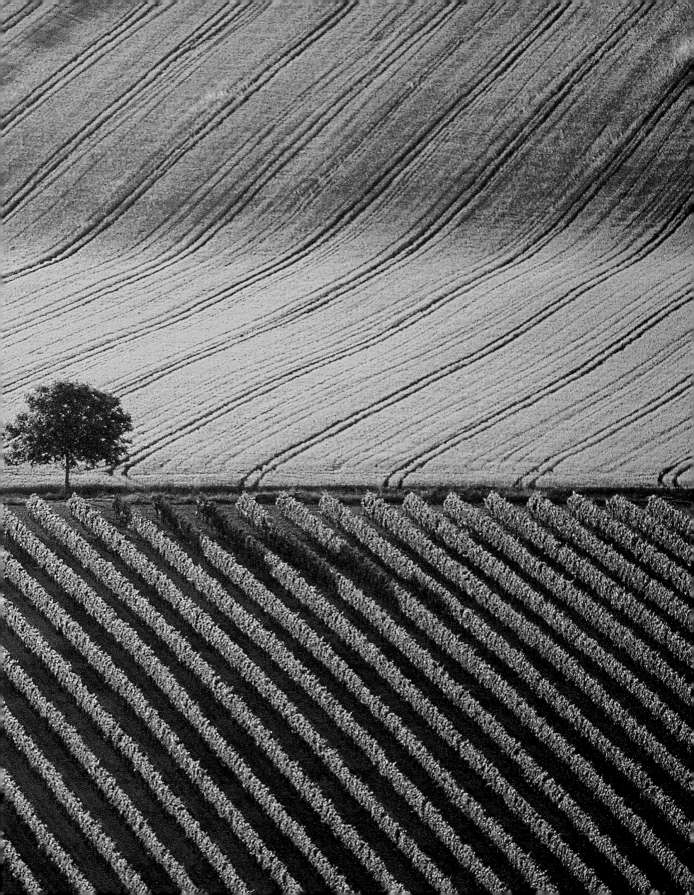

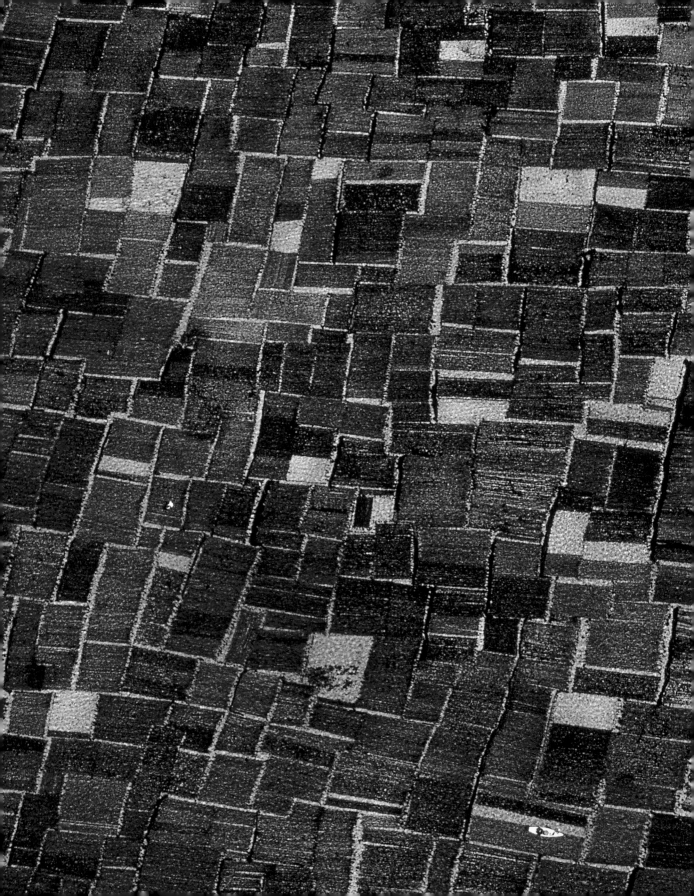

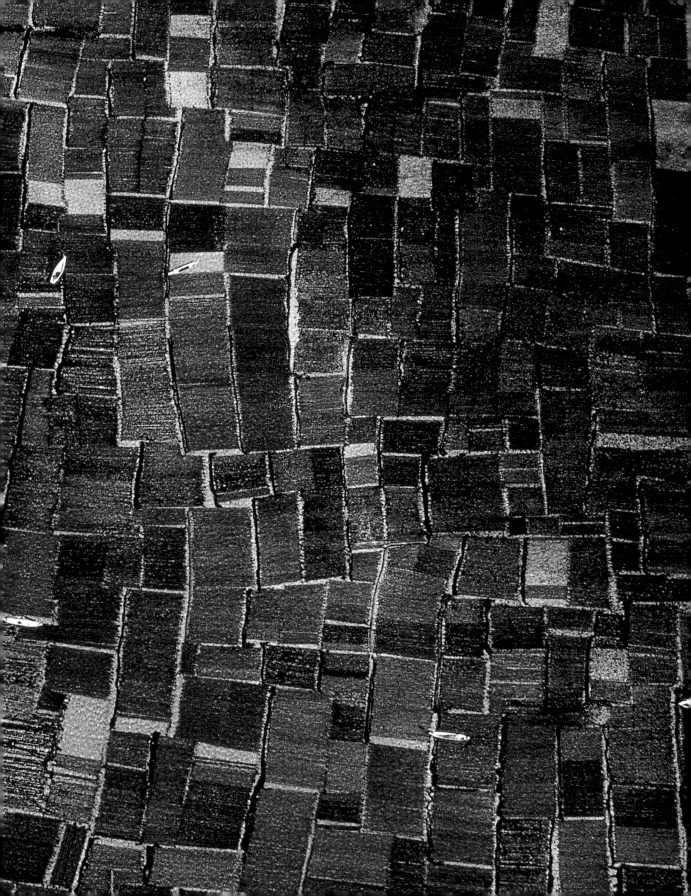

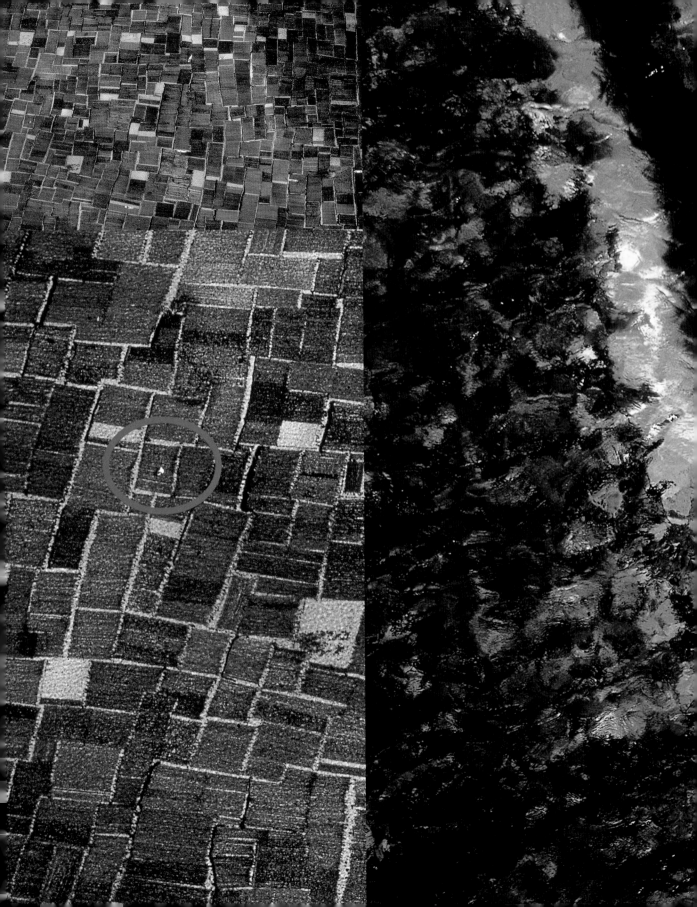

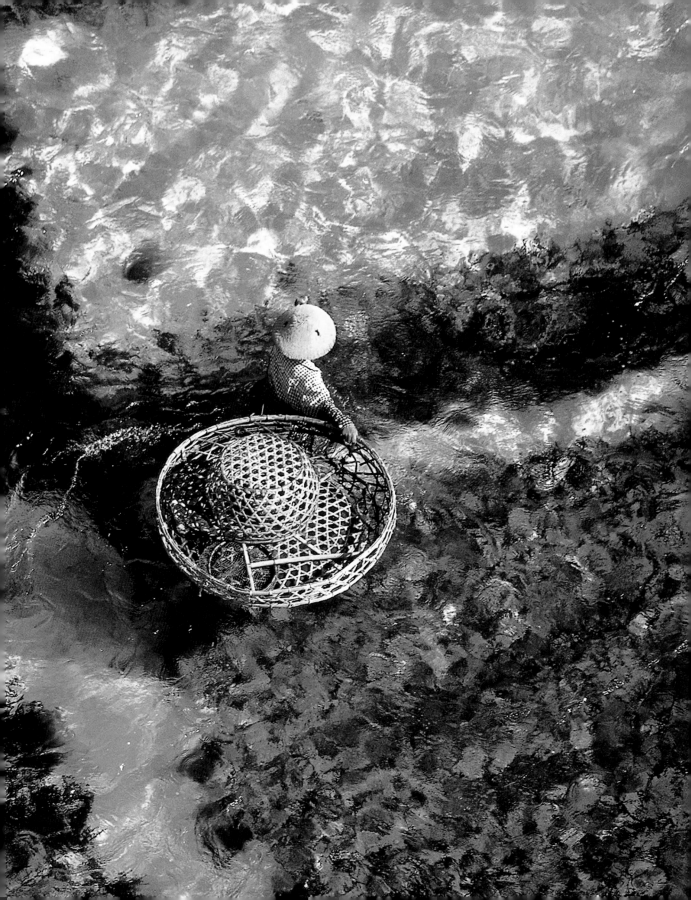

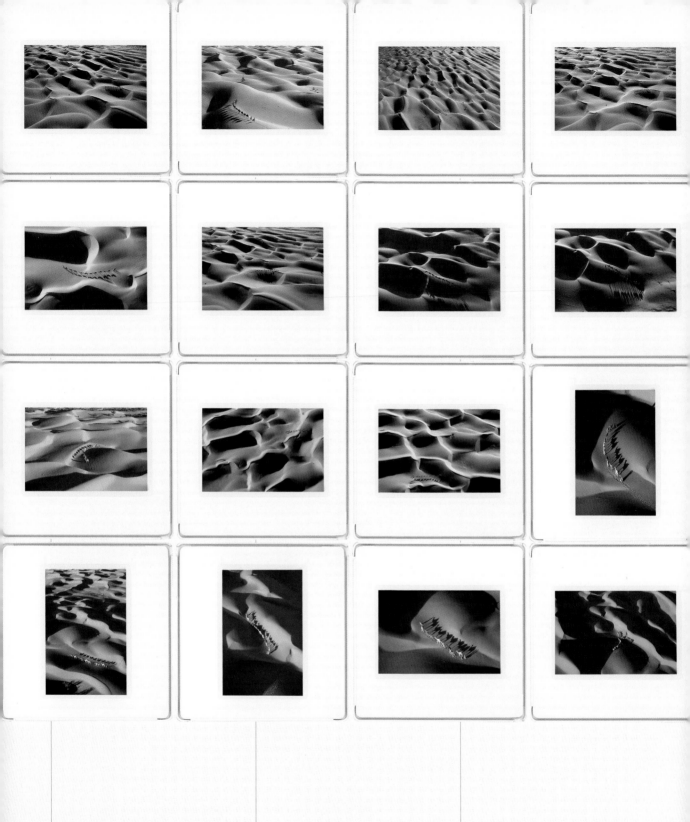

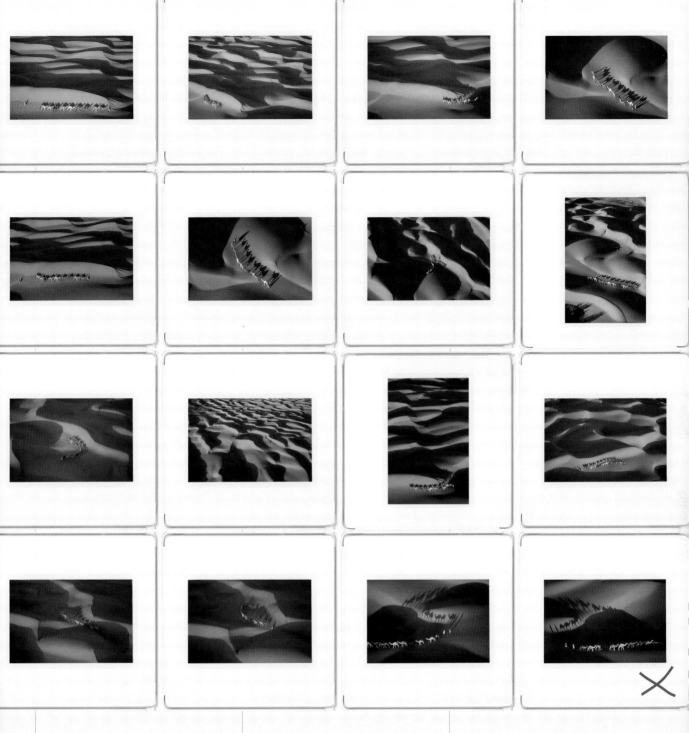

Returning from a job in Senegal, I passed by Mauritania and was aware that a caravan would be moving through the immediate area. I had good weather, enough hours left in the helicopter, but didn't want to proceed until the light was ideal. The camel driver couldn't understand why I was there all that time, waiting for evening to fall. As the sun set, the light went about detailing the entire landscape. In such cases you are ecstatic because the image is there. Such moments are rare. We could be sure it was going to be a success and couldn't wait to see the shots. The effect of the shadow often astonishes people and I am often asked if the photograph was created on a computer. I'd already taken many desert images, but here the caravan would at last offer me a sense of scale.

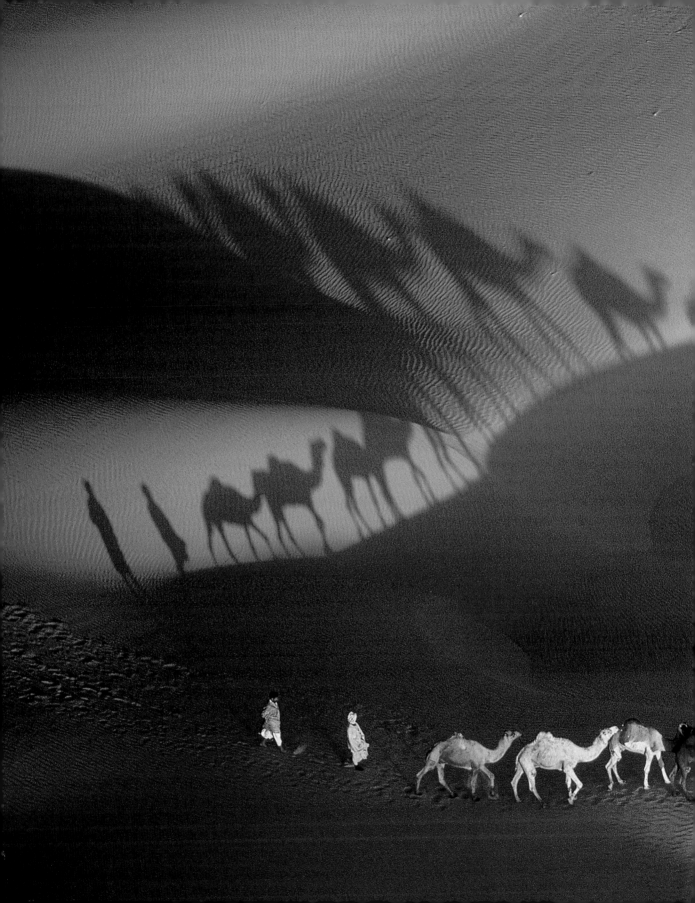

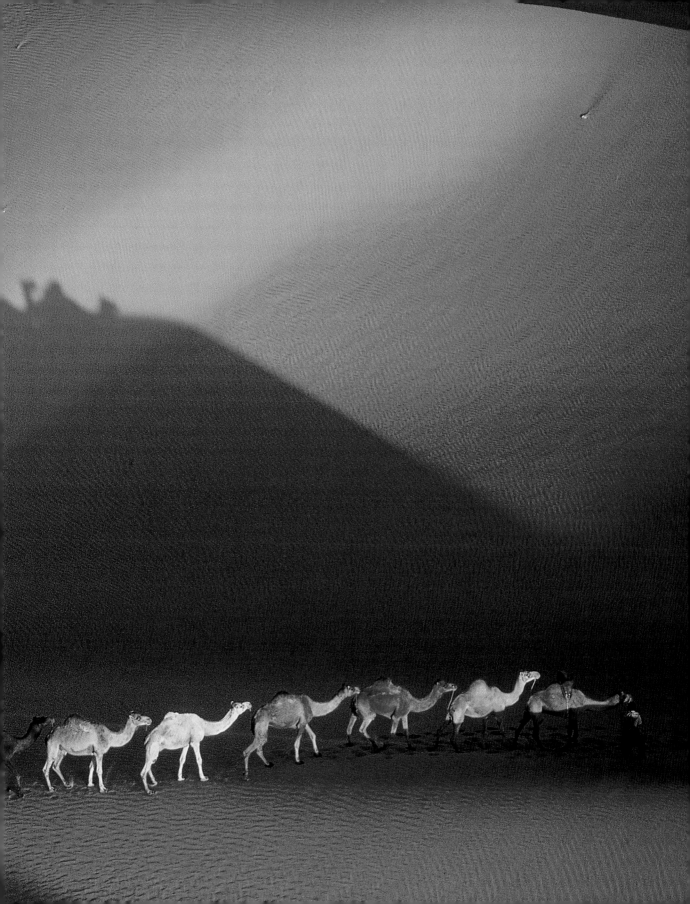

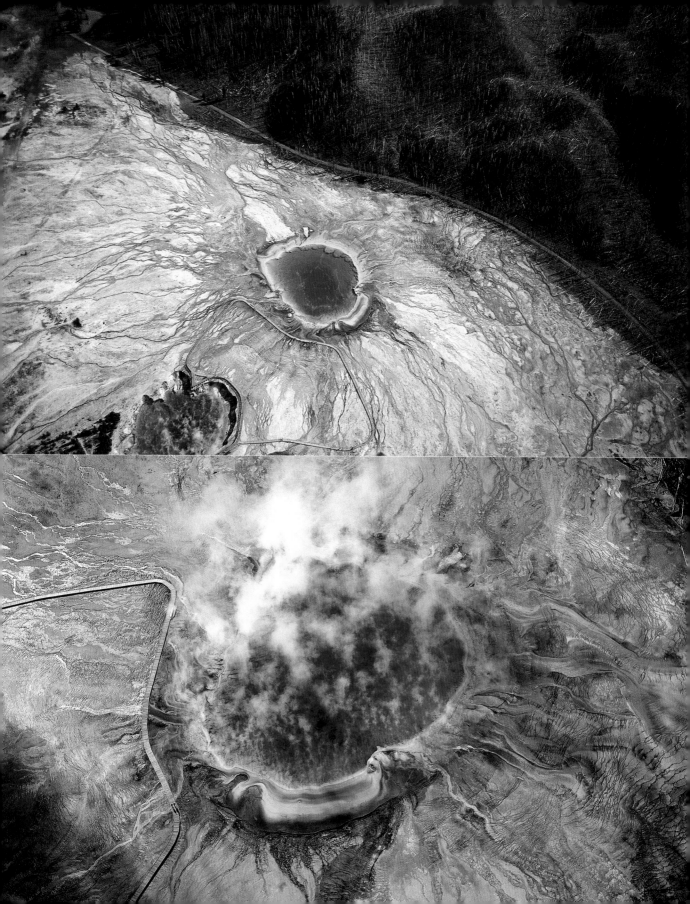

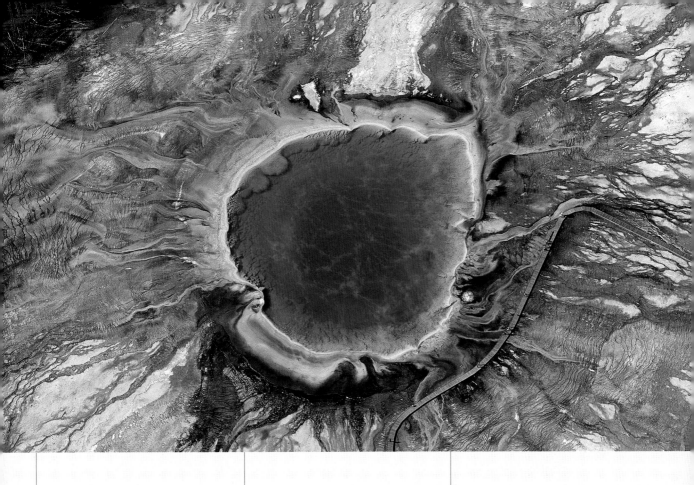

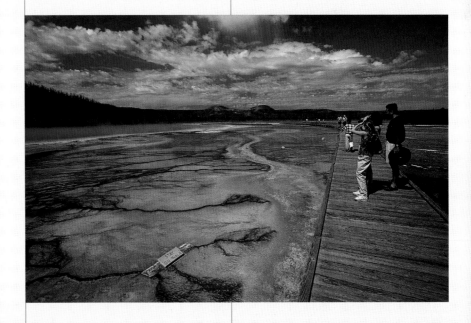

▶ The Grand Prismatic Spring in Yellowstone National Park is a rite of passage for aerial photographers. You cannot see a thing from the footbridge on ground level, yet the colors are dazzling from the air. At dawn, the steam frustrated Yann. He kept the photographs taken in the evening.

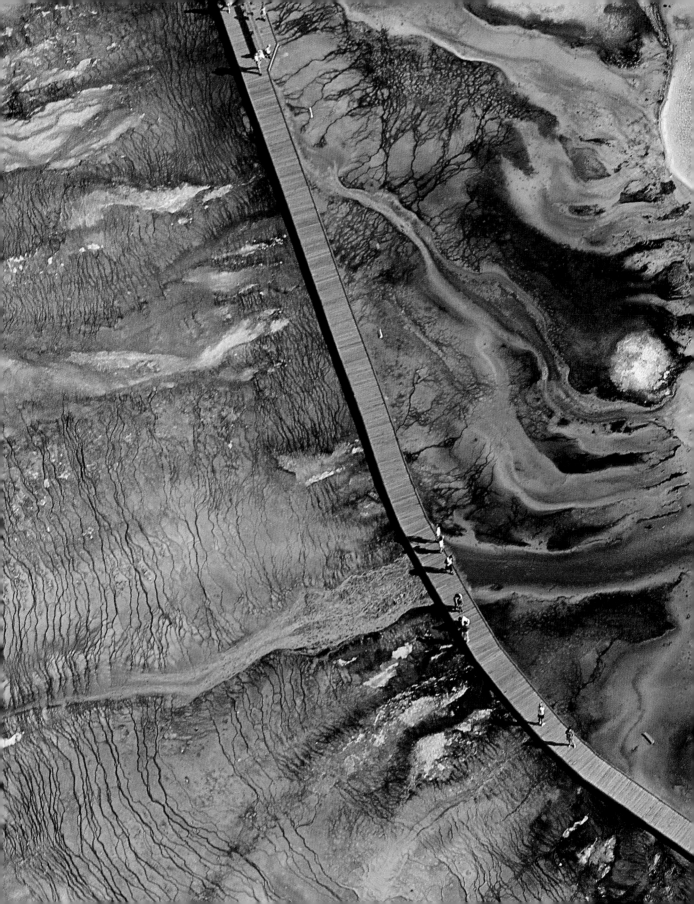

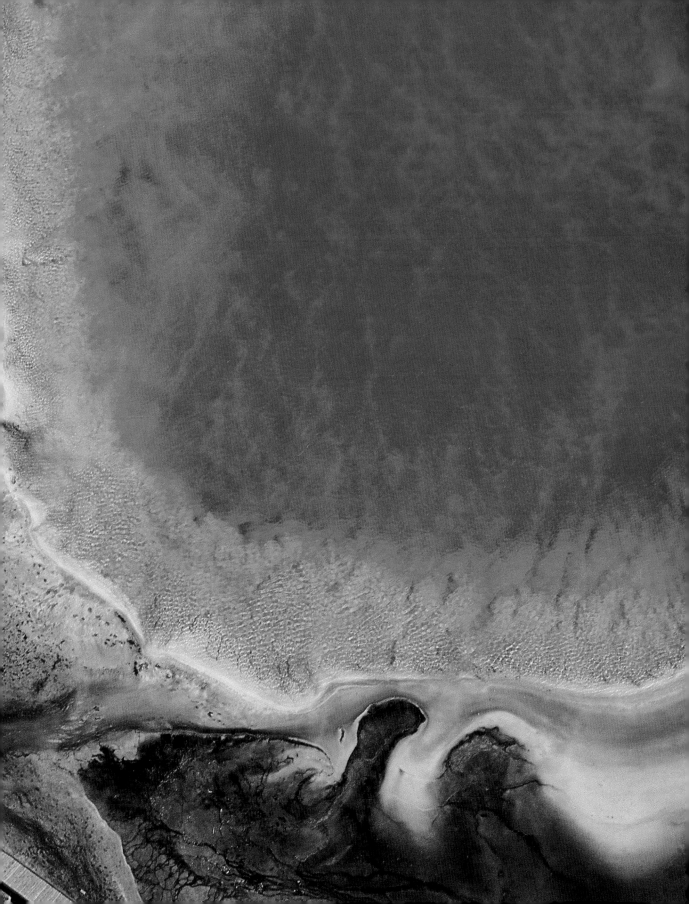

I get just as much pleasure from flying over towns as I do photographing a desert. Viewed from the air, a town is as much a part of nature as an anthill is part of a forest. Certain towns are very striking. Here, I have the impression of surveying an architectural model.

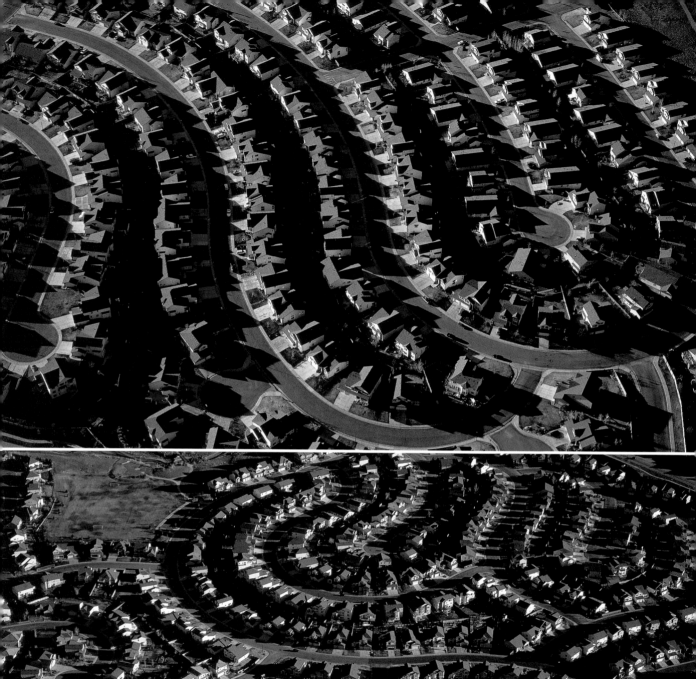
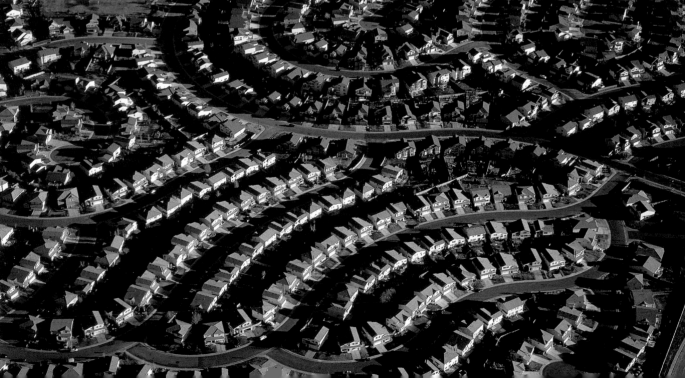

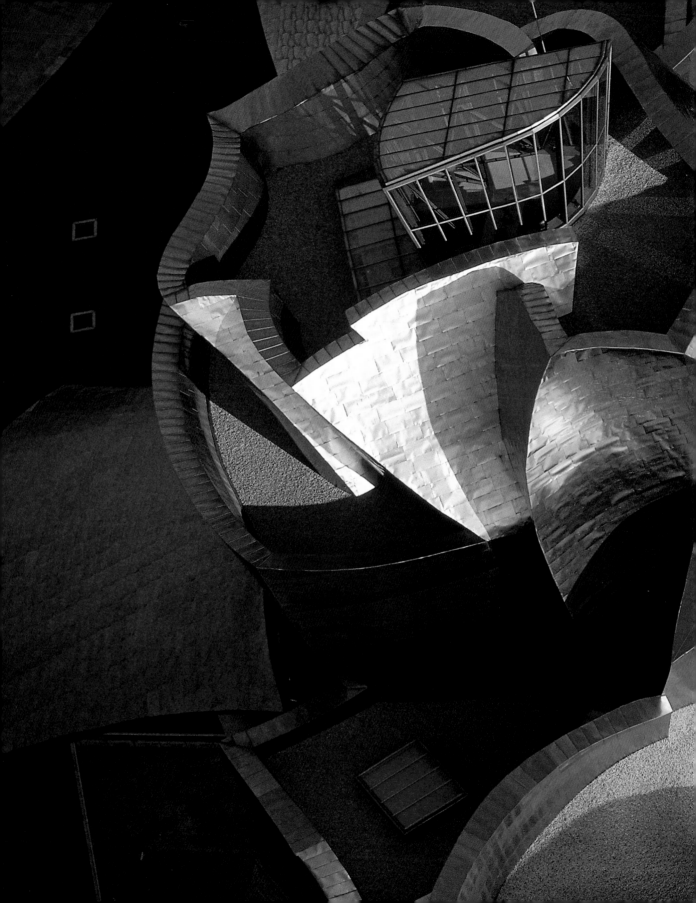

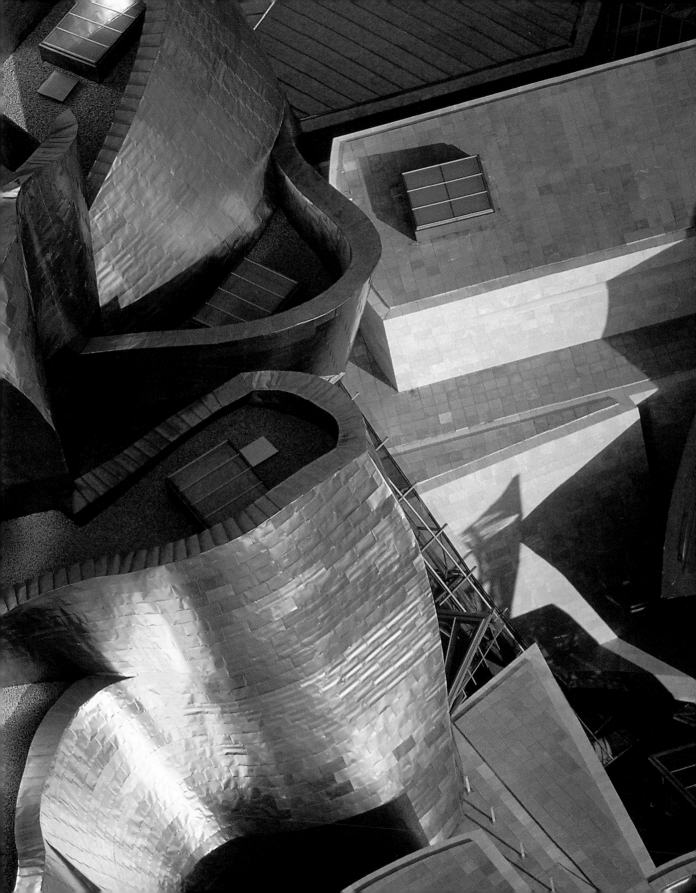

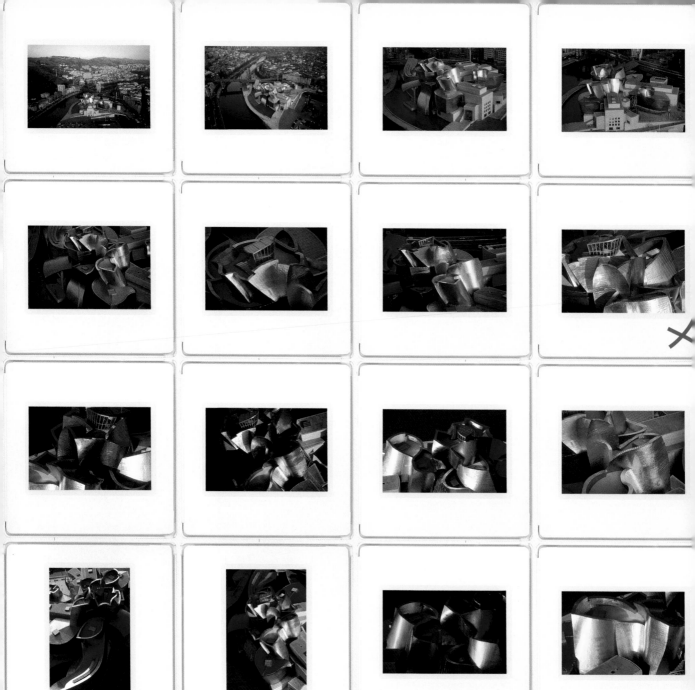

▲ The Guggenheim Museum Bilbao, located in Spain's Basque region, was designed by architect Frank Gehry and displays contemporary art. With its structure of glass, steel, limestone, and titanium, light is captured everywhere. "It is incredible that an architect conceived of such a building and that the town actually accepted it. All the angles are different; it is a kaleidoscope of shapes and light. I would love to produce a book on architecture photographed from the air to examine man's impact upon the Earth."

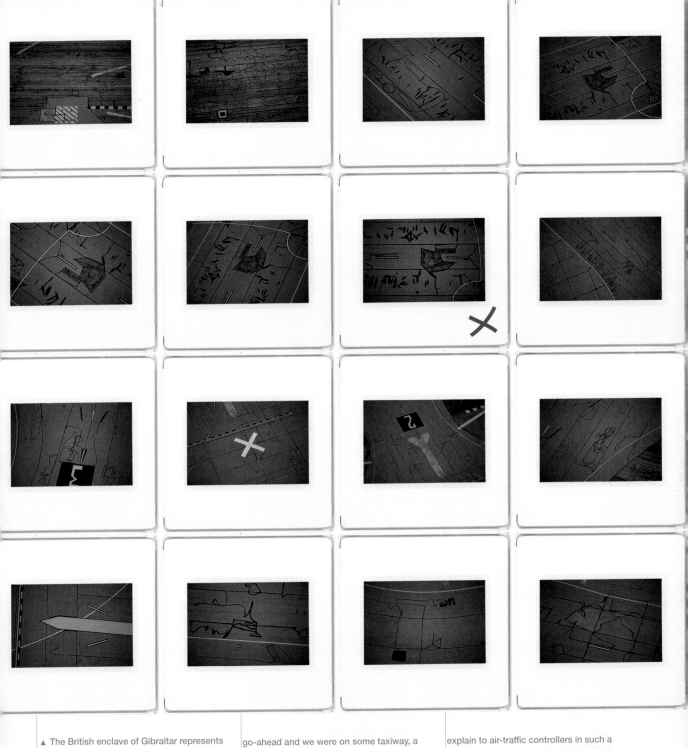

▲ The British enclave of Gibraltar represents one of Europe's last territorial disputes, situated as it is on Spanish soil. The extent of the problem is underlined by a mandatory detour via Morocco even to land there. Wilfried Gouer was the helicopter pilot. "We were on our way to photograph the rock of Gibraltar. The control tower had given us the go-ahead and we were on some taxiway, a little route along the takeoff runway. Yann told me to stop where we were. For twenty minutes, he photographed while I tried to explain to air-traffic control why were parked on a thoroughfare. Well, he's just looking at something...because as far as I was concerned we were in the middle of nowhere; how do you explain to air-traffic controllers in such a sensitive place that we'd spent all this time just photographing the tarmac! It was when the photographs were developed that I finally understood. I immediately thought of a painting by Georges Braque. That is what makes the difference; having the photographic eye to see a potential photo where others don't."

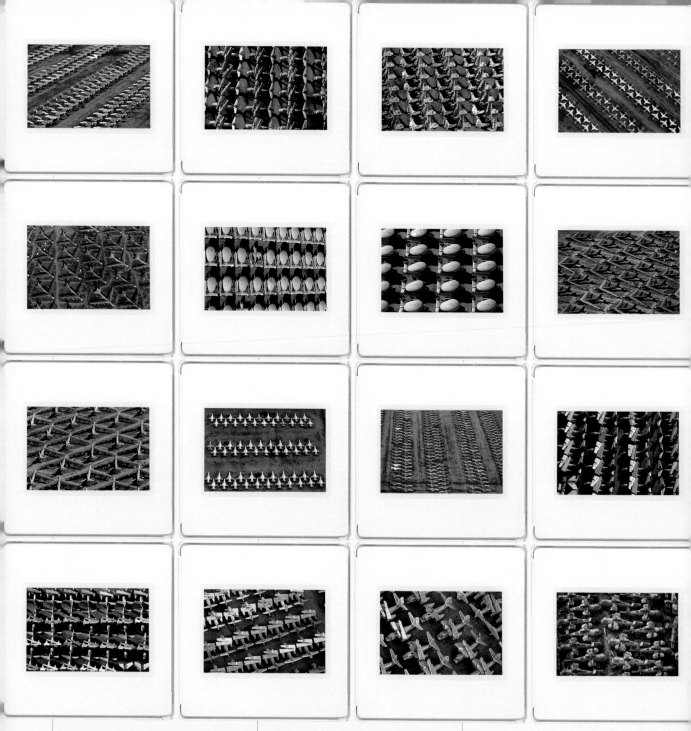

B-52 bombers at the Davis Monthan Air Force Base, Arizona, near Tucson. Seen from the air, these stocks and the sheer number of the objects have an enormous impact. The geometry makes this photograph a beautiful one, but what I've shown here is death: These were the planes responsible for the carpet bombing that killed thousands of civilians in Vietnam. I like this photograph, but I don't like what it represents.

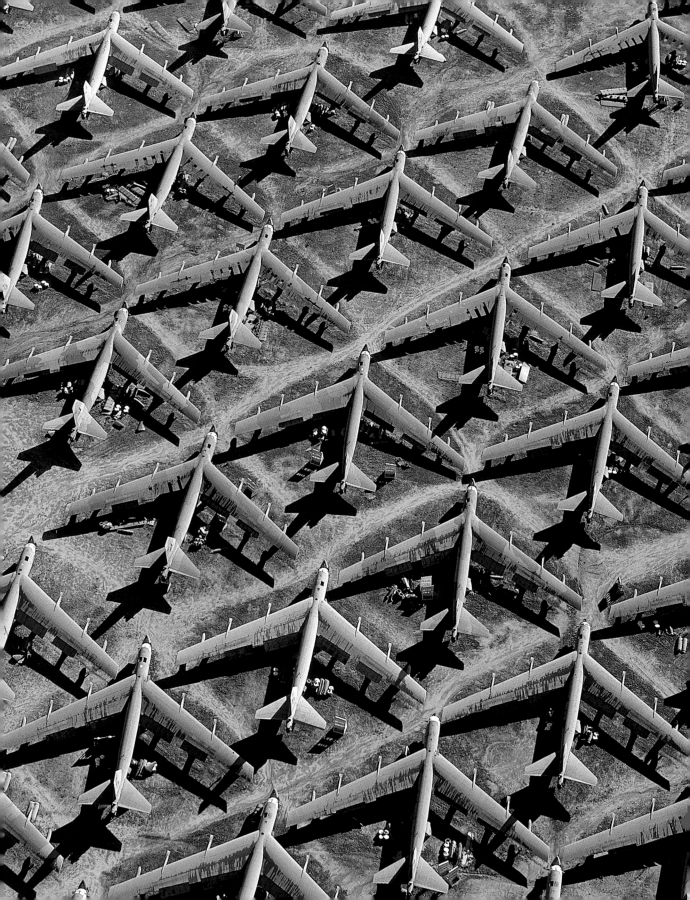

pp. 178–179. In March 2003, Yann was flying over Chile's San Rafael glacier that borders the Pacific. "When circling above the ice in the helicopter, I noticed it was turning from white to sky blue, a blue which seemed unreal against the sunlight. It was magnificent and impossible to have predicted before setting off."

pp. 182–183. Aerial photography at its best. The whiteness of the coral sediment forming this sandbank on the shoreline of Australia's Whitsunday Island contrasts with the blue water of the sea, the green of the river, and the shadow of the clouds. A lonely fishing boat gives the landscape scale.

pp. 186–187. We were flying over Lake Nakuru in Kenya. I was terrified at the prospect of these two million flamingos flying off. When the plane's shadow brushed over them, we sensed their anxiety and cut the motor so as not to frighten them. But after many stops and starts, the motor refused to reengage and we were forced to crash-land on the beach!

pp. 190-191 and 192–193. This flock of ibis was captured in Venezuela very early in the morning; the light was shining from below and the wings of the ibis appeared dazzlingly red and transparent at the same time. But we lost the transparency along

with the eventual print. It was a photograph I wasn't able to produce. We were trying not to disturb them. I was working with a very big telephoto lens, a 400mm, so therefore had an enormous amount of blur.

pp. 194–195 and 196–197. Cotton fabrics drying in Jaipur, India. A successful aerial photograph must combine a critical vision of a country with a geometric composition. "I wanted to speak about women working within India's textile industry."

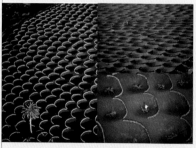

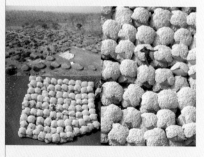

pp. 198–199 and 200–201. Dates drying in Egypt. Here the photograph composed itself: squares of dates drying themselves in yellows, browns, and reds. It was sublime.

pp. 202–203. When we arrived at the Lanzarote vineyards, it was evening and I only had ten seconds to take the photograph; there was barely any fuel left, the red light had already come on. I could only take two shots and I was sure I'd not succeeded. On the right is the same scene during the afternoon.

pp. 204–205. Near Korhogo on the Ivory Coast, a worker saw that Yann was taking photos from the helicopter. He stretched himself out on the bales of cotton to be photographed. Once he landed, Yann spoke with the man, taking his name in order to send him the print. He then took off again to take other photos of him and his friends, "without ever recapturing the same naturalness or elegance."

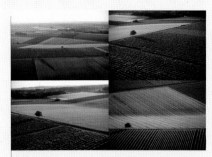

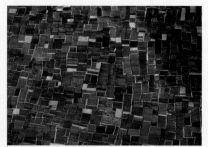

P. 206–207 and 208–209. **Drawn by a line of** Cognac, Yann flew over the vineyards of the region. He searched, absorbed for a long while. He must first "understand the lay of the landscape," so as to extract the maximum in the limited flight time; the budget prevented him from returning. Suddenly the photograph appeared as though a sign.

pp. 210–211 and 212–213. **Used within the** food industry, this algae cultivation in Bali, Indonesia, also serves the pharmaceutical and cosmetic trade. Yann came across this image in another photographer's work and wanted to produce his own. It is one of his favorites because it reminds him of certain paintings by Paul Klee.

▶▶ In Paris, only the Senate Museum proved willing to exhibit the *Earth From Above* photographs. Yann and his team took it upon themselves to conceive and organize a totally free photographic exhibition in the street, visible after dusk as well as during the day. The exhibition met with immediate success. The captions and their engaging message gave added value to the images. The exhibition has since traveled to fifty major cities around the world and is continually expanding. *Earth From Above* constitutes a never ending project. "It is at the exhibitions that I regain the meaning of my work, in seeing the people looking at the photographs. I find a real happiness in this, while taking the shots themselves too often involves moments of intense concentration or stress."

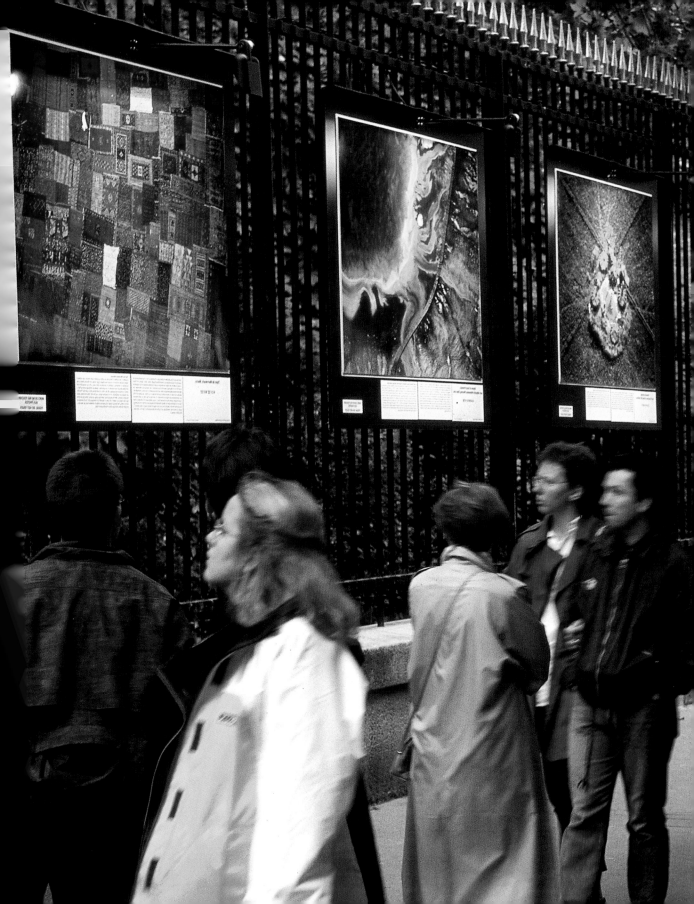

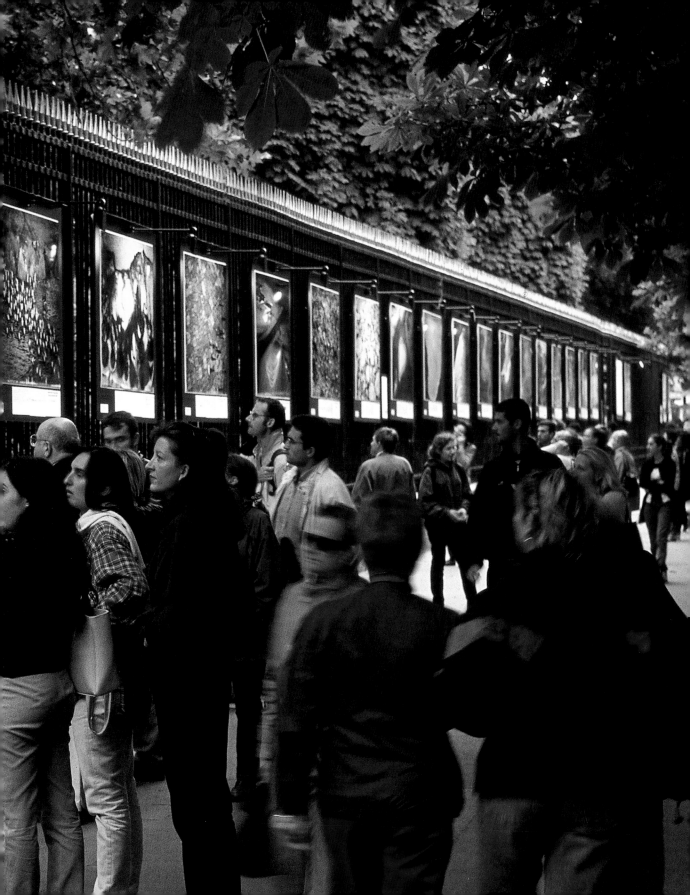

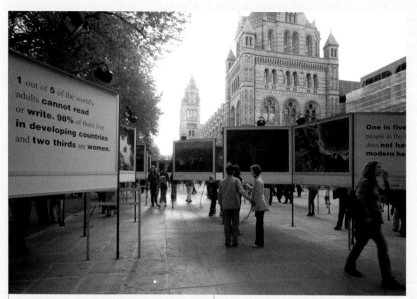

Olivier Bigot, an associate at the Janjac laboratory, for the vision to materialize, as Yann Arthus-Bertrand himself explains. Over a four-month period, the two friends exposed the prints to some of the worst weather conditions. They experimented with various techniques of applying plastic coating in order to discover the most effective formula. Their research was relentless and even continues today in the pursuit of excellence. They had conceived a new type of exhibition, since adopted by many other photographers.

In only a few weeks, the photographer and his project had become a popular phenomenon, bringing magic to all. When it was eventually taken down, over two and a half million visitors had seen *Earth From Above*. Nevertheless, this first stage remains a mere introduction to what gradually became a project.

Several French towns wanted to display the exhibition immediately after it had finished in Paris. Major international capitals like London, Mexico City, Chicago, and Berlin also revealed an interest in presenting "the Earth" of Arthus-Bertrand. But Yann is never satisfied. Although he was proud and pleased with the fame engendered by his exhibition and the enormous success of his book, he nevertheless knew he remained a long way from achieving his goal. As a man committed for many years to the preservation of the Earth and her resources, he feared people simply saw his pictures as spectacular images without a purpose. He is first

Yann Arthus-Bertrand is a man of conviction. He knows what he likes, he knows what he wants; he is persuasive and knows how to persuade others. It was this that enabled him to transform the railings of the Luxembourg Gardens into an exhibition space.

In June 2000, the *Earth From Above* exhibition finished at the museum next to the park. It had been cramped and somewhat out of place. Arthus-Bertrand had taken a long time persuading the museum director for permission to display his work. Despite its success, he felt "his" Earth required a bigger stage. Like a child who dreams of toys before receiving them, Yann wanted to use the garden as an exhibition space, with joggers, landscape, and sky as backdrop. Remarkably, the Senate agreed to let him hang his large-format photographs from the park railings. The exhibition was only

supposed to last a month and a half but ended eight months later. Day and night, the Rue de Médicis was blackened by crowds. They would study the images, almost gluing their noses to them before standing back. Expressions become concentrated, as if they were mapping out a course to somewhere; landscapes, people, and scenes were at last revealed in a different context. It was a *passagiata* in summer....

Arthus-Bertrand's achievement exists less within the innovative arrangement of his photographs than by the technical feat of displaying them within Paris's most prestigious garden. How does one exhibit such large prints outdoors without them suffering from the effects of the weather? Rain, sun, heat, and fluctuations in temperature are all harmful to photographic paper. It required a great deal of patience and the perseverance of

► In July 2003, optician Alain Mikli and Yann Arthus-Bertrand unveiled an exhibition of thirty *Earth From Above* photographs that were accessible to the blind by means of plaques in relief. It was a great success, chiefly due to the innovative nature of the presentation. "The blind were very enthusiastic, but there still remains much to improve upon." Exhibiting the photographs and the plaques together meant that the blind visitors were mixed with sighted ones. "It was an extremely positive aspect that we hadn't foreseen. On the other hand, the guide dogs became thirsty and we did not think to provide bowls of water."

and foremost a reporter and his photographs must have meaning. They carry a message.

And so he decided to create an office within his photo agency, Altitude, coordinating *Earth From Above* project. His sister, Catherine, was made responsible for the organization and production of the projects. Certain conditions were laid down: an exhibition has to include between 120 and 150 photographs, be erected outdoors, remain free and accessible night and day, and last at least two months. Above all, he insisted that the text retain its importance. Each exhibition should present the project and promote lasting development. It must include numerical statistics on life and the environment. The captions must encompass a complete understanding of his photographs. The texts displayed in the Luxembourg Gardens were merely a rough draft to those of today; Arthus-Bertrand has since employed a full-time agricultural engineer to compile them.

Success breeds success. The majority of the exhibitions have been extended. The display in London outside the Natural History Museum remained there for almost two years. In Mexico, five cities have already hosted the exhibition. The organization of the project in Europe resembles an army on the march; this serves only to hearten Yann Arthus-Bertrand, for whom the environmental cause remains a daily struggle.

However, there are two elements of this success he particularly appreciates. The first lies in the people who visit the exhibition by chance and then become so enamored with it that they decide to organize one back in their own countries, so that their fellow citizens can share in the message.

Then there is the fact that the sheer scale of the project often forces them to quit their jobs to devote themselves totally to it, an endeavor of great personal risk. "You never tire of witnessing the enthusiasm surrounding this exhibition," affirms Yann. "I have met some truly wonderful people because of it."

But Arthus-Bertrand is continually striving. He once described his photographs to young blind people in the Luxembourg Gardens for almost two hours. His listeners touched him so deeply he was determined to provide them with a means of seeing his pictures. With the help and dedication of optician Alain Mikli, tactile panels made of acetate were developed. At last the blind and partially sighted could likewise travel the Earth from above.

Jean Poderos
Chief Editor of *Dada*

Since the sudden success of *Earth From Above*, many enthusiasts, or simply those curious to know more, have wished to ask Yann Arthus-Bertrand about the details of his career and, in more general terms, his profession. This book attempts to answer some of these questions. It does not set out to recommend a particular path one should follow in order to become a photographer. Each photographer follows his/her own path guided by his or her interests, experiences, and talents. These paths are numerous and diverse, hence the book can only reveal a partial insight into the world of photography. For any young photographers, amateurs, or enthusiasts who would like to explore some of its other aspects, we have gathered useful information on schools, agencies, and special-interest magazines.

http://

PHOTOGRAPHY AGENCIES

Agence France-Presse: **www.afp.com**
A global news archive since 1930.

Altitude: **www.altitude-photo.com**
www.yannarthusbertrand.org
This agency was founded in 1990 by Yann Arthus-Bertrand. Composed of 70 photographers, it is the only agency in the world specializing in aerial photography.

Associated Press: **www.ap.org**
The oldest international press agency, whose reporters have won a total of 28 Pulitzer prizes.

Contact Press Images:
www.contactpressimages.com
Created in 1976. Frank Fournier, Annie Leibovitz, and Don McCullin are among the photographers represented.

Contrasto: **www.contrasto.it**
In Italy, this agency is esteemed for the choice and quality of its subjects.

Corbis: **www.corbis.com**
Founded in 1989 by Bill Gates, Corbis remains one of the most important image banks in the world. Since taking over the "Sygma" and "Saba" agencies in 1999, and with its own Bettmann collection, Corbis is an exceptional resource for photojournalism.

Gamma: **www.gamma.fr**
Offering news and magazine photo coverage from the last 30 years.

Getty images: **www.gettyimages.com**
Founded in 1995. With 70 million photographs, Getty Images is the most significant image archive in the world.

Grazia Neri: **www.grazianeri.com**
Founded in 1966, this agency produces photography as well as editorial work.

Impact Photos: **www.impactphotos.com**
Founded in 1980, Impact Photos is an international photographic agency, specializing in worldwide reportage and travel images.

IPG: Independent Photographers Group:
www.ipgphotographers.com
Composed of eleven photographers originally from the "Katz" agency, IPG offers a great many talents in a small organization.

K2: **www.k2creatives.com**
Specializing in portraits of actors, singers, athletes, and politicians.

Katz: **www.katzpictures.com**
Agency offering high-quality photojournalism since 1988.

Keystone: **www.keystone-photo.com**
With 15 million images, Keystone has maintained an exceptional visual record since 1927.

Lookat: **www.lookat.ch**
A Swiss photojournalism agency based in Zürich.

Magnum: **www.magnumphotos.com**
Photographic cooperative founded in 1947 by Henri Cartier-Bresson, George Rodger, David Seymour, and Robert Capa.

Minden Pictures: **www.mindenpictures.com**
A California-based photo agency representing imagery of wildlife, nature, and environmental subjects by the best photographers, including Franz Lanting and Jim Brandenburg.

Network Photographers:
www.networkphotographers.com
Created in 1981, this agency offers news and reports from a social perspective.

Ostkreuz: **www.ostkreuz.com**
It was created in 1990 by photographers covering political and artistic developments, as well as travel stories.

Rapho: **www.rapho.com**
Rapho represents the icons of humanist photography, such as Doisneau, Boubat, Niépce, Ronis, Weiss, and Charbonnier, in addition to the new generation of travelers and portraitists.

Reuters: **www.reuters.com**
Created in London in 1851, this agency specializes in politics, the economy, and finance.

VII: **www.viiphoto.com**
This archive includes nine of the greatest war photojournalists.

Sipa Press: **www.sipa.com**
A legendary agency, much like its founder, Göksin Sipahioglu.

South Photographs:
www.southphoto.com
Photojournalism in South Africa from the country's finest photographic reporters.

TCS—The Cover Story:
www.thecoverstory.com
Based in Amsterdam, TCS offers a
complete service for magazines,
including text and images.

Tendance Floue and L'Œil Public:
www.tendancefloue.net
www.œilpublic.com
Two groups, founded in 1991 and 1995
respectively. Each group consists of 10
photographers offering new perspectives
on society.

VU: **www.agencevu.com**
An agency for photographers/authors
covering news, magazine stories, and
portraits.

PUBLICATIONS

American Photo:
www.americanphotomag.com

Aperture: **www.aperture.org**

B&W magazine: **www.bandwmag.com**

Blind Spot: **www.blindspot.com**

British Journal of Photography:
www.bjphoto.co.uk

Camera Arts Magazine:
www.cameraarts.com

Communication Arts: **www.commarts.com**

Digital Journalist (The):
www.digitaljournalist.org

DoubleTake:
www.doubletakemagazine.org

European Photography:
**www.equivalence.com/pavillon/
pav_ep.shtml**

Foto8: **www.foto8.com**

LensWork: **www.lenswork.com**

Nature Photographer:
www.naturephotographermag.com

Outdoor Photographer:
www.outdoorphotographer.com

PDN Photo District News:
www.pdnonline.com

Photo Insider: **www.photoinsider.com**

Photo Life: **www.photolife.com**

Photographie: **www.photographie.com**

Picture Magazine:
www.picturemagazine.com

Popular Photography:
www.popularphotography.com

Redtop: **www.red-top.com**

Revue: **www.revue.com**

HOW TO FIND A SCHOOL

Brooks Institute of Photography:
www.brooks.edu

Center for Photographic Arts:
**www.photography.org/events/
workshops/workshops.htm**

Center for Photography at Woodstock:
www.cpw.org

International Center of Photography:
www.icp.org

Maine Photographic Workshops:
www.theworkshops.com

New England School of Photography:
www.nesop.com

New York University: **www.nyu.edu**

Rochester Institute of Technology:
www.rit.edu/~661www

Santa Fe Photographic Workshops:
www.sfworkshop.com

School of Visual Arts:
www.mfaphoto.schoolofvisualarts.edu

MAIN PHOTOGRAPHY EVENTS
AND ART FAIRS

AIPAD Photography Show:
www.photoshow.com/tps.html

Centre national de la photographie
(National Photography Centre, Paris,
France): **www.cnp-photographie.com**

Festival of Light: **www.festivaloflight.org**

FotoFest: **www.fotofest.org**

FotoFusion: **www.fotofusion.org**

Foundation Cartier-Bresson:
www.henricartierbresson.org

International Center of Photography
(New York, United States): **www.icp.org**

Maison européenne de la photographie
(The European House of Photography,
Paris, France): **www.mep-fr.org**

PhotoEspaña (Madrid, Spain):
www.phedigital.com

Photolucida: **www.photolucida.org**

Photo New York, Photo L.A., Photo San
Francisco:
www.photographynewyork.net

Les Rencontres internationales de la
Photographie (Arles, France):
www.rencontres-arles.com

Review Santa Fe:
http://photoprojects.org

Rhubarb-Rhubarb:
www.rhubarb-rhubarb.net

Visa pour l'image (Perpignan, France):
www.visapourlimage.com

World in Focus:
**www.photomediagroup.com/
worldinfocus/seminarseries.html**

Would you like to support a photographer?

3P: "Photographers for a Photographic Project" is a French organization that aims to finance one major photographic endeavour per year. Intended for a professional photographer, this aid is dependent on the proceeds of photographs sold at auction. The funds are provided both by the generosity of photographers donating their work and also by those buying the photographs. In this way, amateurs can find material with which to begin a collection, while supporting the work of a photographer. Further details can be found at **www.3ppp.org**

Other useful sites
www.worldpressphoto.com

These annual awards, rewarding photographic achievement of the highest level, are open to photographers who have already had work published. The awards are divided into ten categories including news, portraits, sports, and nature. You can download the application form from the web site, which also offers seminars and a master class for young photographers.

www.tpw.it

Toscana Photographic Workshop offers various courses run by top photographers: documentary photography, portrait, nude, nature, and color technique classes are all provided.

Acknowledgments

So many people have helped me during my 25 years in the business that it would be impossible to name them all without forgetting somebody.

These people, I thank from the bottom of my heart.

A special thanks to my friend Robert Fiess, he will know why.

I would also like to share this book with my "photographic" family, not just to praise their technical abilities—which today match the high standards among many other professionals—but also to thank them for their human qualities and warm friendship.

My thanks to the Fujifilm team, who believed in *Earth From Above* since 1994. Without their help, the project would not have been possible.

My thanks to the team at Canon, who have always been there when I needed them during the last 25 years.

Also, I would particularly like to thank Olivier Bigot at the Janjac laboratory and Denis Cuissy at the Rush laboratory.

Finally, I will always have fond memories of my three patient collaborators who contributed throughout the difficult early stages of the book, valiantly resisting my uncertainties, accepting my demands, and supporting me through my doubts: Elizabeth Ferté, artistic director, Céline Moulard from Éditions de La Martinière, and Isabelle Delannoy from *Earth From Above*, who drafted the captions.

Project Manager, English-language edition: Céline Moulard
Editor, English-language edition: Anne McNamara
Jacket design, English-language edition: Michael Walsh and Christine Knorr
Design Coordinator, English-language edition: Christine Knorr
Production Coordinator, English-language edition: Kaija Markoe

Library of Congress Cataloging-in-Publication Data
Arthus-Bertrand, Yann.
[Etre photographe. English]
Being a photographer / Yann Arthus-Bertrand; text by Sophie Troubac; translated from the French by Simon Moore.
p. cm.
Includes bibliographical references and index.
ISBN 0-8109-5616-0 (hardcover)
1. Arthus-Bertrand, Yann. 2. Photographers--France--Biography. 3. Wildlife photographers--France--Biography. 4. Nature photography--France. I. Troubac, Sophie. II. Title.
TR140.A78A25 2004
770'.92--dc22
2004011837

Printed and bound in Singapore
10 9 8 7 6 5 4 3 2 1

Harry N. Abrams, Inc.
100 Fifth Avenue
New York, N.Y. 10011
www.abramsbooks.com

Abrams is a subsidiary of LA MARTINIÈRE

All images from the book are distributed by the Altitude agency (www.altitude-photo.com; www.yannarthusbertrand.org) with the exception of:
Cover: © Philippe Bourseiller; page 1: © Françoise Jacquot; page 9: © Bertrand Machet; page 12: © Claudine Vernier Palliez; page 13: © Antoine Verdet; pages 14-15: © Allain Bougrain-Dubourg; page 54: © Anne Arthus-Bertrand; pages 70-71: © Isabelle Bich; page 77 top and bottom: © Pascal Maître; pages 80 and 82: © Philippe Bourseiller; pages 86 and 88: Françoise Jacquot; page 92 top: Gérard Vandystadt; page 97 top: Philippe Hurlin; pages 108-109, 112 top, 113 top, 166-167: Dominique Llorens (domllorens@hotmail.com); page 168: Raphaël Gaillarde; pages 172 top and bottom right, 173 and 177: Dominique Llorens; pages 234-235: Ambre Mayen.

DVD

Yann Arthus-Bertrand

Being a Photographer

A coproduction Éditions de La Martinière and Éditions du Montparnasse.

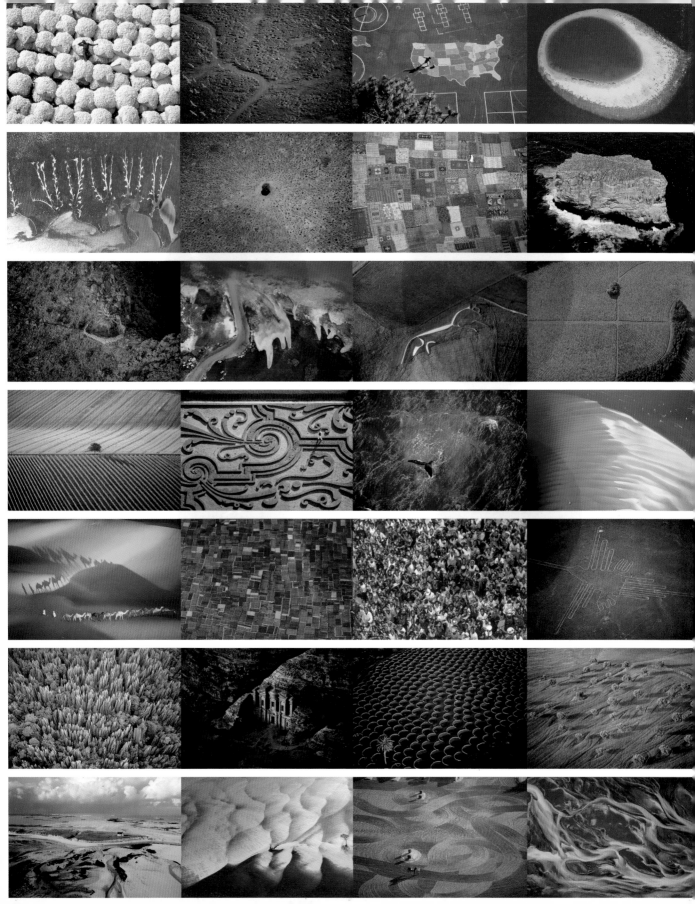